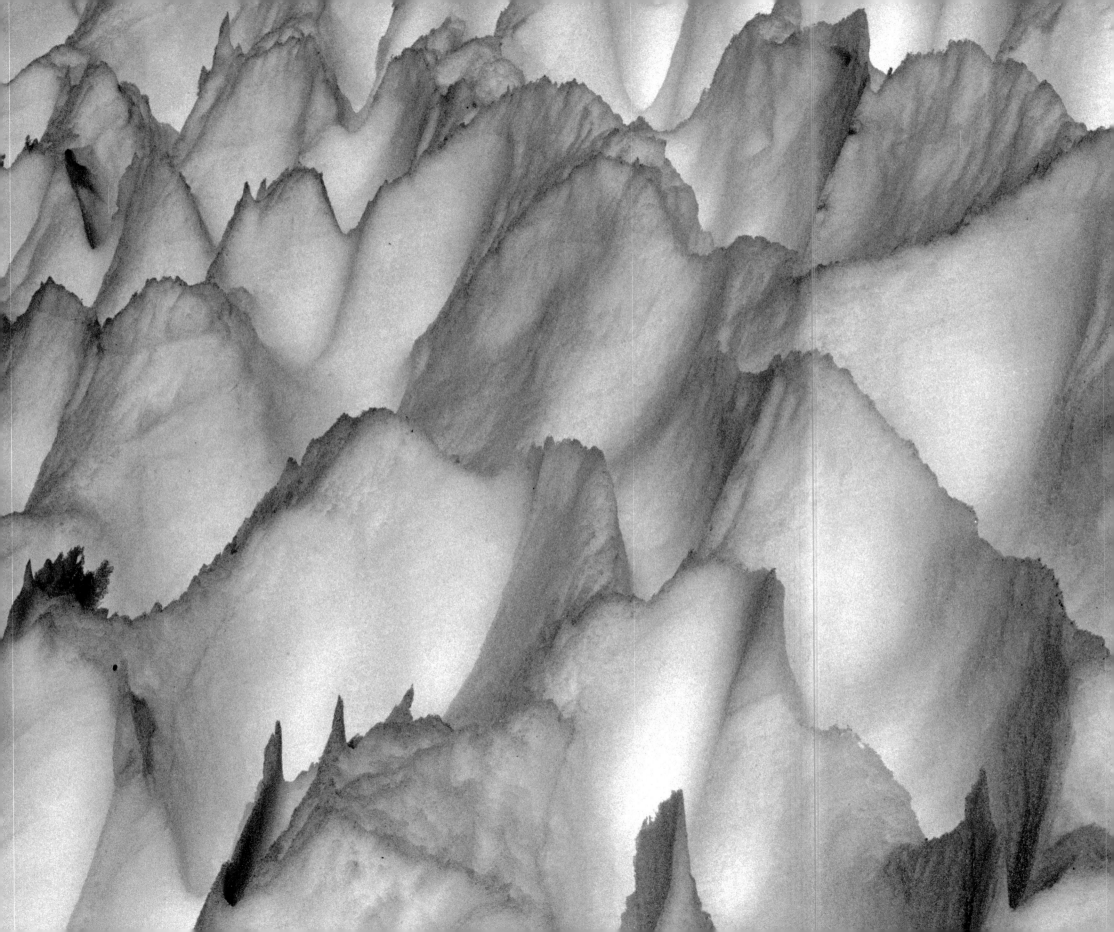

ABOVE ALL

MOUNT WHITNEY + CALIFORNIA'S HIGHEST PEAKS

PHOTOGRAPHS BY DAVID STARK WILSON
TEXT BY STEVE ROPER
FOREWORD BY KENNETH BROWER

YOSEMITE ASSOCIATION, YOSEMITE NATIONAL PARK, CALIFORNIA
HEYDAY BOOKS, BERKELEY, CALIFORNIA

Library of Congress Cataloging-in-Publication Data
Wilson, David Stark, 1961–
Above all : Mount Whitney and California's highest peaks /
photographs by David Stark Wilson ; text by Steve Roper.

p. cm.

ISBN 978-1-59714-107-9 (alk. paper)

1. Photography of mountains–California.
2. Mountains–California–Pictorial works.
3. Wilson, David Stark, 1961– I. Roper, Steve. II. Title.

TR787.W55 2008

779'.955143209794–dc22

2008005635

Cover art:
East face of Mount Whitney, September 12, 2007

Front endpaper and opposite title page:
Detail of sun cups on the Palisade Glacier, July 4, 2003

This page:
Detail of lenticular cloud over Mount Whitney, April 30, 2005

Opposite Introduction:
Detail of Tyndall Creek, August 12, 2003

Final page and back endpaper:
Detail of the east face of Mount Whitney, April 29, 2005

Design: Public

Printed in Hong Kong by Global Interprint

This book is the result of a collaboration between
the Yosemite Association and Heyday Books.

You can find information about the Yosemite Association
at www.yosemite.org, or write to P.O. Box 545, Yosemite
National Park, CA, 95389, or call (209) 379-2646. Orders,
inquiries, and correspondence about this book should be
addressed to:

Heyday Books
P. O. Box 9145, Berkeley, CA 94709
(510) 549-3564, Fax (510) 549-1889
www.heydaybooks.com

10 9 8 7 6 5 4 3 2 1

CONTENTS

FOREWORD

BY KENNETH BROWER

Three years ago, when David Wilson first showed me these images, his portraits of the tallest peaks of his childhood and of my own, I had a rush of mountain memories that veered, suddenly and unexpectedly, fourteen thousand feet downslope and ten thousand miles southwestward to the coral atoll of Kayangel, which stands just eight feet above the sea. Kayangel is the one true atoll in the Palau Archipelago of Micronesia. The atoll's four islets, only one of which is inhabited, comprise a half square mile of sand and palms and one hundred and forty residents.

Somehow Mount Shasta, Mount Whitney, White Mountain, and the Palisades evoked for me that minimalist topography and I remembered the big pisonia tree that grows just above the little coral-riprap peninsula of the atoll's jetty. Under this tree, most afternoons, a Kayangelese matron named Uldekl posted herself, Junoesque, while she mended clothes. In my recollections Uldekl is of a piece with the tree. She was the sister of Siakong, a spearfisherman legendary throughout all Palau, a powerfully built man who was as proficient as anyone at the available climbs on Kayangel—sixty or seventy feet up to the crowns of the tallest palms—but whose specialty lay in the other direction. Siakong was a great free-diver with a superhuman breath-hold capacity and an affinity for the depths. One day he failed to return from a dive and was never seen again. He had grown bored with life up in the atmosphere, they say, and he chose to live the rest of his days with the fishes. In Uldekl's broad shoulders and in her calm you could glimpse the man her brother had been.

The gnarled pisonia at the Kayangel jetty is one of the power spots on the atoll. Traditional peoples who live intimately with their landscapes come to recognize these special places, loci to which myth, lore, clan history, and magic tend to gravitate. An unusual boulder can anchor the spot, or a natural arch in Navajo sandstone, or an unquenchable spring.

Under the big pisonia on Kayangel I could sometimes feel the preternatural force of the tree. In its shade I lamented our lives in the West, spent so much indoors, deracinated, acquainted often with many places but truly familiar with none, insensitive to the metaphysical emanations of the landforms around us, rich in gadgets but impoverished in our sense of terroir and terrane and terrain, our estrangement growing with each generation, the spiritual and magical dimensions of our landscapes steadily flattening out under our feet.

But now, studying David Wilson's images of Polemonium, Starlight, and Thunderbolt, of Tyndall, Russell, Williamson, Muir, and Langley, I realized that my old pisonia-tree lamentations needed adjustment. No one could ask for better power spots than the tall peaks of the American West. A loincloth and bare feet are not required; a pilgrim can detect the aura and energetics perfectly well in parka and boots. Mountains have always been the salient power spots for those peoples lucky enough to have them: Fuji, Kilimanjaro, Denali, Navajo Mountain, Khumbila, Machupuchare. There is Mount Kailash in Tibet, sacred to Hindus, Buddhists, Jains, and Bön. There is Adam's Peak in Sri Lanka, its summit countersunk with the giant foot-shaped hollow that for Muslims is a footprint left by Adam in his thousand-year penance in Ceylon. For Buddhists it is the footprint of Buddha, for Christians the footprint of St. Thomas, and for Hindus the footprint of Siva.

The 14,000-footers of the Far West collect history, as power spots should—the deeds of John Muir, Clarence King, François Matthes, Ansel Adams, Norman Clyde. The big peaks are lodestones for legend and for family and personal lore. For the two authors of this book, as for me, the 14,000-footers were formative. We are all three Berkeley boys; we all passed at different times through Garfield Junior High; but our summer educations were at altitude. At night, for all three of us, these peaks took their big, jagged, inky bites out of a firmament of stars that were five times brighter and a thousand times more numerous than those we knew at home. By day, the reduced atmospheric pressure of those high slopes and summits gave us headaches and nosebleeds. Then, after three or four days of acclimatization, we would wake one morning to that peculiar

afflatus that comes at high altitude, that sensation of indomitability, the peaks having browned us up, muscled our legs, and visibly thickened and reddened our blood. The Sierra Nevada turned both of this book's authors into climbers. The mountains shaped David Wilson's vocation, architecture, for in his designs he is always trying to incorporate natural forms, and they shaped his avocation, photography, in that when his subjects are not actual mountains, they are manmade structures that echo mountainous shapes. The Sierra turned Steve Roper into our foremost historian of the climbing history of the range.

My own introduction to California's ultimate peaks was as a small boy at the heels of my father, hurrying to keep up with his long stride down the trail. If the Sierra Nevada for me was formative, for my father, David Brower, the first executive director of the Sierra Club, it was transformative. He spent his twenties in the Sierra as one of the preeminent rock-climbers of his generation, with more than sixty first ascents in the range. Up there he experienced some kind of slow-building, thin-air revelation, for when he finally came down from the mountains it was with the ambition to save the planet. He built the Sierra Club into the most powerful environmental nonprofit in the country and went on to found Friends of the Earth, the League of Conservation Voters, and Earth Island Institute. The keystone for the whole edifice, for which he felt the deepest love and concern, was the wild and snowy range that had launched him. One of the great evangelicals of his movement, he converted all four of his children with sea-level preaching at our dinner table—good, stirring talk—and yet the lessons I remember best are the mountain lessons.

"It's easier to stay warm than get warm," went one maxim, delivered on the trail. How true that turned out to be! And how crucial! It has served me as well in the actual Arctic as it did in the Arctic-Alpine Zone along the Sierra crest. Don't camp right on a stream, as nights there are ten to fifteen degrees colder than they are a hundred feet upslope. Don't blind yourself with a flashlight; turn it off and see how well your feet find their way in the dark. Don't camp under big trees in a big wind. Sling your tarp, as a matter of pride, as low as you possibly can. (In the Sierra a tent is for sissies.) In rock-climbing, work well within your margin of safety; the thrill of the climb should never be in the danger, but in the pure pleasure of the granite under your hands.

It is no mystery to me now, a half-century later, as I contemplate David Wilson's images and Steve Roper's words, why these lessons are so indelibly imprinted. It is because they were imparted amidst the sacred peaks. It is because we evolved as hunter-gatherers in particular landscapes and understand, in our genes, the importance of clan history, lore, and ritual connected to these home places. In this grounding we are kin to Uldekl under her pisonia and to Siakong deep in the sea.

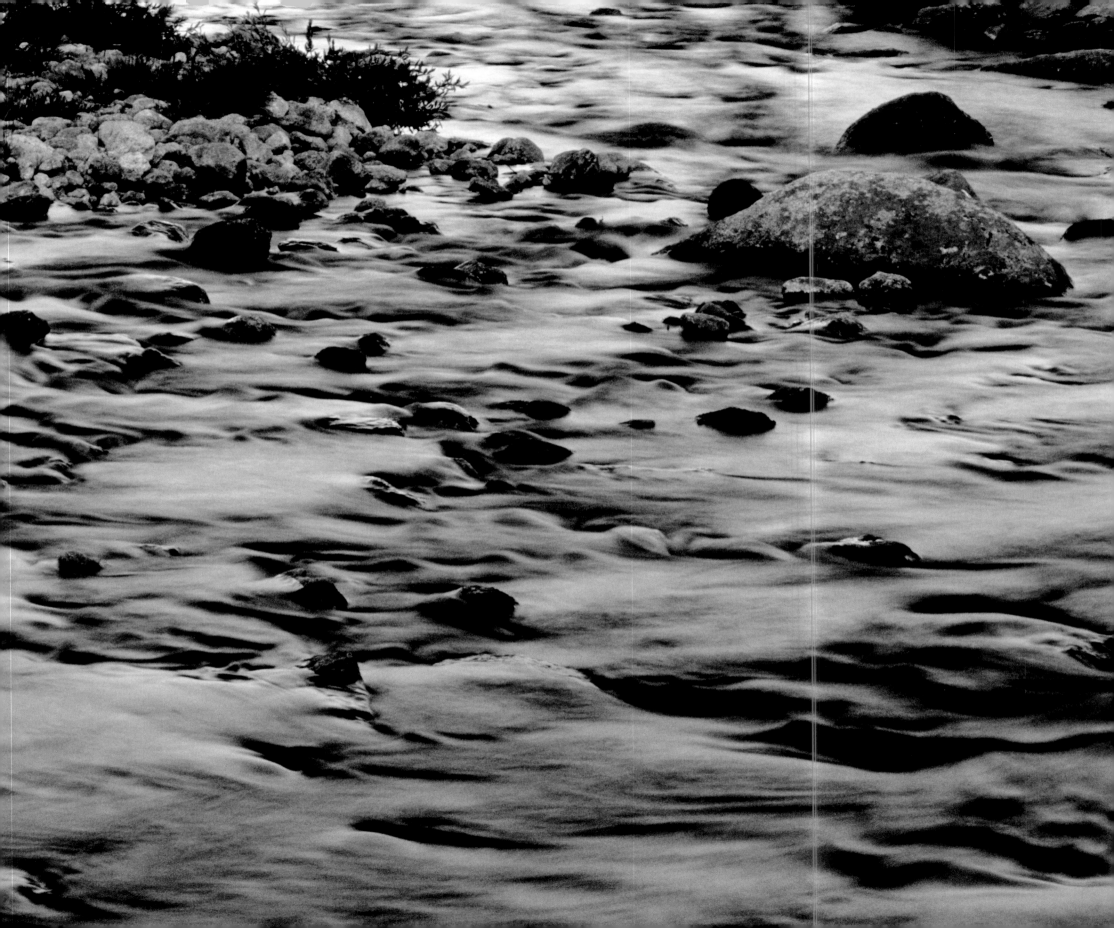

INTRODUCTION

Not surprisingly, California's highest peaks vary in shape, geology, and prominence. Some are mere spikes along a ridge, one appears to belong on the moon, and some are glacier clad. Most are splendid mountains. These Fourteeners, as the fifteen peaks rising above 14,000 feet are called, are featured in this book of David Stark Wilson's unique photographs.

We mountaineers who lust after the highest peaks in a state, or a nation, or a continent can hardly explain such endeavors. Yet there's something special about "magical" altitude numbers. The Scots have their cherished Munros, rounded hills above 3,000 feet. Coloradoans, like Californians, also have their Fourteeners, many of them undistinguished but still mandatory for a huge cadre of peakbaggers. The Seven Summits, high points of the continents, have been sought after for a quarter of a century by rich folk and their guides. The Asian high point, Mount Everest, and the other thirteen 8,000-meter (26,247-foot) peaks of the Himalaya are the most famous to be found on collectors' lists— an unattainable goal for most mortals. If a certain Sierra height seems a bit arbitrary, there's certainly good precedent.

Many of California's Fourteeners are spectacular, or at least rise in spectacular surroundings. Pristine lakes and meadows lie beneath these mountains. Major rivers speed toward the sea, and, near their sources, one can often step across them in a single stride. Solitude reigns, and from May to October the sky is clear for weeks on end. Yes, summer thunderstorms roll in occasionally, but these are dramatic and even fun—unless you are up high. The High Sierra is known as the Range of Light. It is also often called the Gentle Wilderness. Both are true.

Many of the Fourteeners have a human history that the lesser peaks lack, and several are household names even to nonclimbers. Old-timers, and many youths, gaze upon these peaks from their towns, thinking of past or future exploits. Growing up in the Central Valley in the 1880s, young Theodore Solomons, later to become a preeminent Sierra explorer, stared at the distant mountains, seeing them not merely as background objects, but as "the most beautiful and mysterious sight" he had ever beheld. He envisioned himself "in the immensity of that uplifted world, an atom moving along just below the white, crawling from one end to the other of that horizon of high enchantment." Such mountains foment dreams, and this is all to the good in the complex world we inhabit.

David Stark Wilson has climbed and backpacked in the High Sierra for decades, often in the company of one of his favorite climbing mates, the late Galen Rowell. Together they established high-quality routes up and down the range. David, like Galen, saw that such expeditions weren't just about doing new routes. The High Sierra is a phenomenal place, and much of the lure of delving deep into the backcountry is the privilege of taking a leisurely look at the landscape in all its moods. And a camera, in the right hands, can capture much of this feeling.

This is not a book about the peaks' geology or natural history. Nor is it a guidebook. It's a book of unique photos and a potpourri of interesting information—some of which was new to me as I searched libraries and the Internet. A disclosure: I have occasionally used prose from my earlier books.

It's going to take me at least fifty-four years to climb all fifteen of California's 14,000-foot peaks, a rather dismal achievement.* To be sure, I completed all but one by 1980 (much of this time I had instead labored on the cliffs of Yosemite Valley). But I forgot about Mount Langley, that lonely outrider in the far southern Sierra. An attempt in the autumn of 2007 failed because of early snowfall. But I can't wait for the next! When I finally conquer mighty Langley, I shall take a bizarre pride in knowing that I might forever own the world record for the longest time interval for climbing these fifteen sky-bending mountains. The shortest interval, by the way, is a mind-boggling three and a half days. Those who aspire to climb these peaks in less time than my quest, or more time than the record holder, should look at these photographs and dream on.

* California's Fourteeners are, from highest to lowest elevation, Mount Whitney, Mount Williamson, White Mountain Peak, North Palisade, Mount Shasta, Mount Sill, Mount Russell, Polemonium Peak, Starlight Peak, Split Mountain, Mount Langley, Mount Tyndall, Mount Muir, Middle Palisade, and Thunderbolt Peak.

somewhat as to the best method of approaching it. During the previous autumn, from a nearby peak, he had noted a narrow ridge or, perhaps rather, knife-edge leading upward toward the summit. Although it was too deeply gashed to *permit one to* follow its crest, there appeared to be a shelf on its northern side that might perhaps be *used* followed to a point not far below the summit. It was with the purpose of reaching this knife-edge that he was making a *shelf-* circuit to the east of the peak.

After luncheon he continued southward *over* across patches of deep snow and across a stretch of rough talus to the base of a ridge which, being only about five hundred feet in height, he soon surmounted. The route ahead looked formidable — at times, impossible. To the south the drop was perpendicular; to the north, after descending at a steep angle for a few feet, it fell away sheer. However, impractical as it might seem from a distance there was always a safe passage, and narrow though it might

Excerpt from the journals of Norman Clyde, used with permission of
The Bancroft Library, University of California, Berkeley: BANC MSS 79/33 c,
Carton 2, Folder 53 (from "The First Ascent of Mt. Russell")

THE WHITNEY REGION

Thirteen. That was my age when I made my first serious trip into the High Sierra. And what a place to savor the experience: Mount Whitney! The impetus was a Sierra Club trip I had read about in the club newsletter during the spring. My dad, a research chemist, had recently joined the club, perhaps to please his boss, Hervey Voge, a well-known Sierra mountaineer. Voge had just finished the first guidebook to the High Sierra, and my dad had helped on this project. I pleaded with my parents to let me go on an August trip Voge was leading into the backcountry west of Whitney. They agreed. And so I signed up for the first-ever "Sierra Club Wilderness Base Camp."

The club had sponsored basic Sierra outings since 1901. All sorts of extra adventures were offered in the ensuing years. On rugged "Knapsack Trips" one wandered almost at random, carrying everything needed. "Burro Trips" were easy, slow-moving ramblings, perfect for families. On "High Trips," the most thrilling adventures of all, as many as one hundred and fifty people moved steadily on established trails through the high country for several weeks, their duffle bags—and all commissary gear—carried by endless mule trains. "Base Camps" were designed for more sedentary folk. Up to eighty people would hike for one day to a lovely timberline site, perhaps seven miles into the range, there to spend the next ten days exploring their surroundings on day trips. Small groups would go out each morning to climb a peak, to fish, or just to hike over to the next lake or canyon.

By the mid-1950s the club's leaders were aware that many popular sites were becoming trampled with so many visitors. What to do about this? One answer was to cut back on the number of participants. Another was to reconsider the age-old High Trips; the pack trains were tearing up trails and ruining meadows (these beloved trips ceased in the 1960s). Yet another was to retreat further into the high country, finding pristine sites and treading lightly. And this was the reason for my trip of 1954: to go somewhere where no big group had ever gone.

To differentiate this trip from a normal Base Camp, the word "Wilderness" was added, along with many caveats about the difficulty. This is what attracted me.

Fifty of us hardy hikers took two full days to reach a pretty, untouched lake partway up the trailless Crabtree Lakes Basin, not too far from the western base of Whitney. During the following week I climbed a few easy peaks, endured an endless hailstorm under an inadequate tarp, and watched the fishermen in our group haul sixteen-inch golden trout from a nearby lake. The graduation-day finale was the hike up Whitney on the way back to civilization. I was breathless as I approached the summit, not from the altitude, but from trotting the last few hundred yards.

~~~~~~~~~~

Of all the regions of California's Range of Light, no other has a reputation like that of the Mount Whitney group. Whitney itself, known since the 1870s as the highest point in the Lower Forty-Eight, is of course the lure. But the eleven-mile stretch of peaks hosts five more Fourteeners: Tyndall in the north, Langley in the south, and Russell, Williamson, and Muir in between, plus a number of lesser but fine-looking heights. The Whitney region is also a rock-climber's

paradise, with dozens of high-quality routes. Adding to the appeal of this remarkable place, if one is historically inclined, is the strange series of events that took place nearly a century and a half ago—the drawn-out saga of Clarence King.

King, later to become famous as author of *Mountaineering in the Sierra Nevada* and as the first chief of the United States Geological Survey, was a youth in search of adventure in 1864. Having graduated from the Yale Scientific School with a degree in geology, King came west to work with the California Geological Survey as this organization charted the unknown regions of the state.

In July 1864 a small group of geologists, surveyors, and mapmakers, including King, worked its way toward the Great Western Divide, a massive subrange lying west of the main Sierra crest. William Brewer, the field leader of the Survey, climbed a conspicuous peak with a companion. At the top of this towering mountain—immediately named Mount Brewer—the two were captivated by the endless array of peaks, canyons, and cirques to the east. Taking advantage of the bird's-eye view, Brewer named many of the most prominent peaks, including one massive landform fourteen miles to the southeast: Mount Whitney. This mountain, named for the director of the Survey, seemed to be the Sierra's loftiest point.

Back at camp, the two climbers related the day's adventures to the others. The vision of such high, unexplored peaks rising only a few miles distant proved too much for Clarence King to bear. The twenty-two-year-old geologist begged Brewer to let him attempt one of the huge peaks, preferably Whitney itself. Brewer, having noticed the chaotic landscape lying between Mount Brewer and the Whitney massif, gave his permission reluctantly.

King and packer Richard Cotter soon embarked on an adventure that has become a classic of High Sierra folklore. Their five-day trek across absolutely uncharted terrain involved the most difficult and intricate cross-country travel ever attempted in North America. Small cliffs continually blocked progress,

and ledges that appeared to lead to easier scrambling terminated over hideous drop-offs. Talus slopes were steep and unstable, and treacherous snowfields lingered.

Nevertheless, the terrain that makes up this region is by no means as intimidating as King implies in his embellished account recorded eight years later in *Mountaineering in the Sierra Nevada*. Most adventure writers of the late nineteenth century apparently felt their audience would be impressed only with sensational feats, and the journey King related consequently glows with drama and suspense. In one famous scene, Cotter, in the lead on a steep cliff, drops King a rope and informs him that he can place his weight on it if he so desires. Thus reassured, King decides it would be more sporting to climb the rock itself instead of pulling himself hand over hand up the rope. On reaching Cotter, he is shocked to see his companion perched precariously on a sloping ledge. Though it is possible that Cotter was indeed a foolish youth who endangered both his and King's life, it seems more likely that King simply exaggerated the incident.

King and Cotter finally managed to reach the top of a high peak, but it was Mount Tyndall (as it was later called), not the higher and more distant Whitney. King's failure to climb the range's highest point exasperated him, and immediately upon his return he begged his chief to let him try again. Brewer, knowing his assistant could fill in yet more blanks on the Survey's charts, gave the impatient youth a hundred dollars and an escort of two soldiers. This small expedition crossed the Kern River plateau and, after several days of needlessly complex maneuvering, finally set up camp beneath the real Mount Whitney. But the route they chose was too difficult and King again failed to reach his goal.

King's professional duties kept him in other regions of the United States until 1871, but in June of that year he detoured to Lone Pine, the village east of Whitney, confident that he would not be disappointed a third time. With a companion he managed to struggle upward to a prominent summit, but storm clouds blanketed the nearby peaks and rendered the view worthless. Although this meant that King could not confirm his success, he returned to his

geological duties certain he had reached his goal. The word spread that the nation's highest peak had been conquered.

The emotions of the young geologist must have ranged from disbelief to anger to humiliation when, two years later, he read a scientific paper claiming he had reached a "false Whitney" in 1871. The author of this disturbing piece, W. A. Goodyear, had recently ascended King's mountain and had been astonished to see, only five miles to the north, a significantly higher peak. King hurriedly entrained for California and, on September 19, 1873, he finally stood atop the towering peak he had first heard about nine years earlier. But there he endured yet another disappointment, for a note in a pile of rocks indicated he was not the first to reach the summit. One month earlier, three fishermen from the Owens Valley, hearing of the controversy, had taken advantage of their on-the-spot location to solve forever the mystery surrounding the mountain.

So ends King's final adventure in the High Sierra. As historian Francis Farquhar has noted, King was "far too cock-sure, far too impetuous, to be a good mountaineer." Still, I feel that Clarence King is one of the most endearing characters ever to roam the high country. Despite his ineptitude, he topped four California Fourteeners in ten years: Tyndall in 1864; Shasta in 1870; Langley in 1871; Whitney in 1873. Not bad for the horse-and-buggy days!

Later in life, back in the nation's capital, King became friends with some of the most noted literary figures of the late century. At King's funeral, in 1901, William Dean Howells and Henry Adams helped bear his casket to the grave. In his most celebrated work, *The Education of Henry Adams*, Adams said of King: "He knew America, especially west of the hundredth meridian, better than anyone....He had something in him of the Greek—a touch of Alcibiades or Alexander. One Clarence King only existed in the world."

~~~~~~~~~

Another soon-to-be-illustrious character arrived in the Whitney region only a month after King's success, undoubtedly attracted by the first-ascent controversy. John Muir, in a remarkable example of endurance, was the first to climb Whitney directly from the east—the precipitous side. In just over forty-eight hours, walking from the village of Independence (not from the much closer hamlet of Lone Pine!), Muir trekked cross-country through unknown terrain and climbed a steep gully just to the right of the impressive east face. This became known as the Mountaineer's Route, and Muir later wrote a wonderful admonition to prospective climbers: "Well-seasoned limbs will enjoy the climb of 9,000 feet required by this direct route. But soft, succulent people should go the mule way." (By the time Muir wrote this, a rough trail on the west side had been built; mules apparently reached the top as early as 1881.)

The reputation of John Muir, by far the best-known Sierra sage, remains untarnished nearly a century after his death. Mountaineer, writer, and naturalist, he will be associated forever with the late-nineteenth-century West. An inquisitive youth, stricken with wanderlust, Muir first visited the Sierra Nevada in 1868, at age thirty. For a few years he tended sheep, milled fallen logs, and scrambled to remote vantage points, pausing to study the trees, rocks, and canyons. These observations paid off, for in the late 1870s he put forth a radical theory about the origin of Yosemite Valley. Professional geologists had long subscribed to the "cataclysm" scenario, wherein the bottom of the gorge had somehow violently dropped thousands of feet, creating a deep chasm. Muir, not so much a heretic as a careful observer, thought otherwise. Burnished granite slabs, with well-defined striations parallel to the main axis of the valley, indicated that glaciers had helped carve the great cleft. Younger and more curious than the aging academics, Muir took to the high country to investigate further. Here he found living glaciers, remnants of the vast ice sheets that once had blanketed the range; this was further proof that such large glaciers had once existed. Over the next few decades Muir's view of how the U-shaped trenches of the High Sierra had been formed became generally accepted—a triumph of personal investigation over textbook speculation.

Muir was a loner, a wanderer who thought nothing of taking a week-long trip to timberline country with only a few hunks of bread and a blanket. He'd curl up

among gnarled whitebark pines at dusk, arise at dawn, stretch, and continue on his way, never knowing or caring where or how he'd end up that night: high or low, catnapping on a bed of pine boughs or shivering on some airy perch. This nontraditional way of traveling in the mountains elicited a wry comment from the eminent naturalist C. Hart Merriam in 1916: "In spite of his having spent a large part of his life in the wilderness, he knew less about camping than almost any man I have ever camped with."

Little is known about the exact course of Muir's wanderings, for though he kept meticulous and eloquent notes of the natural world, he rarely reported his itinerary or his climbs of Sierra peaks. This is unfortunate, for in addition to being a first-rate naturalist and writer, Muir was also a first-class climber. Luckily, he did record a few of his feats. His 1869 ascent of Cathedral Peak, above Tuolumne Meadows in the Yosemite high country, ranked as the most difficult climb accomplished up to that time in the United States. Alone as usual, he squirmed his way up the final steep spire without a rope, a feat not often imitated today by casual climbers.

As Muir became older and more famous, his trips to the Sierra tapered off in frequency and intensity—as was true of most of the early explorers. Foreign trips, family obligations, lectures, books—all kept him from his beloved Sierra. Still, men of letters and power sought him out for his views of the natural world, for example Ralph Waldo Emerson, John Burroughs, and Theodore Roosevelt. The latter wrote Muir before a visit to Yosemite Valley in 1903: "I do not want anyone with me but you, and I want to drop politics absolutely for four days, and just be out in the open with you." The pair had some memorable moments on this trip, including one that should not be emulated today. One night, as they camped alone on the valley floor, a chilled Muir set fire to a huge, standing dead pine. "Hurrah!" shouted the president. "That's a candle it took five hundred years to make. Hurrah for Yosemite!"

Another Roosevelt/Muir anecdote is related in Ralph Hoffmann's *Birds of the Pacific States* (1927). Two tiny, drab birds were at issue. As Hoffmann writes,

"When Theodore Roosevelt first met John Muir, it is reported that his first question was, 'How can one tell the Hammond from the Wright Flycatcher?' It is doubtful whether any future President of the United States will have the slightest interest in the problem."

~~~~~~~~~~

Mount Whitney soon became a desirable goal. Hardy tourists labored up the western side, thrilled to reach the nation's high point. Others came, too. In 1881 scientists became interested in the mountain as a site for solar observations. As one result of this brief study, the summit and surrounding region were for twenty years America's most unlikely military reservation. Later, after the military called it quits, the Smithsonian Institution built a stone shelter on the summit to house astronomers who planned to investigate the possibility of water vapor on Mars during a propitious viewing time in the late summer of 1909. Nothing came of this experiment, but the shelter still stands.

The name "Whitney" did not gain universal acceptance for some time after Brewer applied it in 1864. Locals in the Owens Valley called it "Fishermen's Peak" for several years, and for a while it bore the dreadful name "Dome of Inyo." The California legislature even became involved, in 1878 formalizing the present name.

An even more pedantic controversy concerned the mountain's height. This had dropped from 14,878 feet in 1873 to 14,522 in 1881, and then to 14,496 in 1928. Reaching the summit in 1954, I saw a shining summit plaque declaring its height to be 14,495.811 feet. Impressed by this lunatic number, I still thought about the waste of taxpayers' money to get the peak accurate to the thickness of a fingernail. What if a bird had shat upon the topmost point an hour earlier—or later? The current USGS topographic map indicates 14,494 feet, though a figure eleven feet higher has now been proposed owing to recent satellite-connected research about the true shape of our "globe."

If King and Muir became recognized names in the late nineteenth century, the same cannot be said of the first ascenders of three of the region's other Fourteeners. As mentioned, three fishermen climbed Whitney first, from the easy western side. They were the first on record, yes; it's quite possible that Indians had ascended the peak long before Europeans and Americans ever saw it. Are any of these names and life stories important here? Perhaps not.

The same applies to the first ascenders, in 1884, of Mount Williamson, that off-crest giant five miles north of Whitney. Had the Williamson climbers written about their exploits—or had they become as famed as King or Muir—then we would pay attention. Williamson is certainly a major peak, visible for many miles if one is driving down U.S. 395. If human history is a bit lackluster here, one can turn to wildlife. A subspecies of the bighorn sheep known as the Sierra bighorn sheep roams the eastern flanks of this region and points north. Down to about a hundred animals in 1995, the species has made a notable recovery. Hikers and climbers are forbidden to travel in certain districts for parts of the year to avoid disturbing this still-rare species.

Mount Muir, just south of Whitney, was first ascended by persons unknown. It was also named by an unknown, and it is certainly not worthy of much prose here. From a few directions the mountain, just south of Whitney, looks like an actual peak, but truth be told, Mount Muir is a bump not worthy of the great naturalist's name.

The same cannot be said of 14,086-foot Mount Russell, less than a mile north of Whitney. This is a sublime peak, though hidden from most viewpoints. Even from the top of Whitney it seems a mere shadowy form, superimposed against the background granite. But from below, especially from the southwest, its towering arêtes and faceted walls rise into the sky seemingly forever.

Enter Norman Clyde, the most illustrious Sierra mountaineer of the first half of the twentieth century, seeking adventures in the far south of the Sierra. And what did he choose but Mount Russell, the last unclimbed Fourteener in the Lower Forty-Eight (Thunderbolt Peak, climbed by Clyde and others in 1931, was shown to be a Fourteener only when new topographic maps appeared in the early 1950s). Clyde worked his way up Russell, found no evidence of a previous visit, and then decided, with a thunderstorm brewing, to descend an unknown arête to the lowlands, knowing that if this didn't pan out he might have to climb back to the summit and possibly get zapped before revisiting his ascent route. All went well for a while. Then he paused. He later described his hesitation: "A rather formidable wall appeared to bar farther progress. On one side was a vertical cliff, on the other a steeply shelving slope; but by an assortment of gymnastic maneuvers familiar to every rock-climber I was able to let myself down in safety to the base of this obstacle." This section would cause only a momentary delay for modern-day climbers, but when I think of Clyde's position—alone, with not a soul in sight, at 14,000 feet, where a broken leg would be a death sentence, and with thunder rumbling nearby— I am impressed.

Yet another bold person arrived in the same region, late in 1928. Like Clyde, Orland Bartholomew was a loner, and his solo, hundred-day winter trek might well be the ultimate Sierra adventure, one never to be repeated, given modern technology with its special skis, cold-weather gear, GPS transceivers, and cell phones. Gene Rose, author of *High Odyssey,* a 1987 book about this achievement, calls it "perhaps the most ambitious and adventurous feat by one man during [the twentieth] century." Writing about the mountain men of the 1920s and earlier, Rose continues: "While most felt the sting of the Sierra winter at some time, they were content to exit the high country with the first snows since it was just good common sense."

Bartholomew was not content to spend the winter in a warm house. Starting on Christmas Day, this daring fellow skied, alone, from the southern end of the Sierra to Yosemite Valley, along the way making the first winter ascent of Mount

Whitney. During the previous autumn he had placed eleven food and equipment caches in the High Sierra. Nevertheless, his daily pack weighed some sixty pounds, a rather impressive load for a cross-country skier. Following more or less the course of the present John Muir Trail, the thirty-year-old Bartholomew crossed thirteen passes, ascended 70,000 vertical feet, and survived a vicious avalanche during his trek. His remarkable achievement is slightly tainted by the fact that it wasn't continuous: he left the mountains twice for breaks—totaling about twelve days—in towns in the Owens Valley.

wwwwww

Norman Clyde was back in the area during the summer of 1931 for yet another dramatic adventure, this one uncharacteristically done with other mountaineers, including Robert Underhill, an easterner who had climbed in the Alps and who knew how ropes and pitons were used, mysteries more or less unknown to Californians. Sierra Club mountaineers had lured him to the Sierra to teach them such esoteric techniques as belaying and rappelling. After a few climbs in Yosemite and the Palisades (including the first ascent of Thunderbolt Peak), Underhill and Clyde teamed up with two teenagers, Jules Eichorn and Glen Dawson, to attempt the huge east face of Mount Whitney, considered sheer and probably unclimbable.

Underhill, a philosophy professor at Harvard, wrote a lengthy article about the climb. On the first day of their approach march he described their "outrageously heavy knapsacks," commenting that Clyde's was an "especially picturesque enormity of skyscraper architecture." That night, as the group stared at Whitney's east face, he had doubts: "I felt that it would be a mighty hard nut to crack. Certain vertical black lines, indicating gullies or chimneys, were indeed visible, but the questions remained whether they were individually climbable and susceptible of linkage together into a route. Every rock-climber knows, however, that such questions as these can be answered only at very close quarters."

He was right. At close range the rock was broken and not terribly steep. Ledges and ramps appeared every few feet, bypassing short vertical sections. The climb turned out to be far easier than anyone had thought, and three hours and fifteen minutes after they left camp they were shaking hands on the summit.

Few parties today manage to do the route this quickly, but the climb soon became a classic, and thousands of mountaineers have enjoyed such features as the Washboard, the Fresh-Air Traverse, and the Grand Staircase. I have done the route only twice, but I recall being thrilled, more than usual, to have trod such splendid and historical terrain. I should add that I was definitely huffing and puffing both times. Even easy rock-climbing at 14,000 feet is debilitating unless you are perfectly acclimated. Afternoon thunderstorms also can be a problem; the climb should not be taken lightly. And then there's the descent. If you drop down Muir's Mountaineer's Route to a high camp, your knees will not forgive you. Or if, as I once did, you do the climb in one day from the roadhead at Whitney Portal, the 6,000-foot ascent and the ten-mile trail back will test your endurance. But at least this way you won't have to suffer a pack of "skyscraper architecture."

Many more routes have been done on the eastern escarpments of Whitney and its impressive satellite, Keeler Needle. Some of the climbs are among the most difficult in the High Sierra. Nearby Mount Russell, relatively difficult to reach, contains more than a dozen super rock-climbs. While many unexplored walls have yet to be touched, it seems safe to say that the most prominent cliffs have been found. The emphasis now will shift to short, difficult climbs on minor outcrops.

## SOURCES AND FURTHER READING

Clarence King's *Mountaineering in the Sierra Nevada* (1872) makes for interesting reading, even though one must take certain passages with the proverbial grain of salt.

William Brewer's account of his time with the California Geological Survey can be found in *Up and Down California in 1860–1864: The Journal of William H. Brewer*, ed. Francis Farquhar (fourth edition, 2003).

Francis Farquhar's thorough overview of Mount Whitney's history, "The Story of Mount Whitney," was printed in the *Sierra Club Bulletin* in four parts: Vol. 14, No. 1 (Feb. 1929); Vol. 20, No. 1 (Feb. 1935); Vol. 21, No. 1 (Feb. 1936); and Vol. 32, No. 5 (May 1947).

John Muir's eloquent *Mountains of California* (1894) provides a lively glimpse into his wanderings and the state's geography.

Norman Clyde's comments about his ascent of Mount Russell come from the 1927 issue (Vol. 12, No. 4) of the *Sierra Club Bulletin*.

Gene Rose's *High Odyssey* (revised edition, 1987) tells the story of Orland Bartholomew's amazing solo ski tour.

Robert Underhill's comments about the east face climb of Whitney come from the 1932 issue (Vol. 17, No. 1) of the *Sierra Club Bulletin*.

Paul Richins Jr. has written a thorough overview of Mount Whitney itself: *Mount Whitney: The Complete Trailhead-to-Summit Hiking Guide* (2001). This book describes in detail thirteen varied approaches to the mountain.

Climbers will appreciate Stephen Porcella and Cameron Burns' *Climbing California's Fourteeners: The Route Guide to the Fifteen Highest Peaks* (1998). Eighty-four routes are described on this region's six Fourteeners; most of these are technical in nature.

A superb, waterproof topo map of most of the Whitney region is Tom Harrison's *Mt. Whitney Zone*, with a commendable scale of two inches to the mile (www.tomharrisonmaps.com).

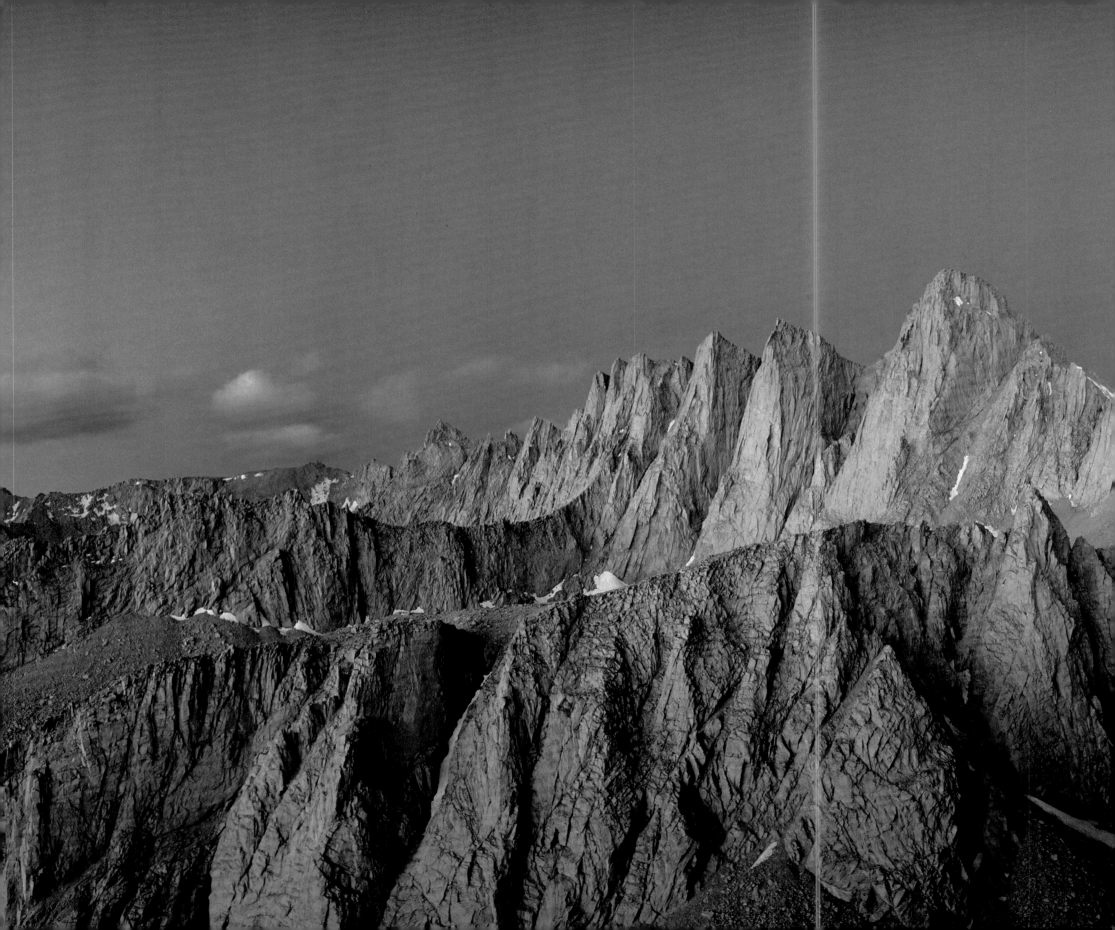

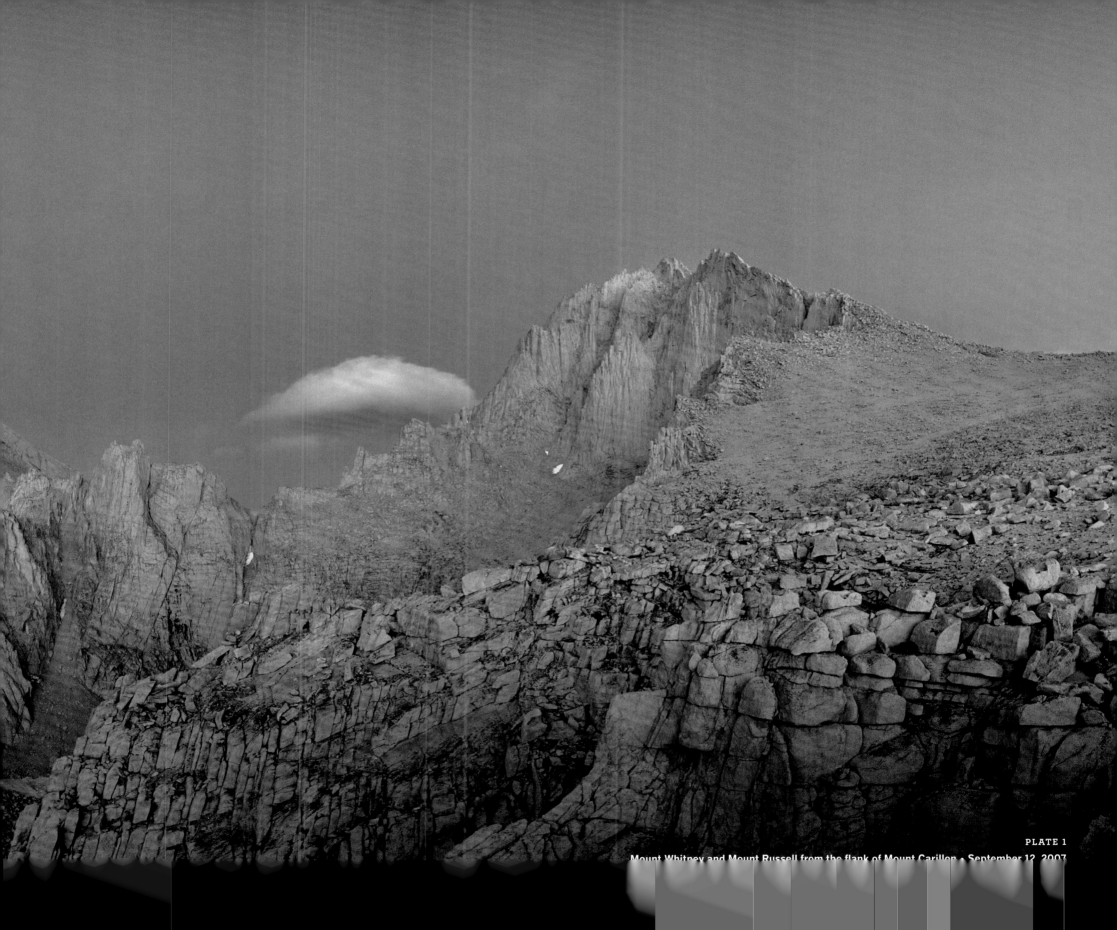

Mount Whitney and Mount Russell from the flank of Mount Carillon · September 12, 2007

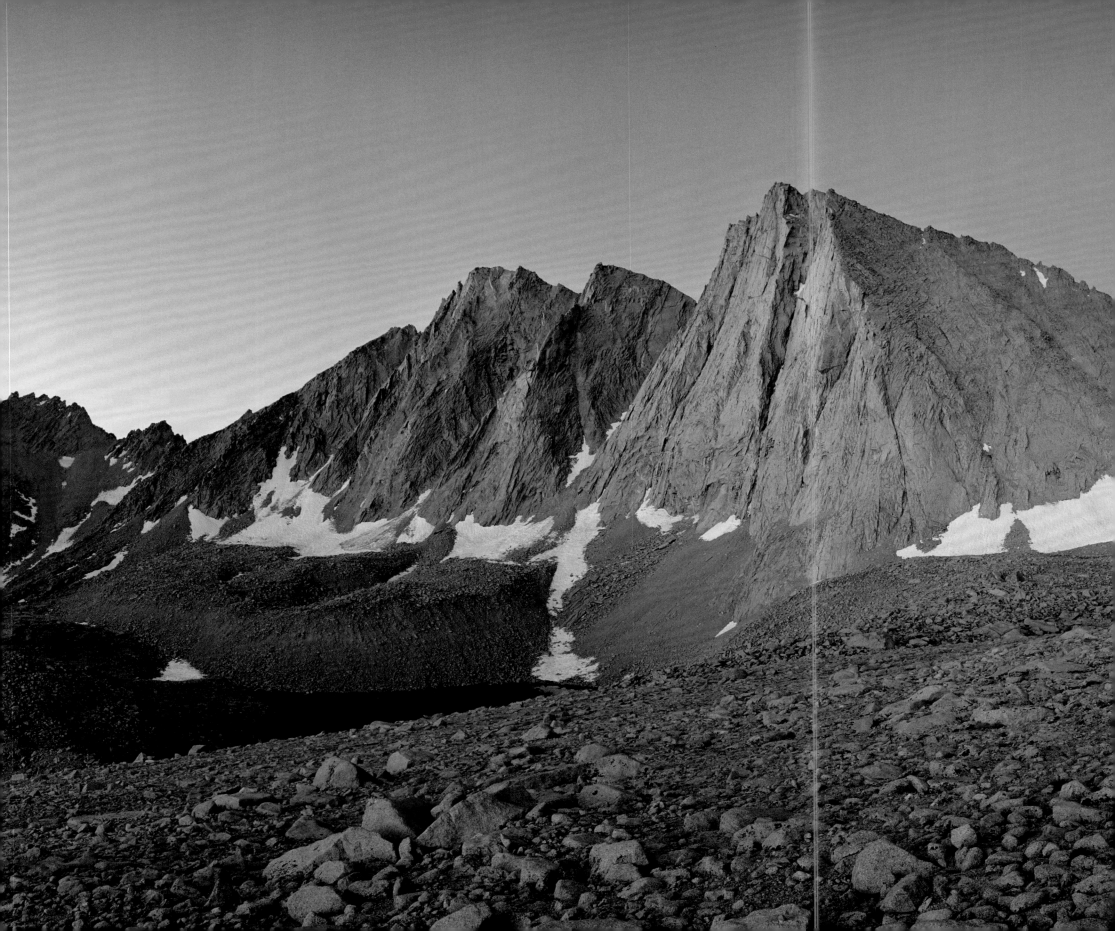

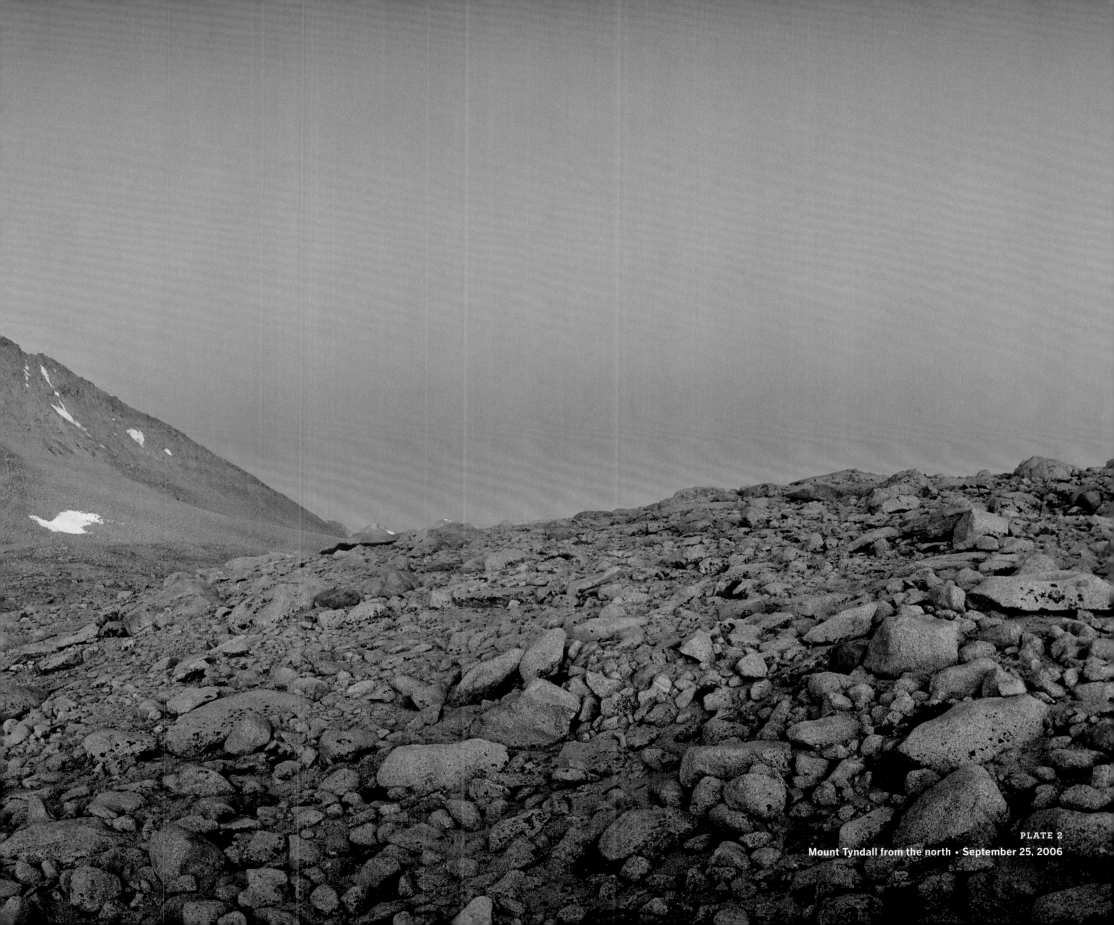

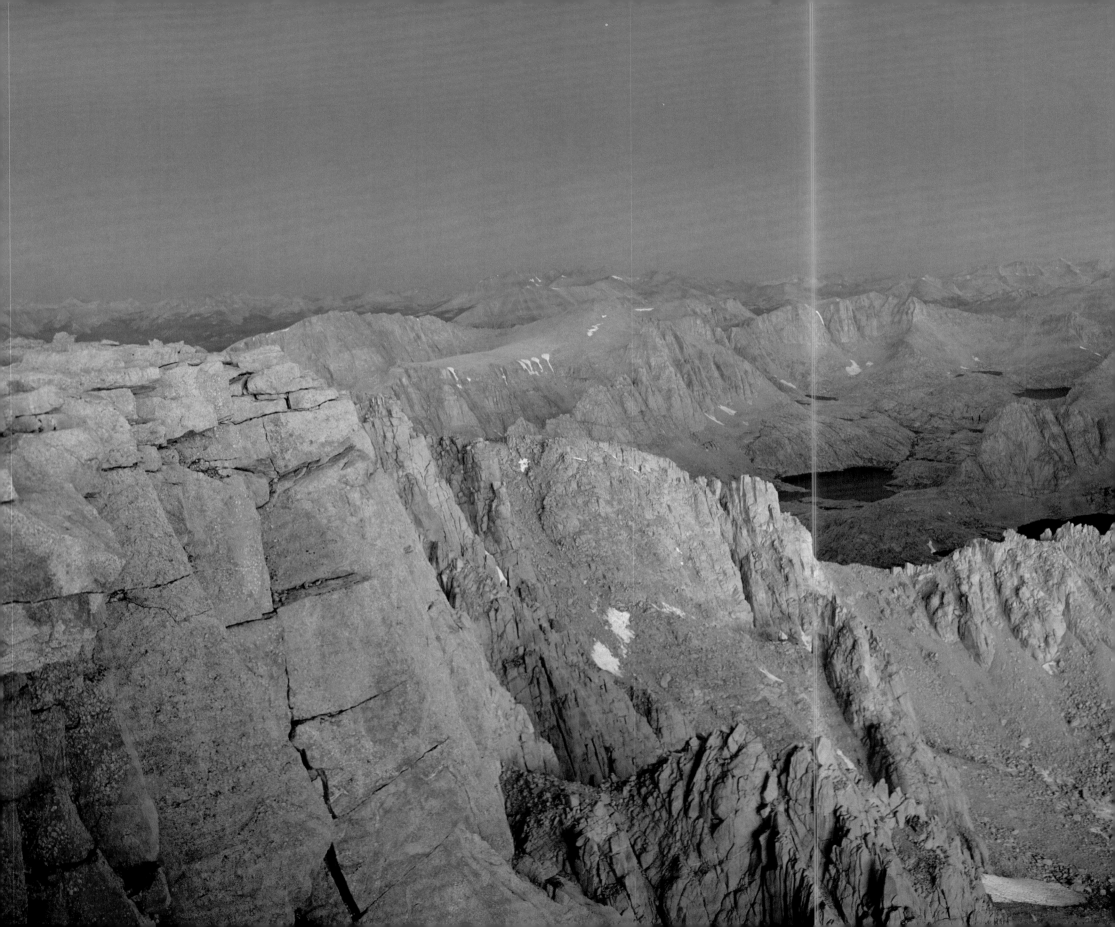

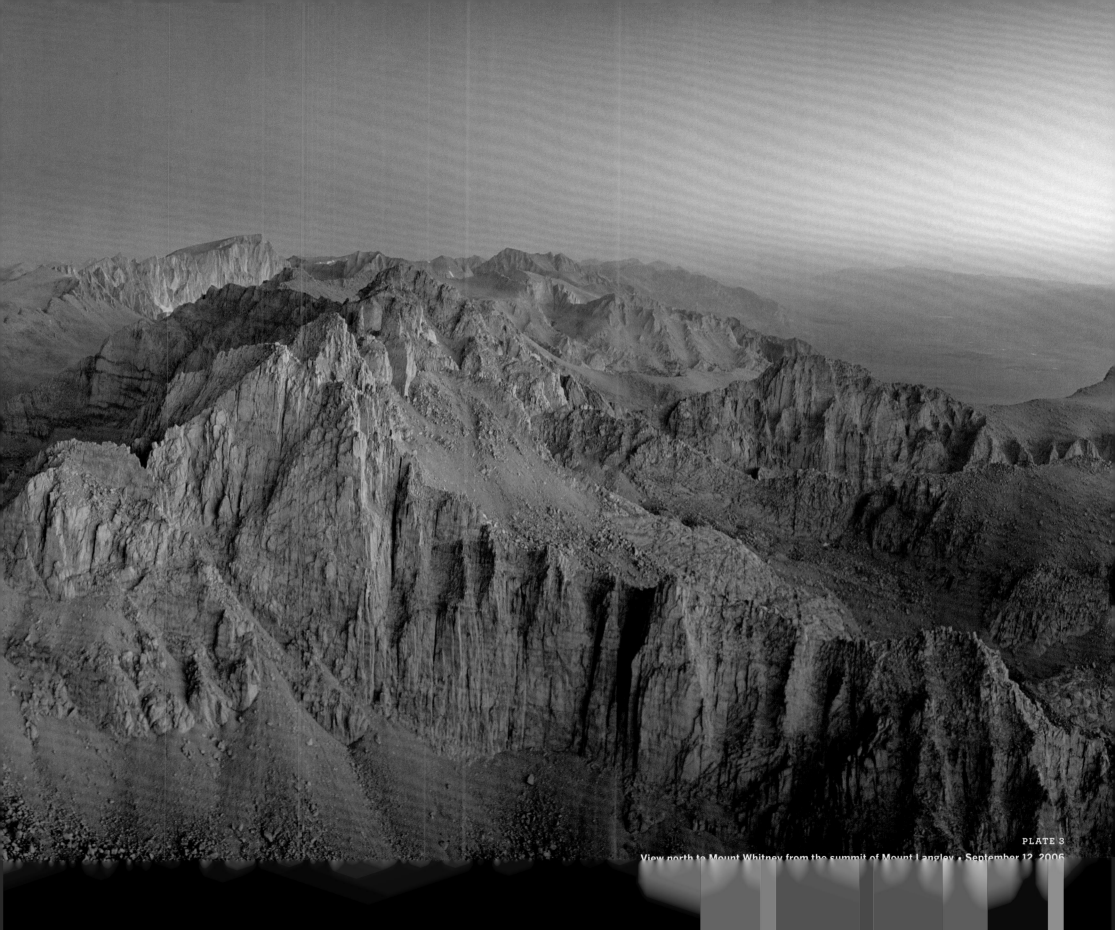

PLATE 3

View north to Mount Whitney from the summit of Mount Langley · September 12, 2006

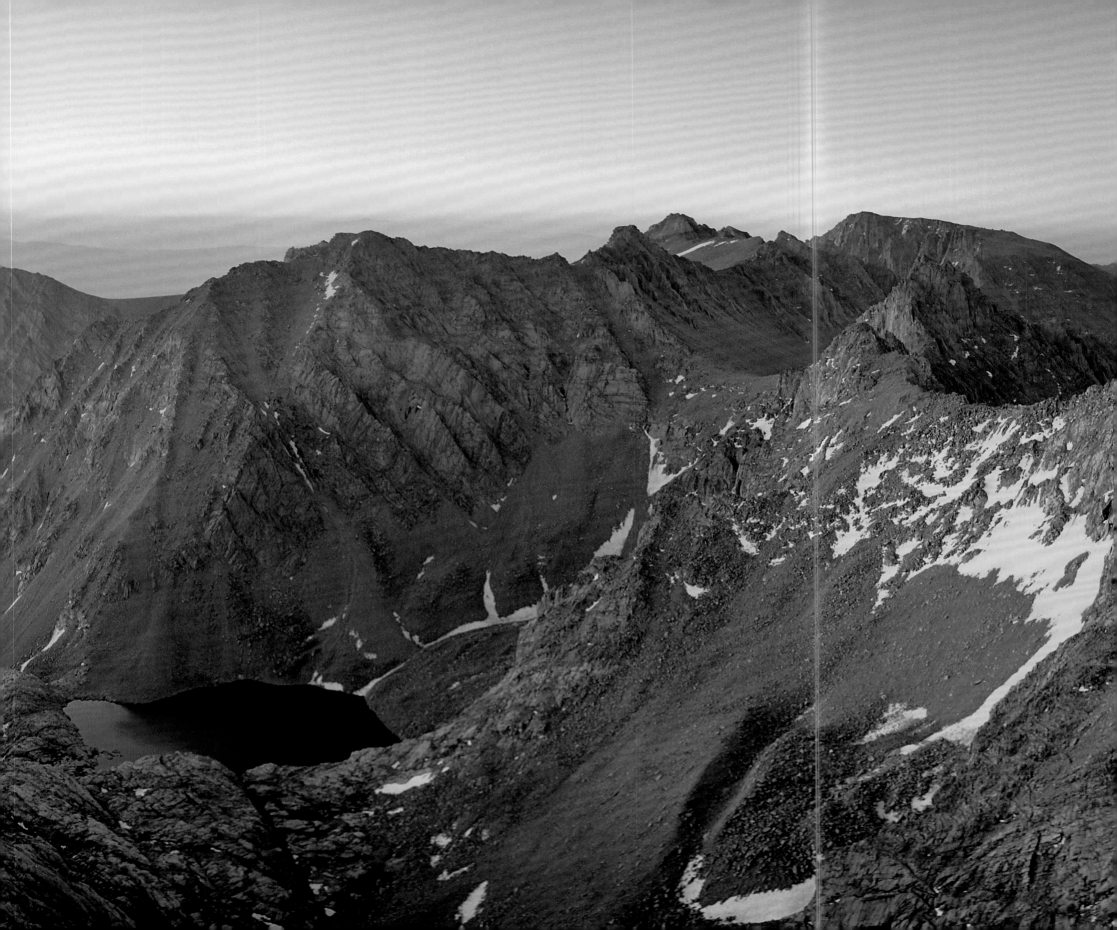

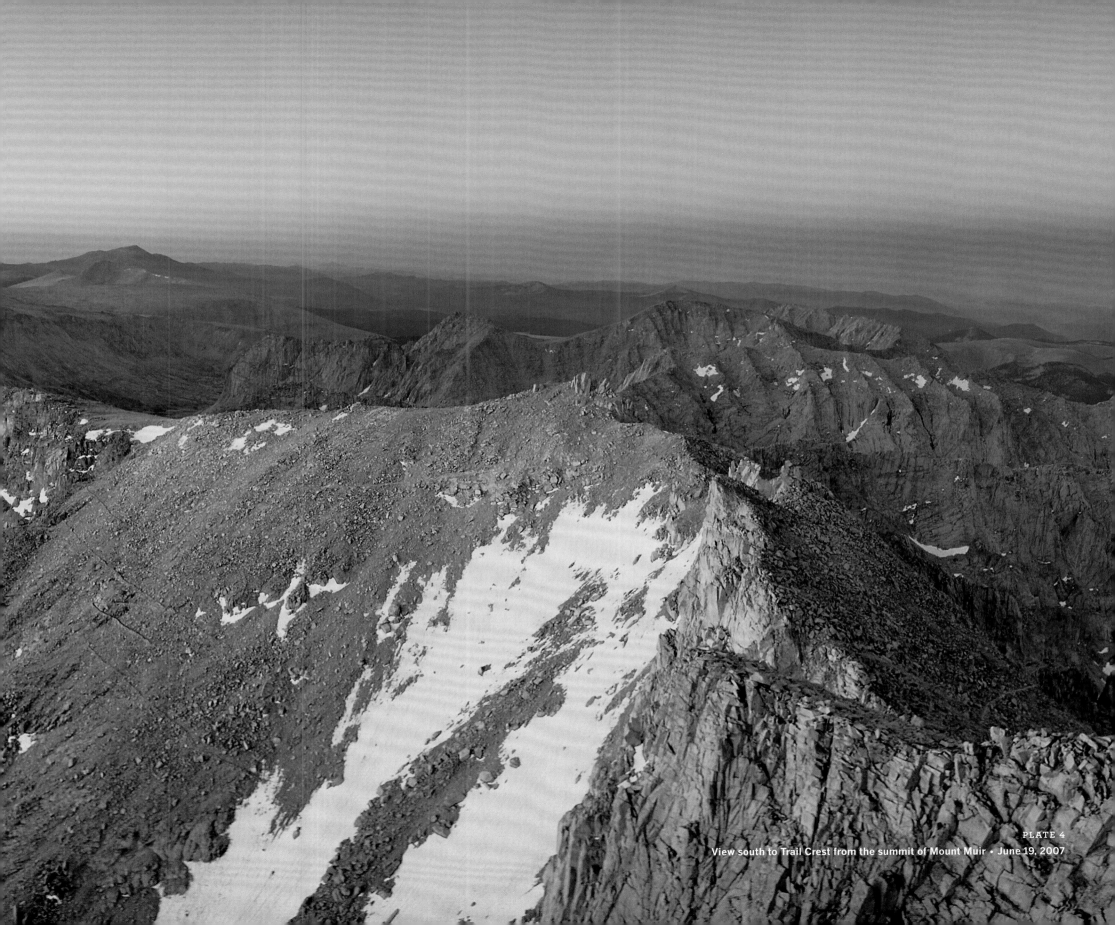

View south to Trail Crest from the summit of Mount Muir · June 19, 2007

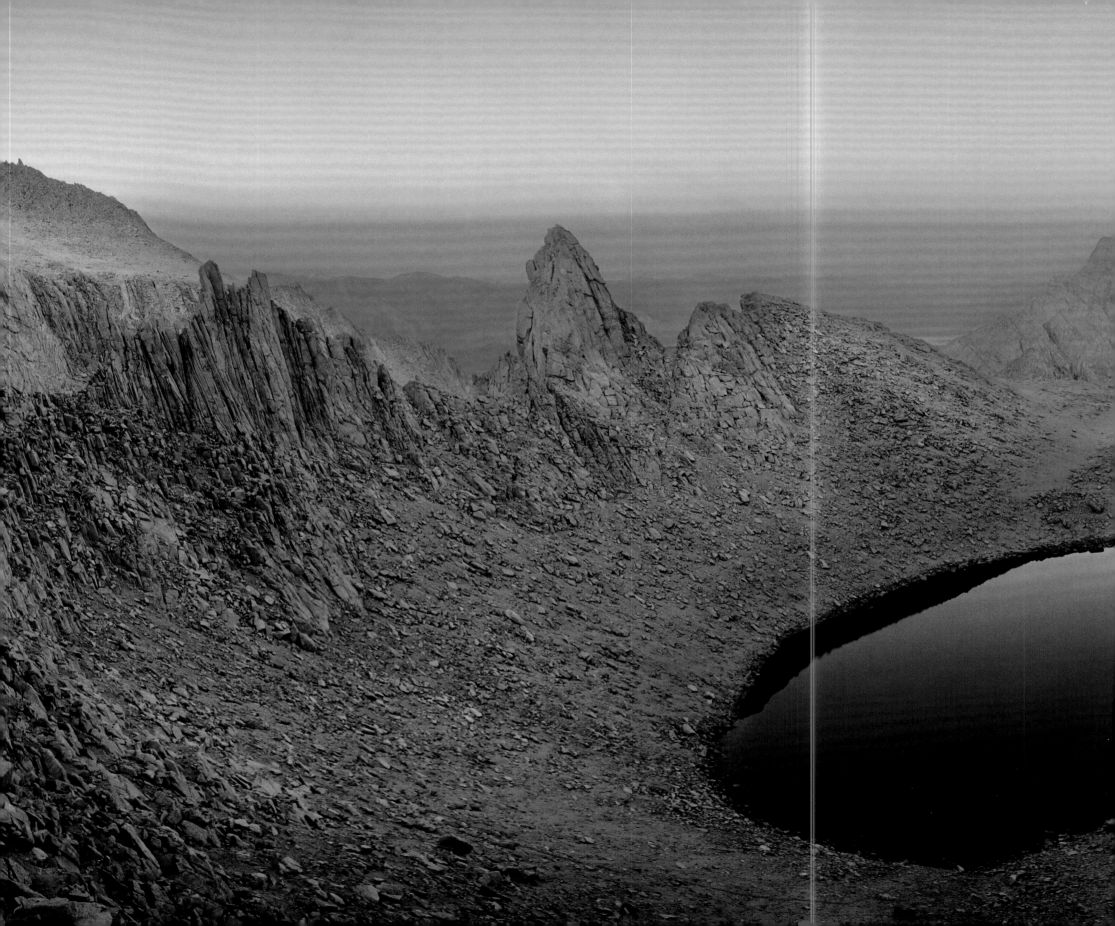

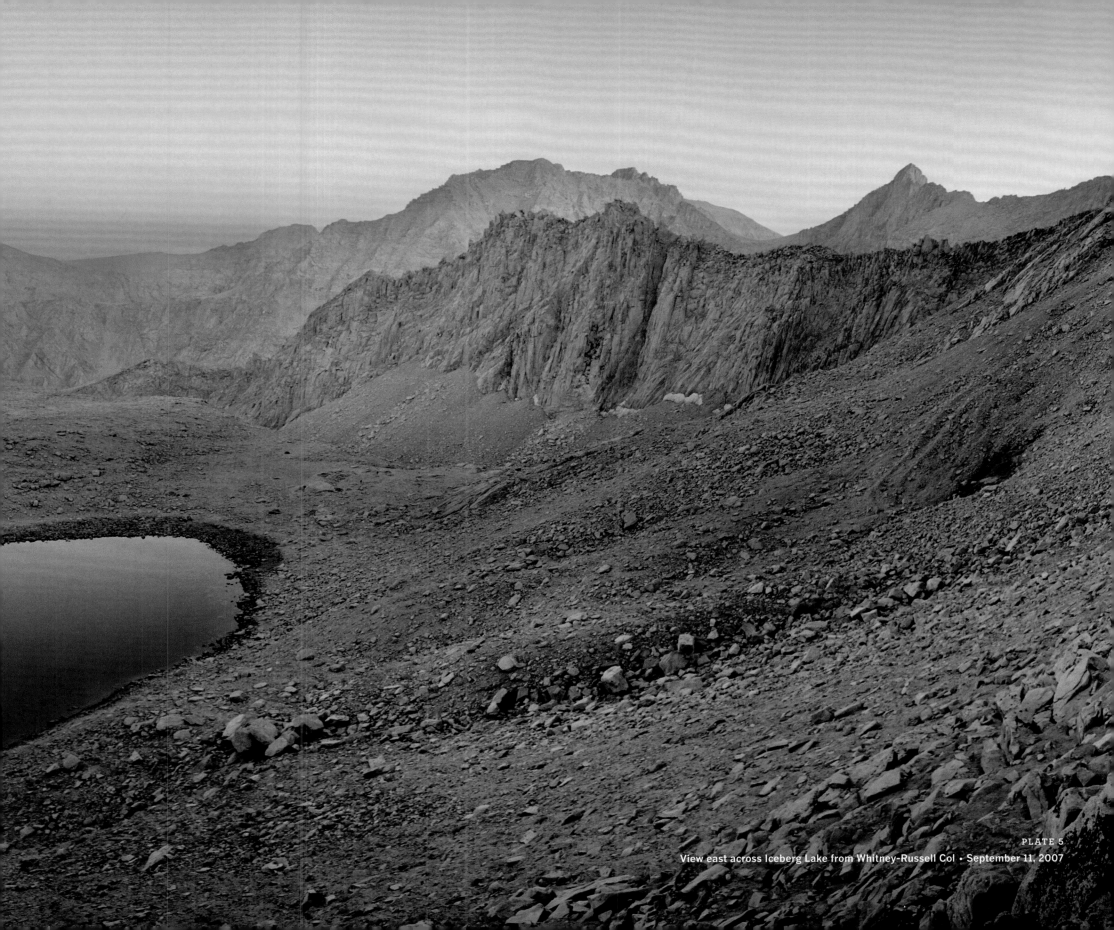

PLATE 5

View east across Iceberg Lake from Whitney-Russell Col • September 11, 2007

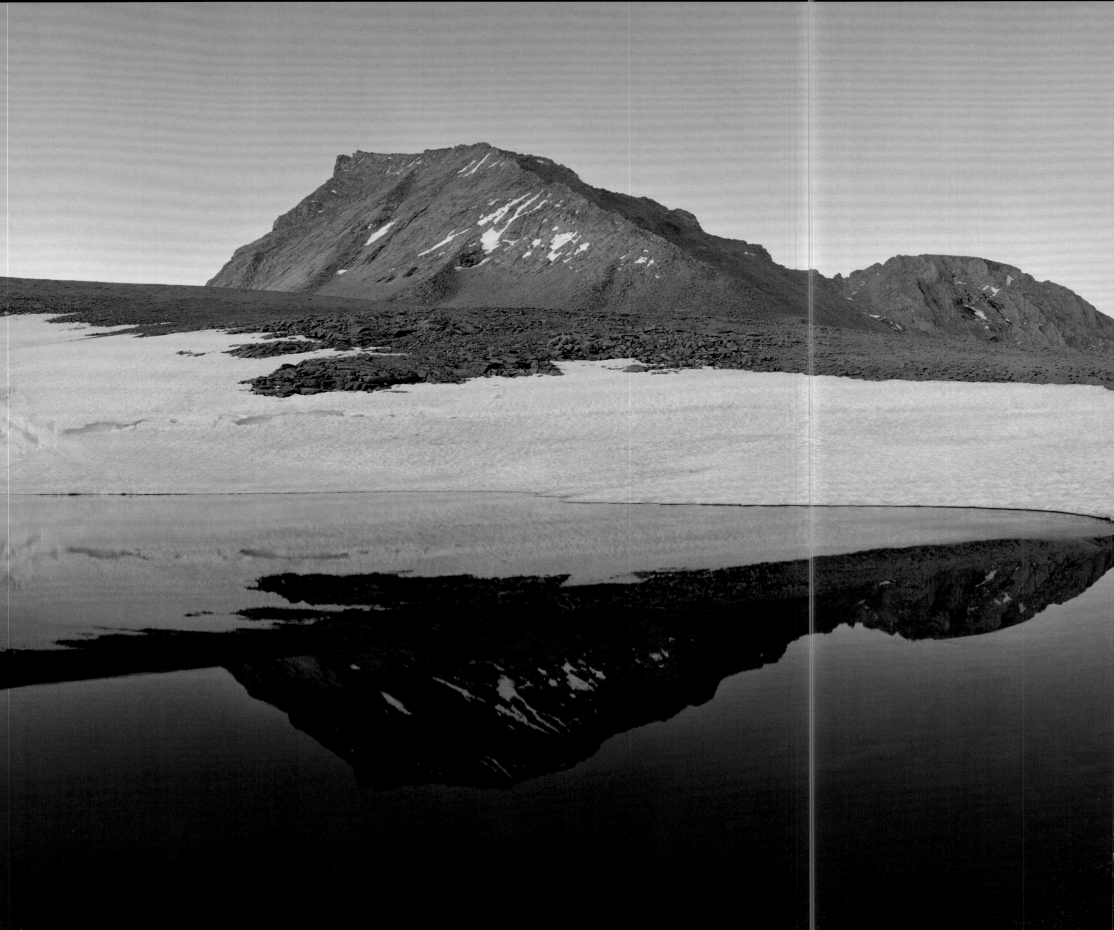

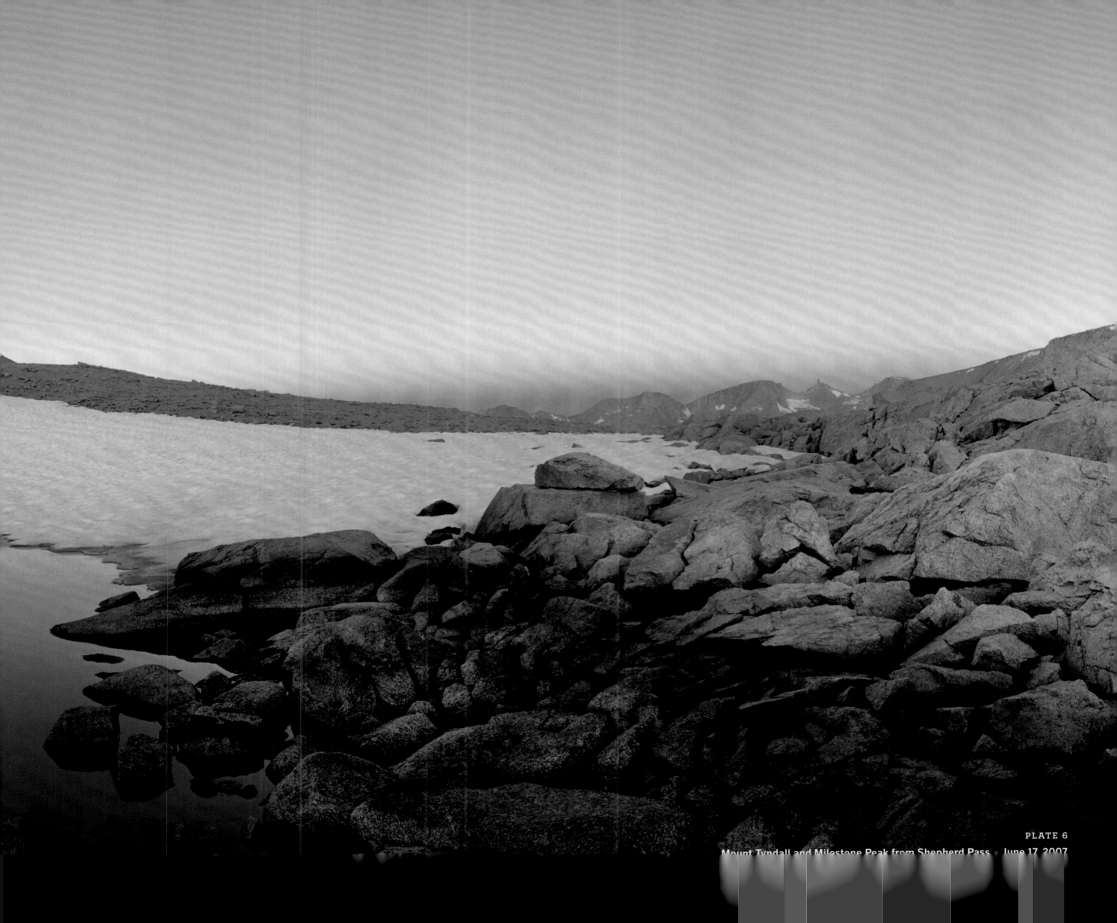

PLATE 6

Mount Tyndall and Milestone Peak from Shepherd Pass · June 17, 2007

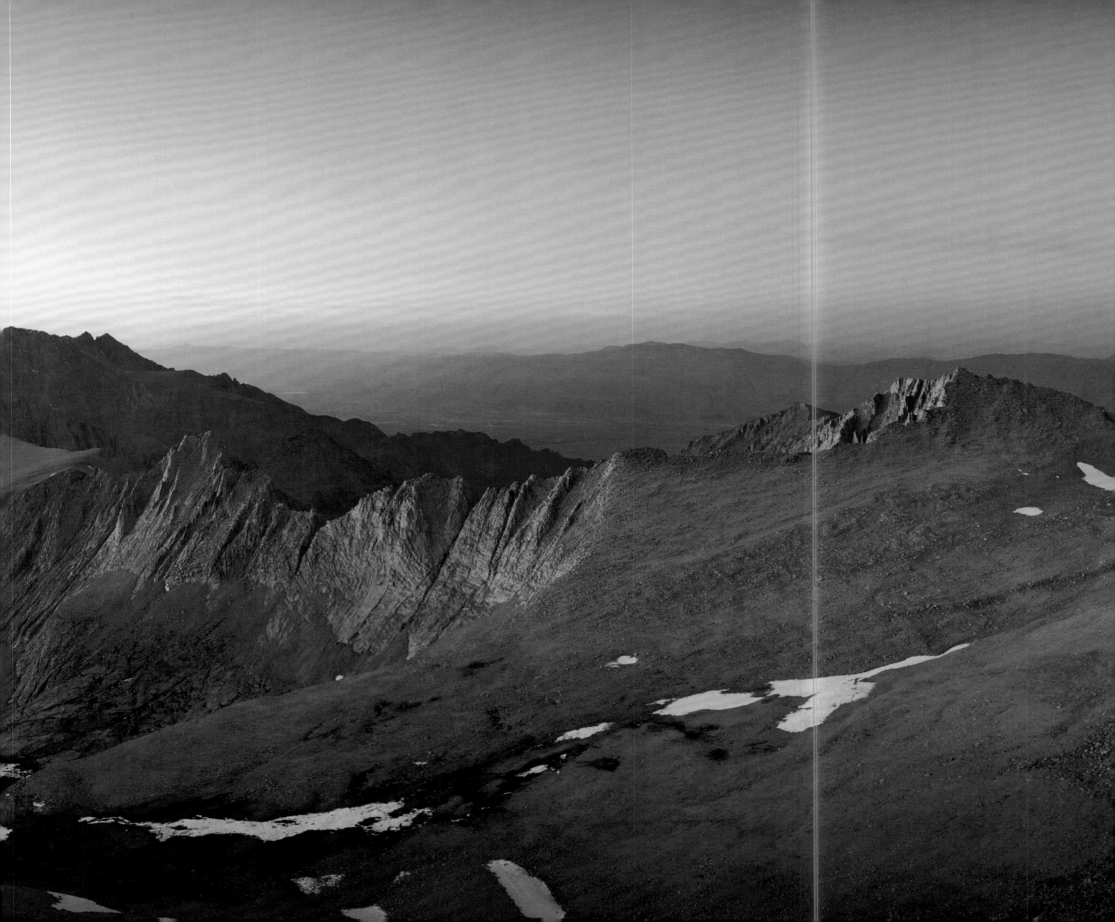

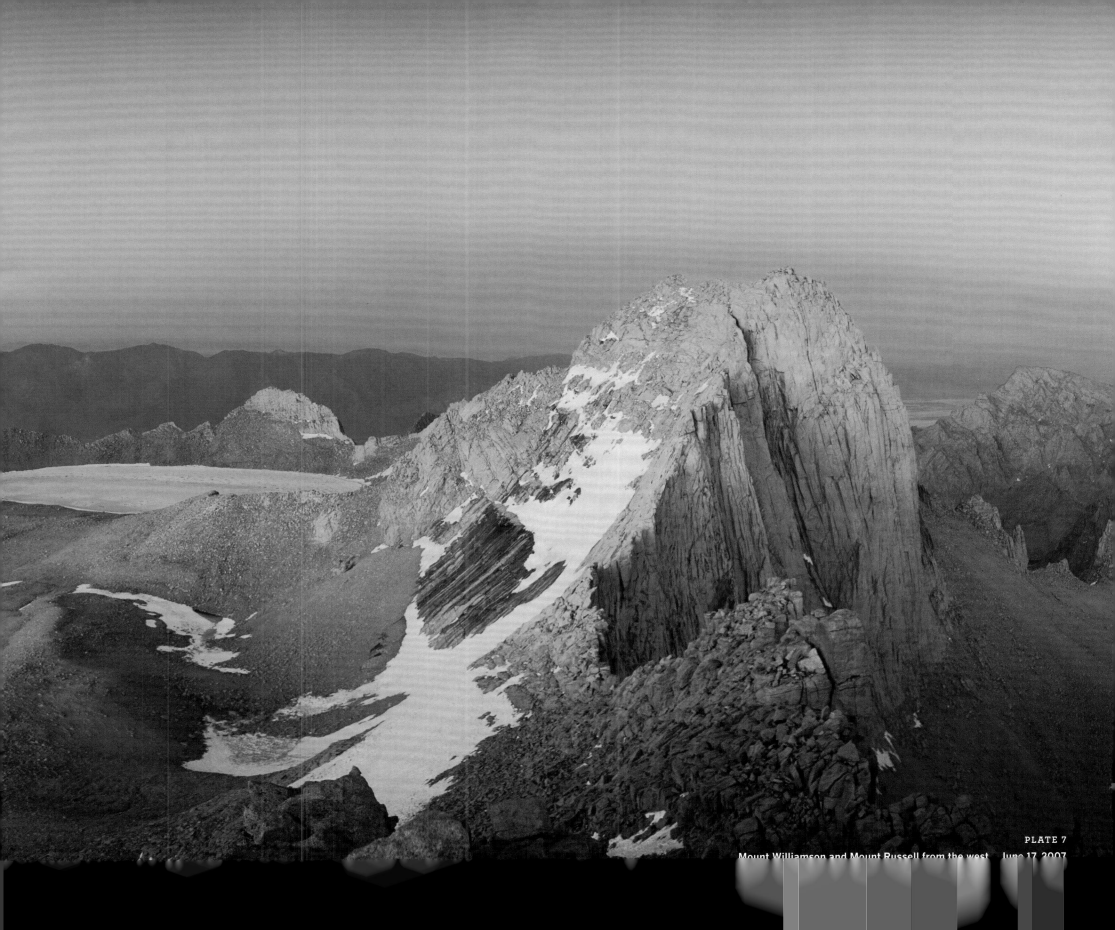

PLATE 7

Mount Williamson and Mount Russell from the west   June 17, 2007

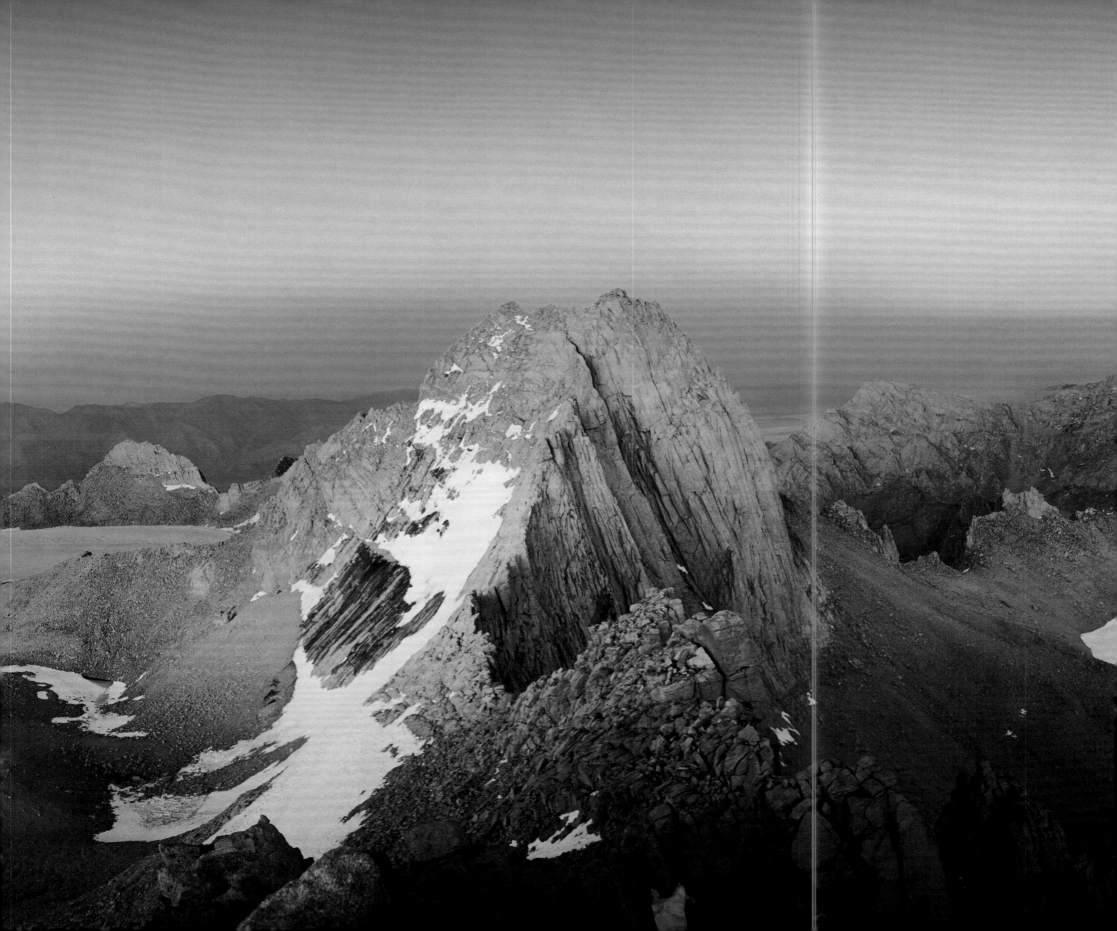

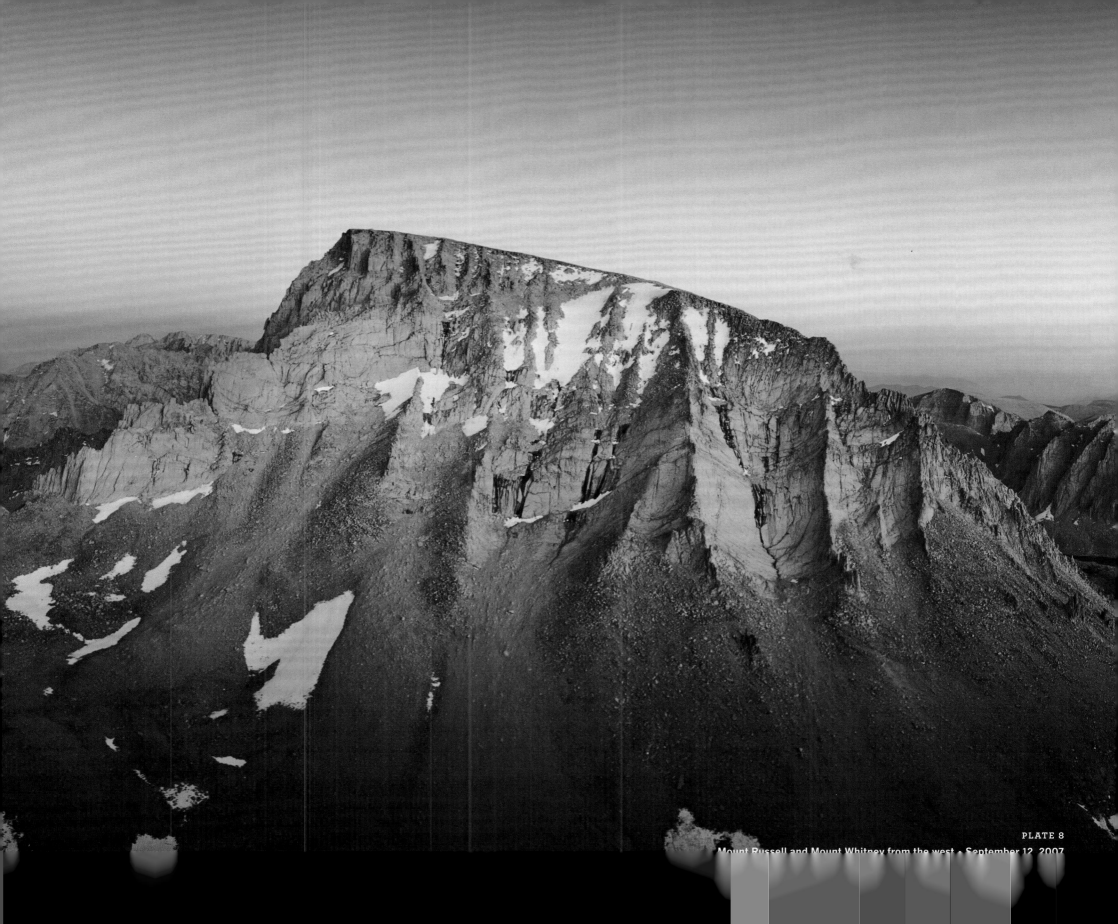

PLATE 8

Mount Russell and Mount Whitney from the west · September 12, 2007

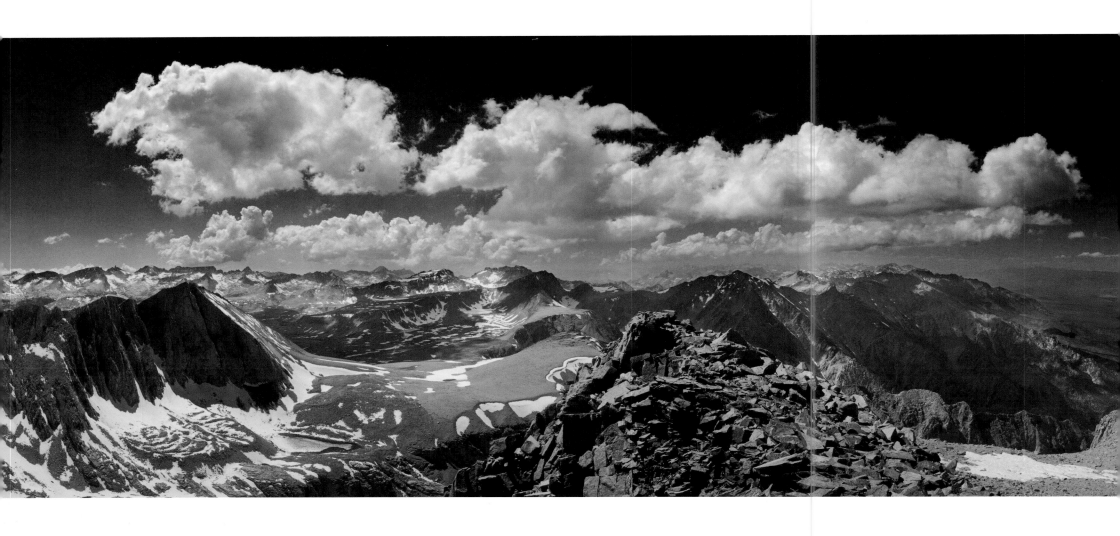

PLATE 9

**Mount Tyndall from the summit of Mount Williamson • June 19, 2004**

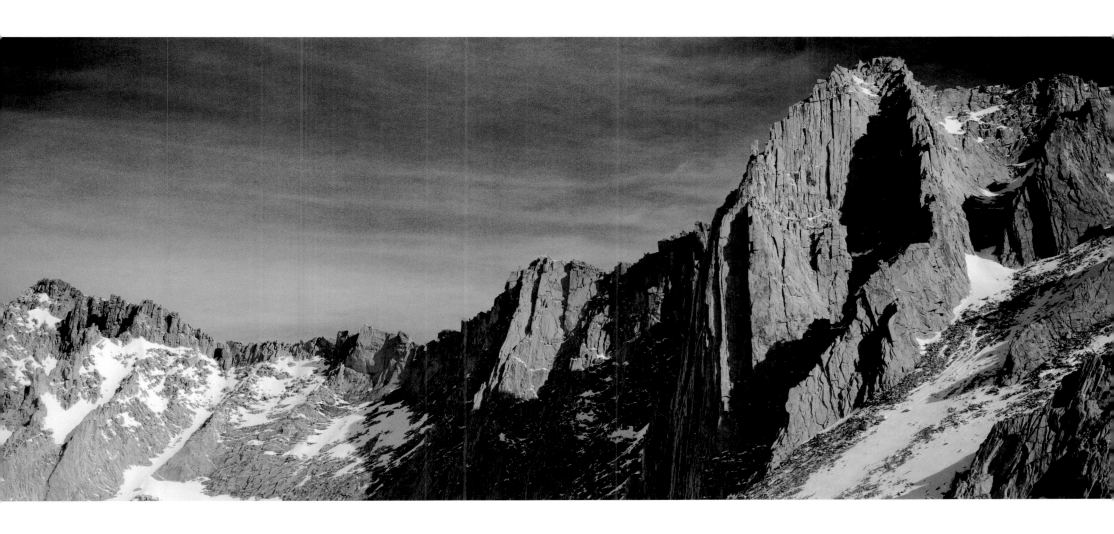

PLATE 10
The south face of Mount Russell • April 30, 2005

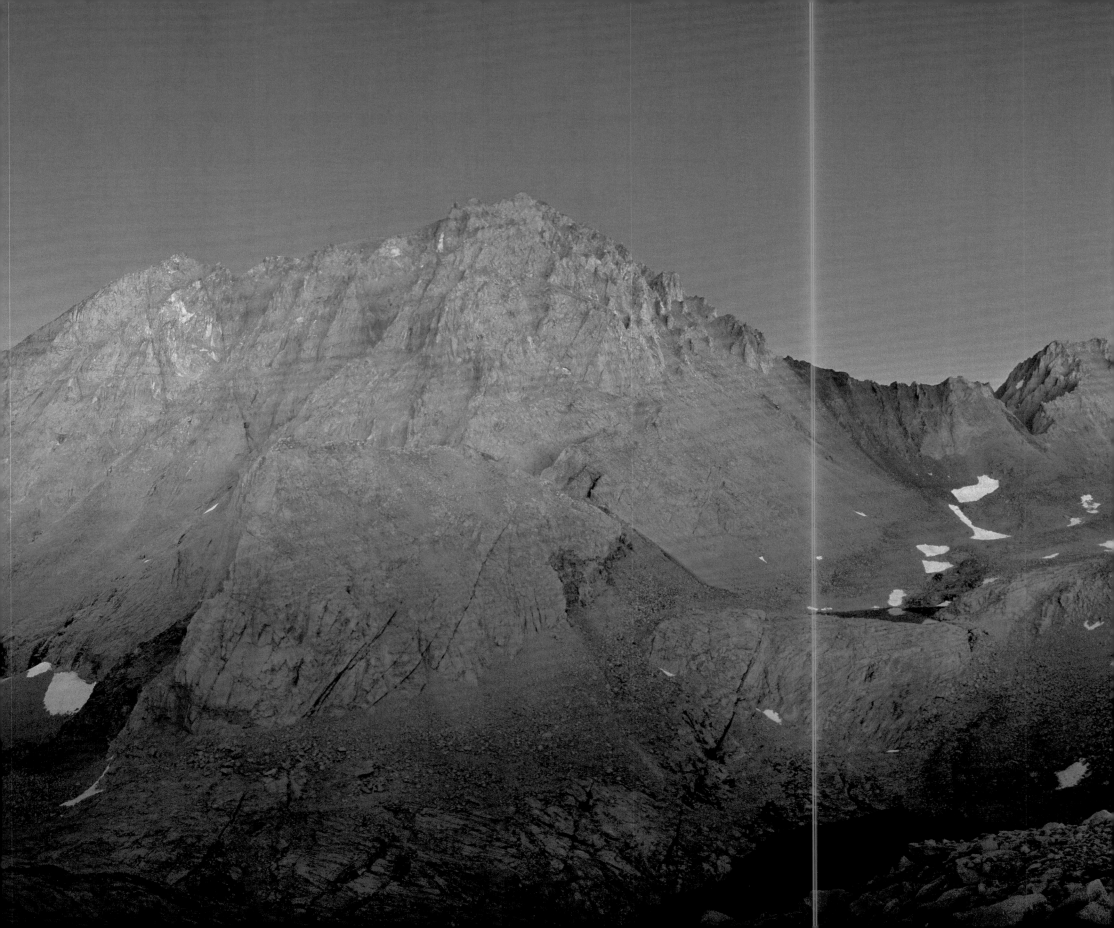

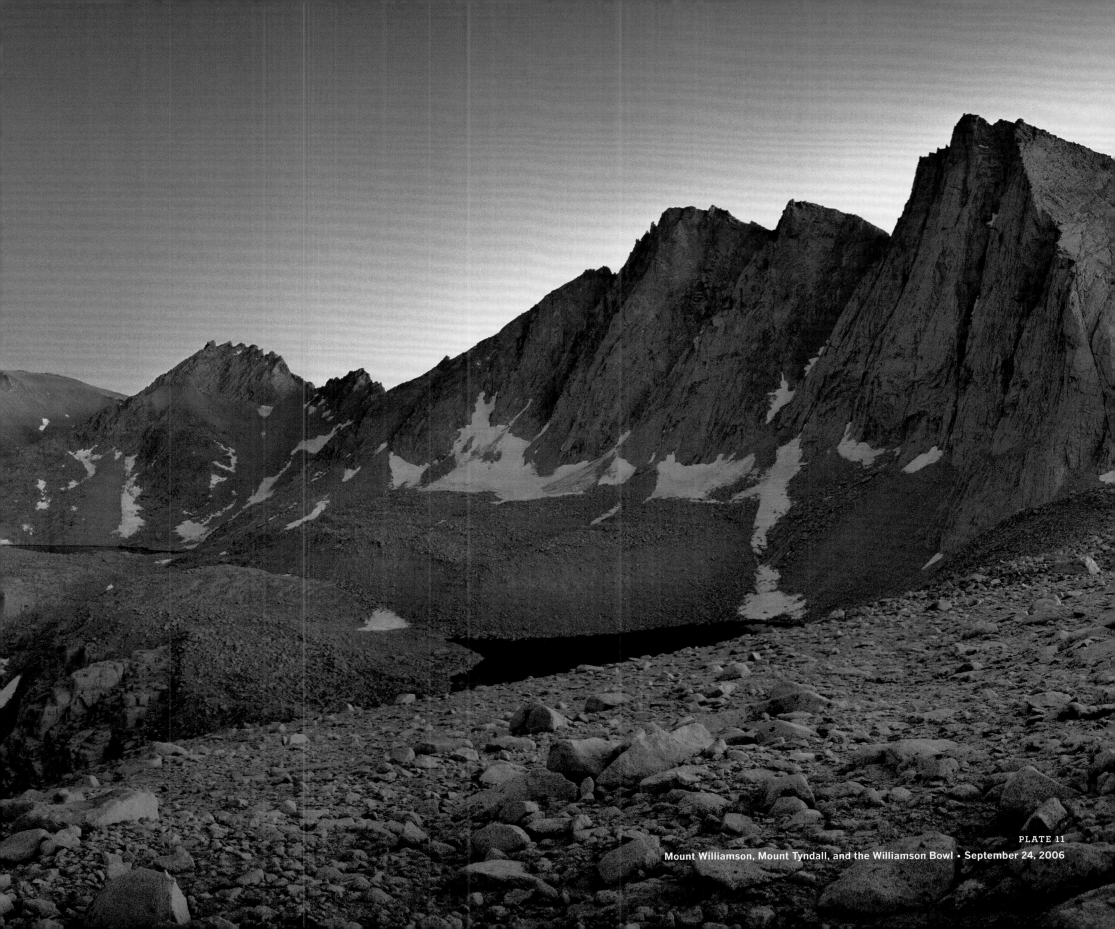

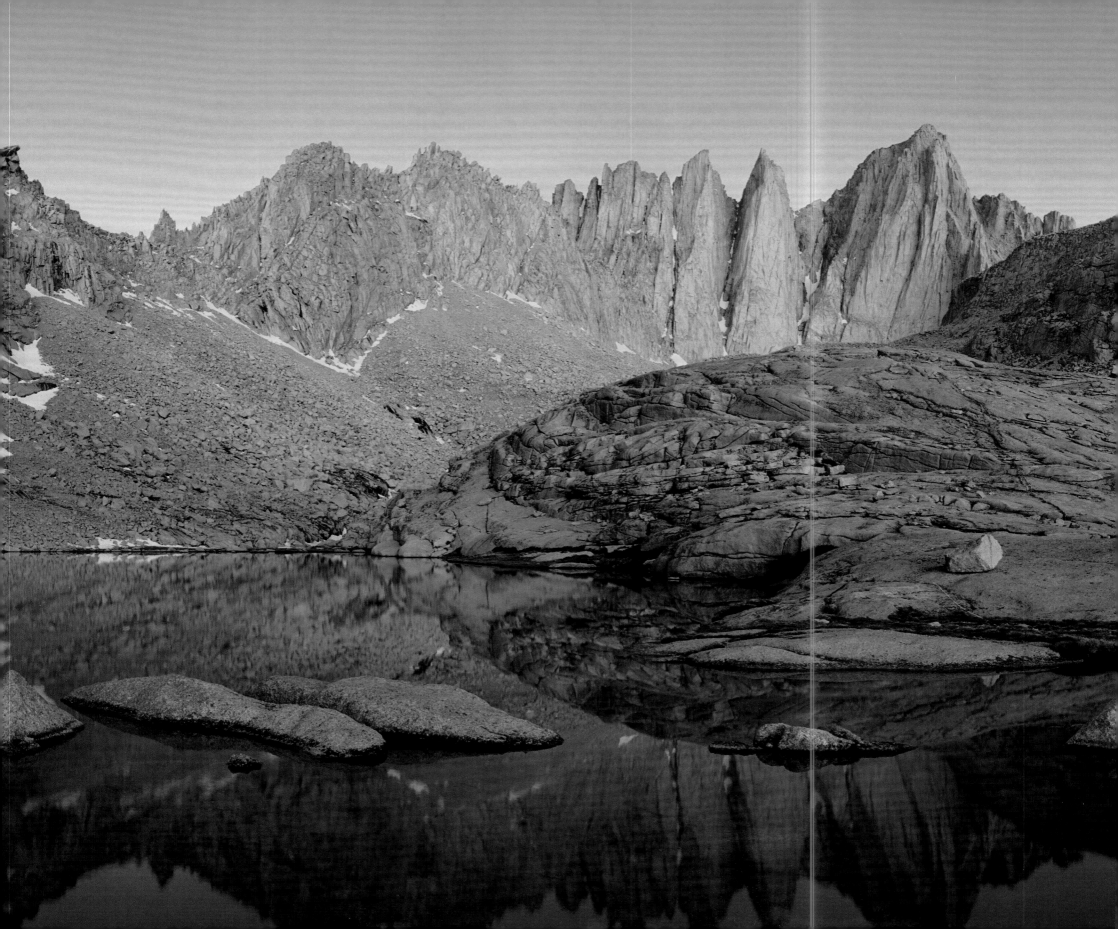

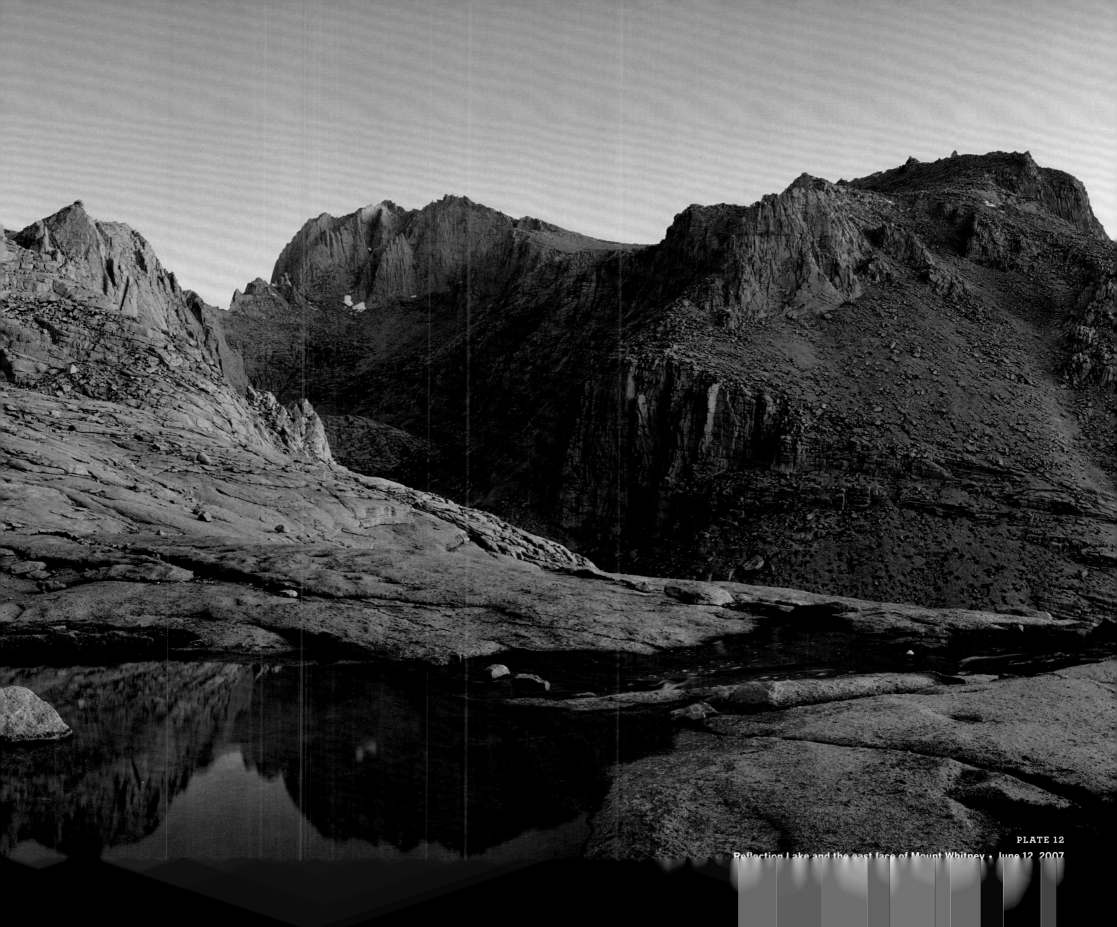

PLATE 12

Reflection Lake and the east face of Mount Whitney • June 12, 2007

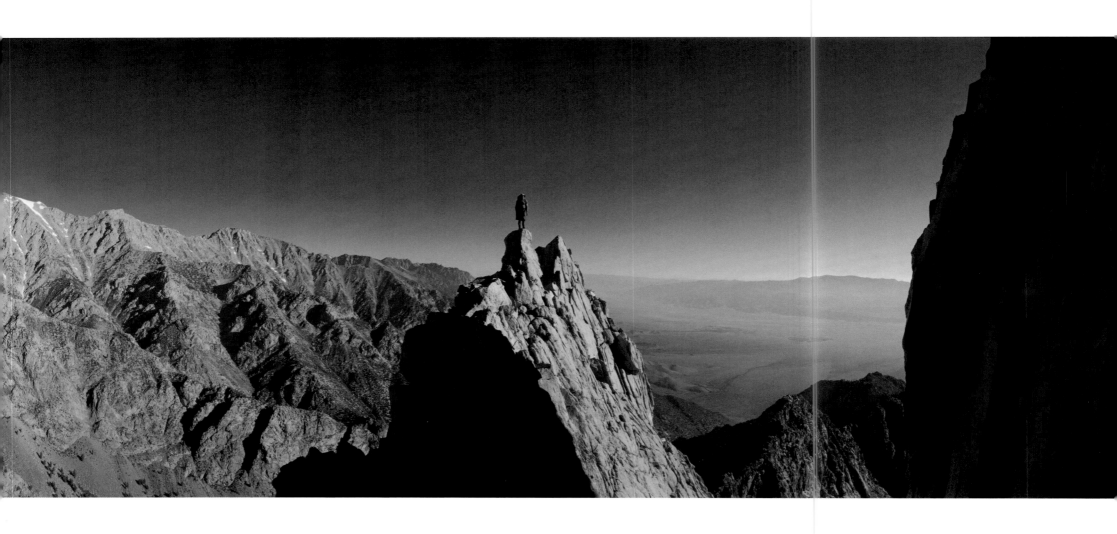

PLATE 13

**The northeast ridge of Mount Williamson • June 19, 2004**

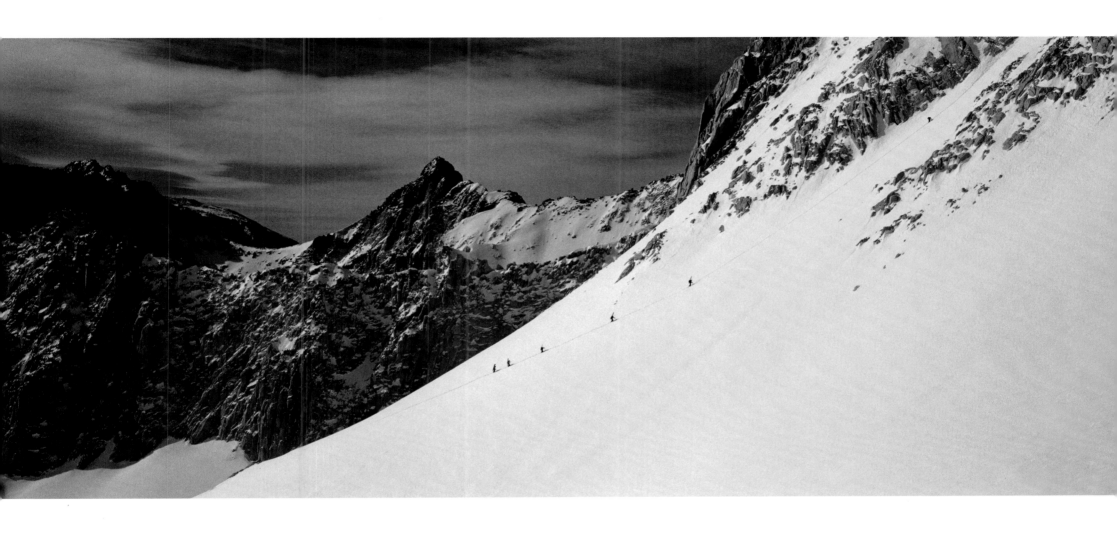

PLATE 14
On the northeast ridge of Mount Williamson • April 30, 2005

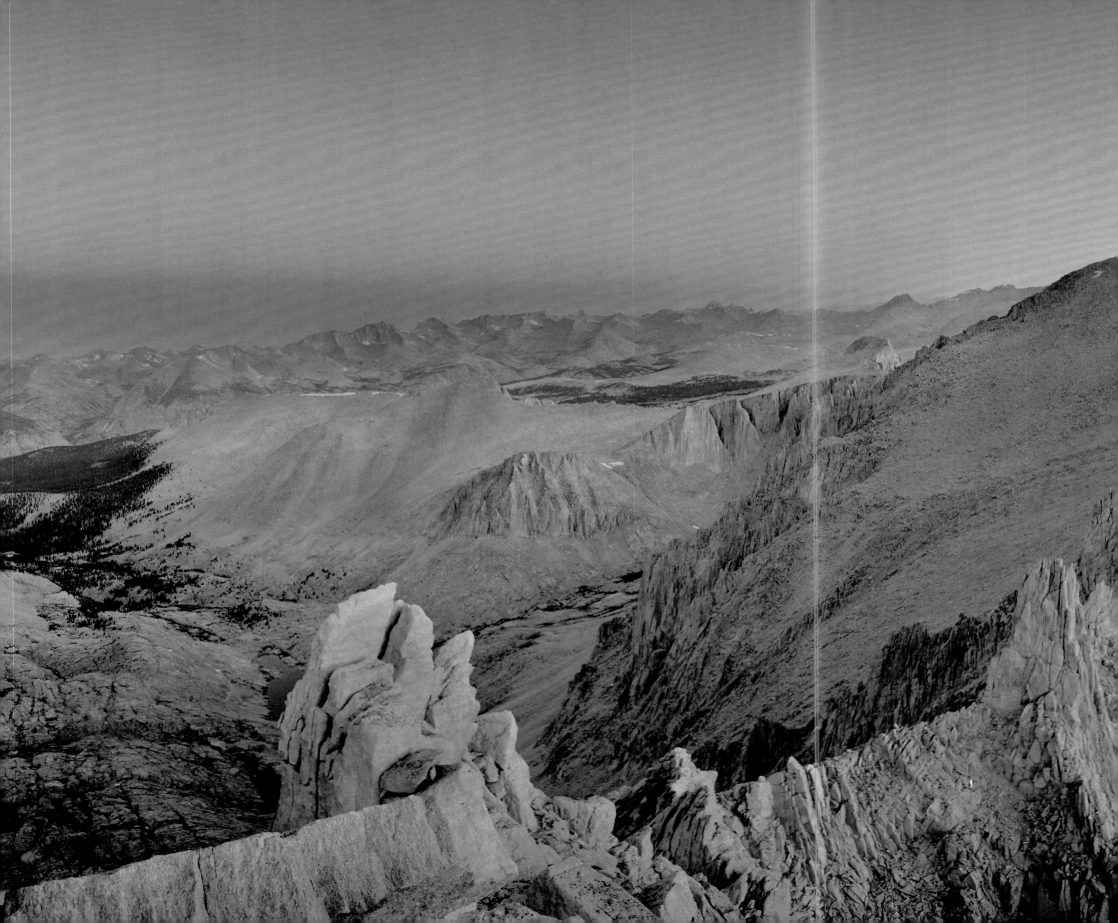

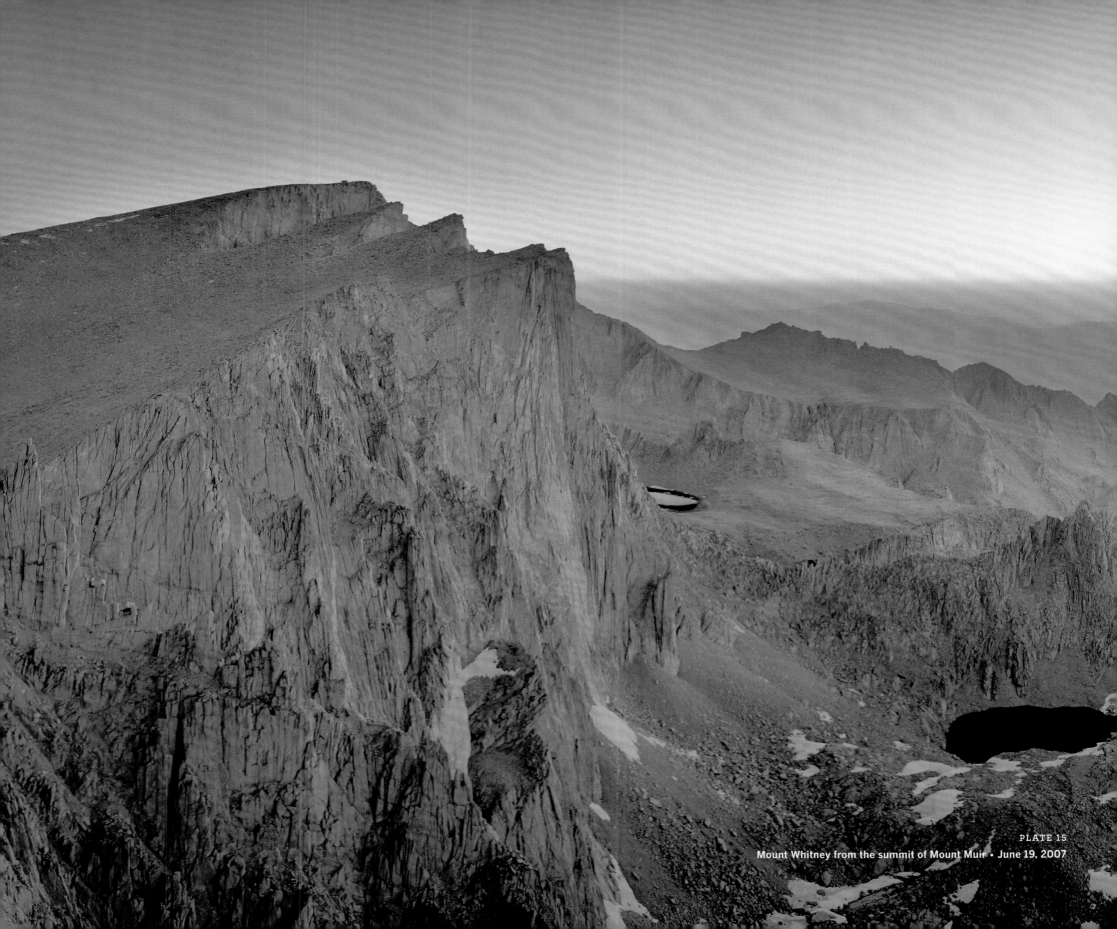

Mount Whitney from the summit of Mount Muir · June 19, 2007

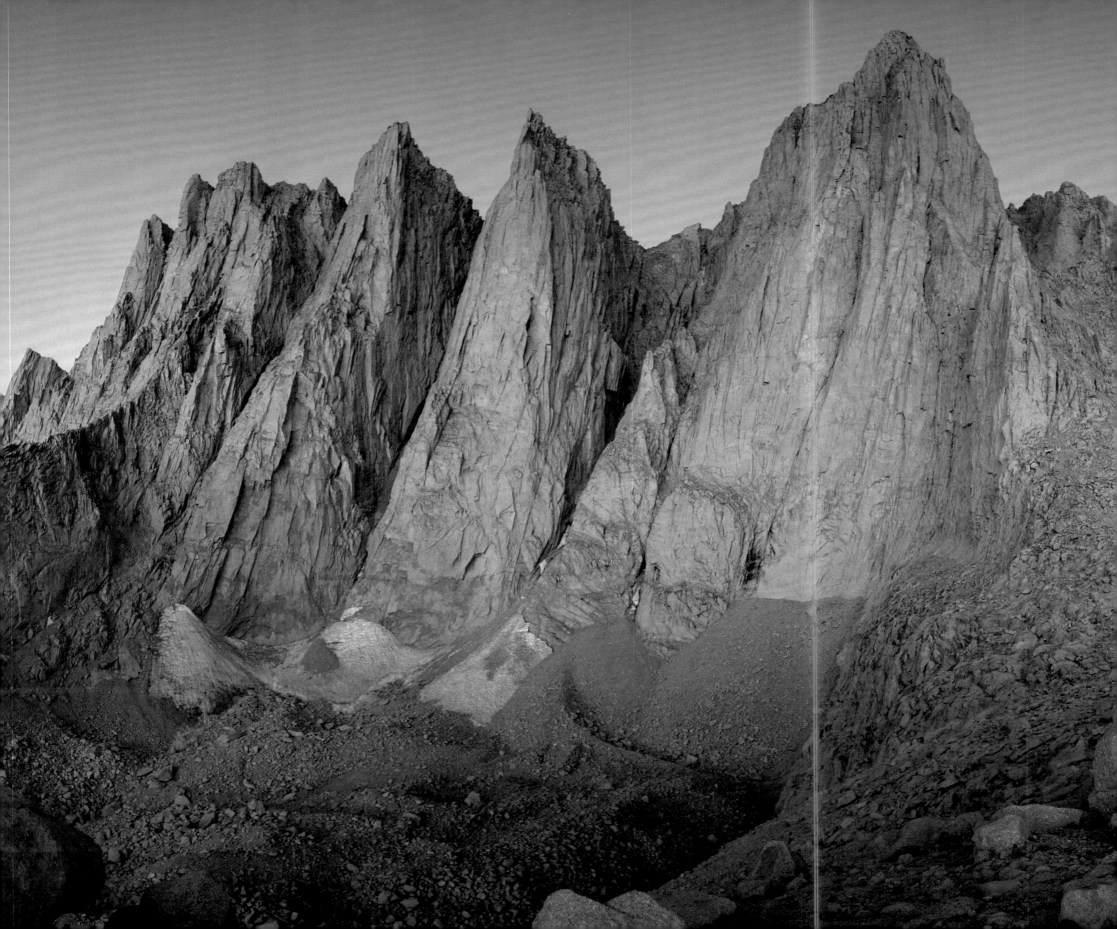

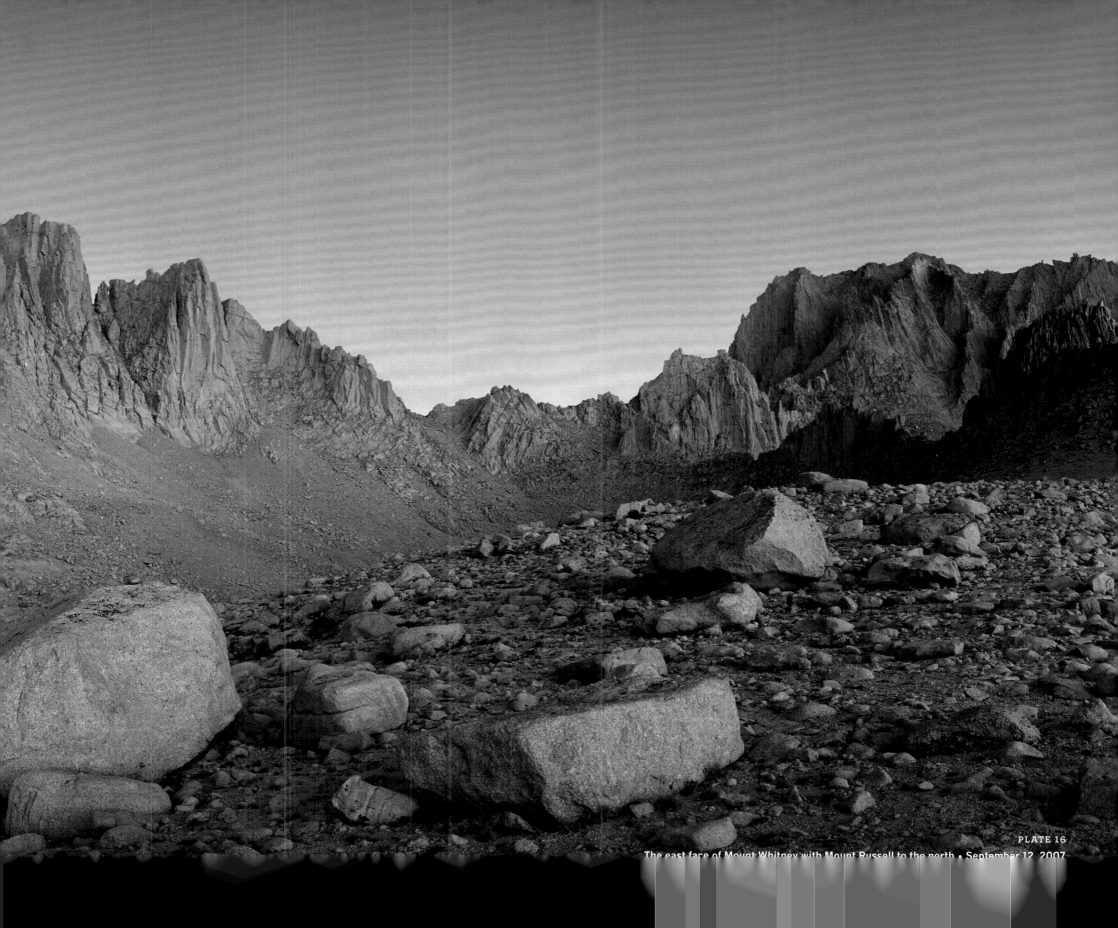

PLATE 16

The east face of Mount Whitney with Mount Russell to the north · September 12, 2007

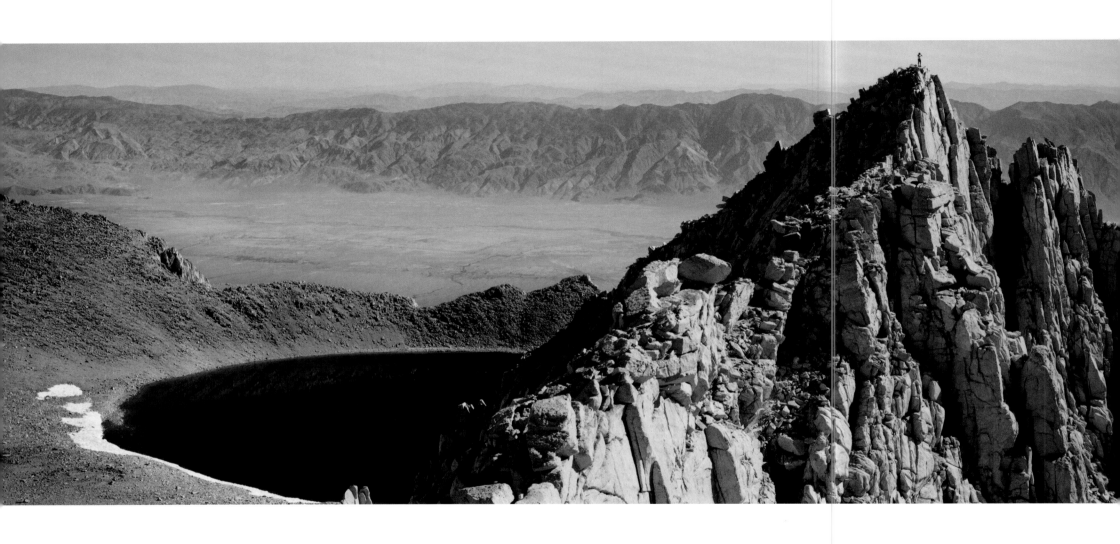

PLATE 17

**Summit of Mount Russell and Tulainyo Lake from the east • September 22, 2003**

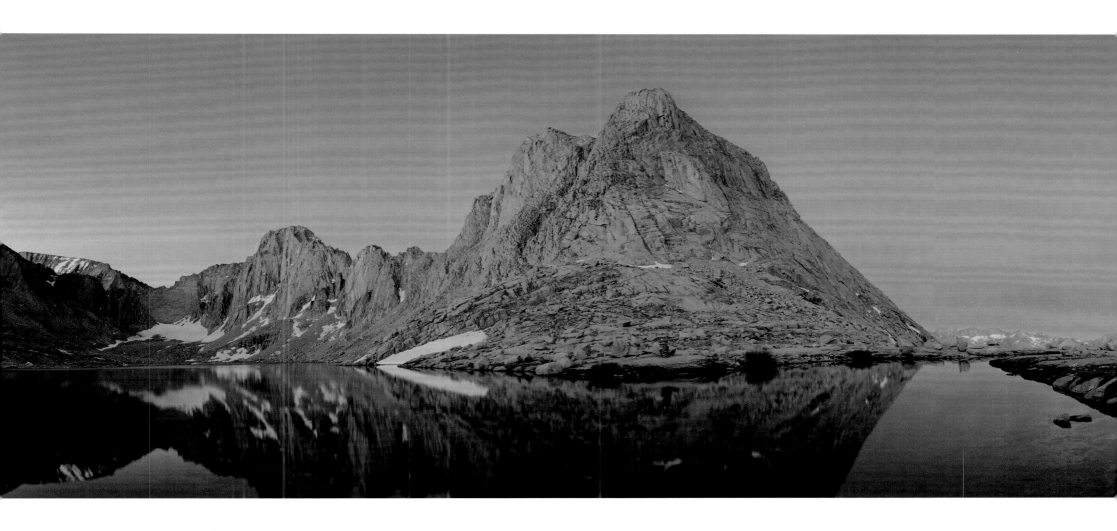

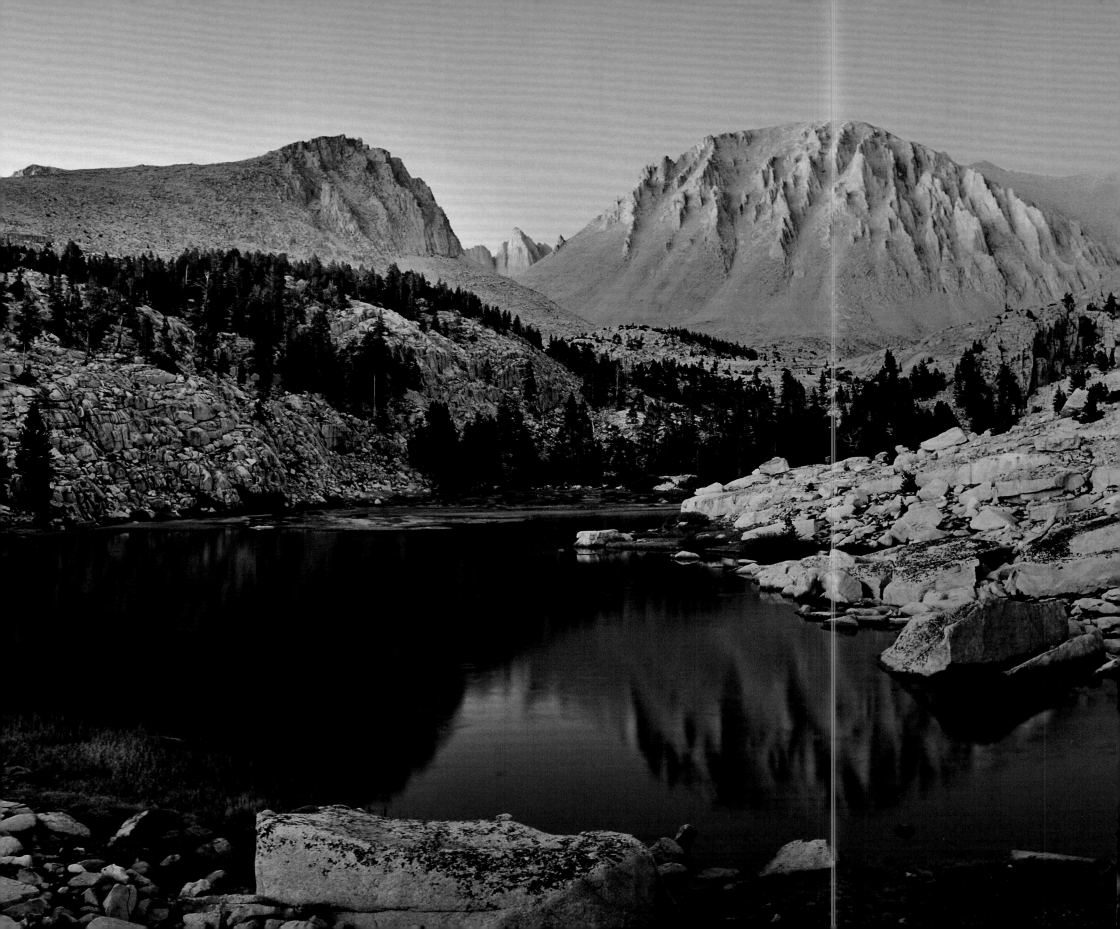

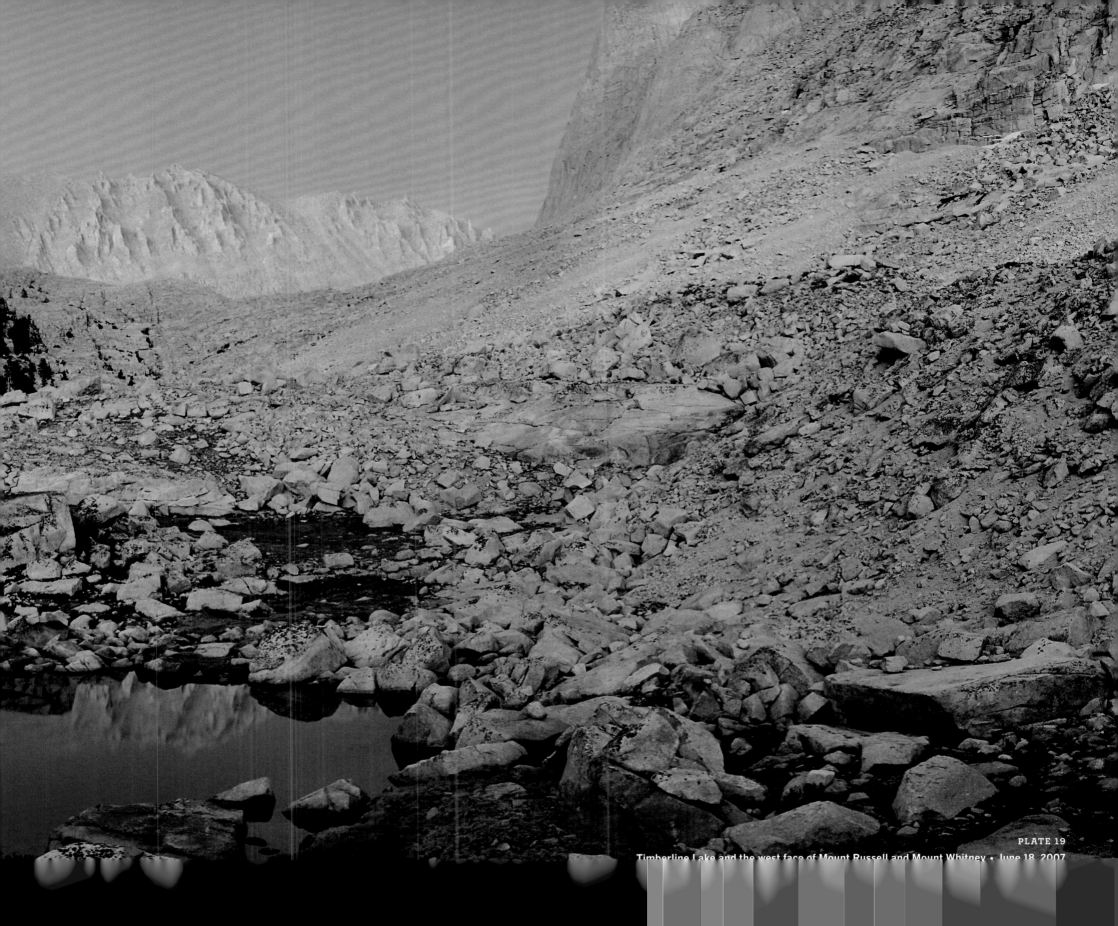

PLATE 19

Timberline Lake and the west face of Mount Russell and Mount Whitney • June 18, 2007

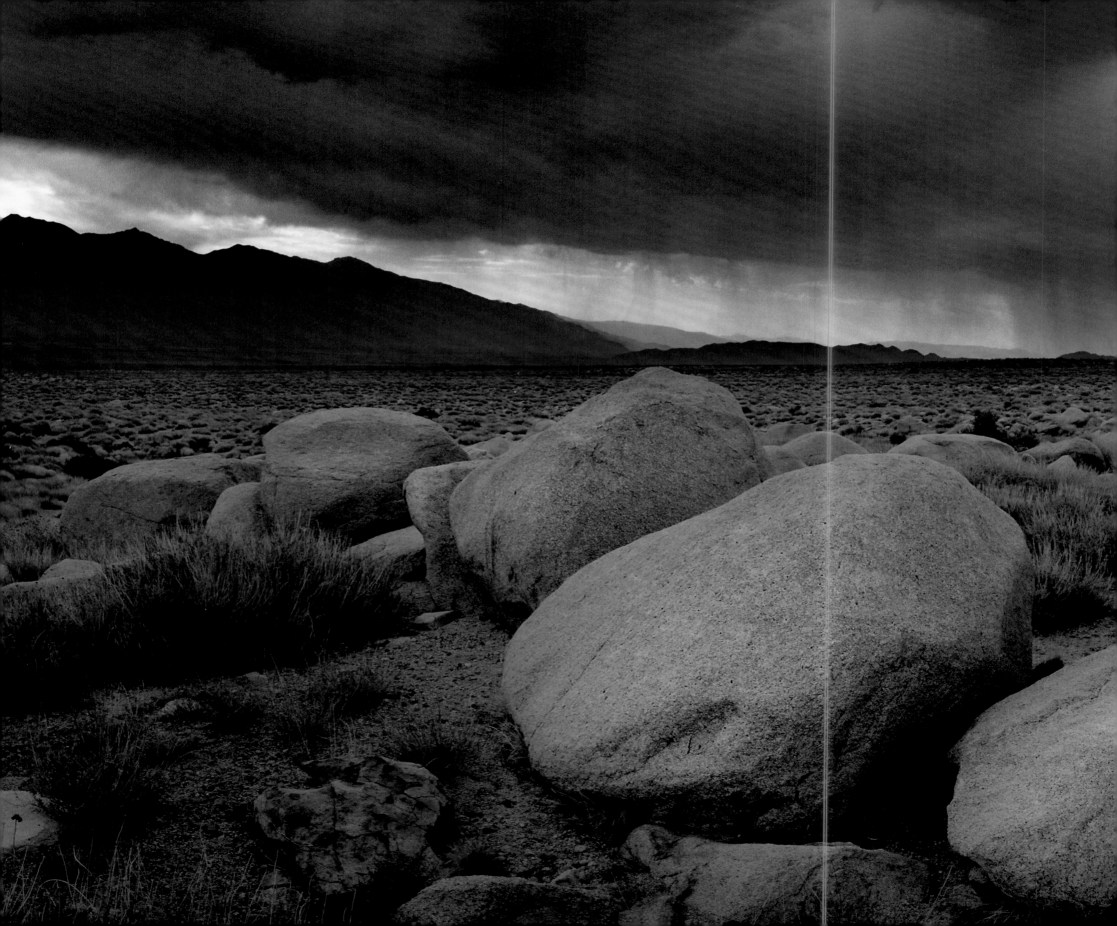

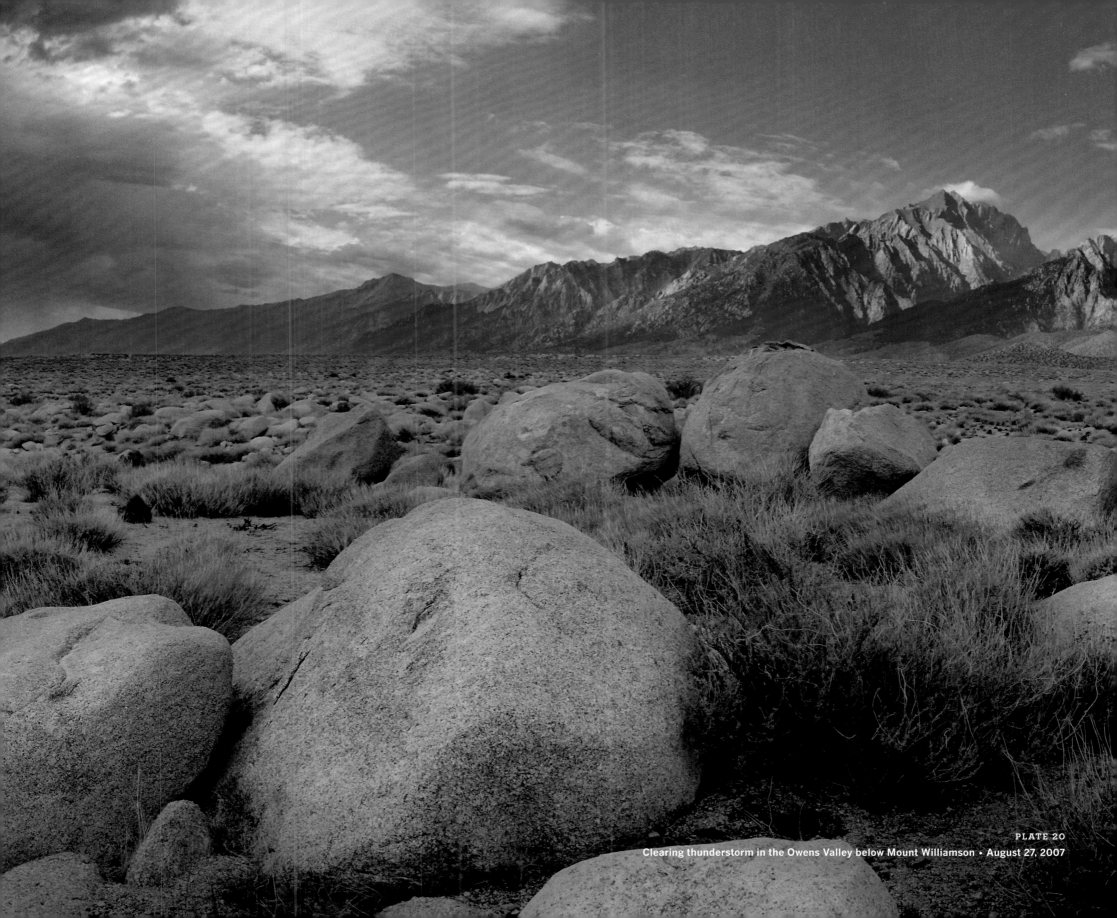

PLATE 20

Clearing thunderstorm in the Owens Valley below Mount Williamson · August 27, 2007

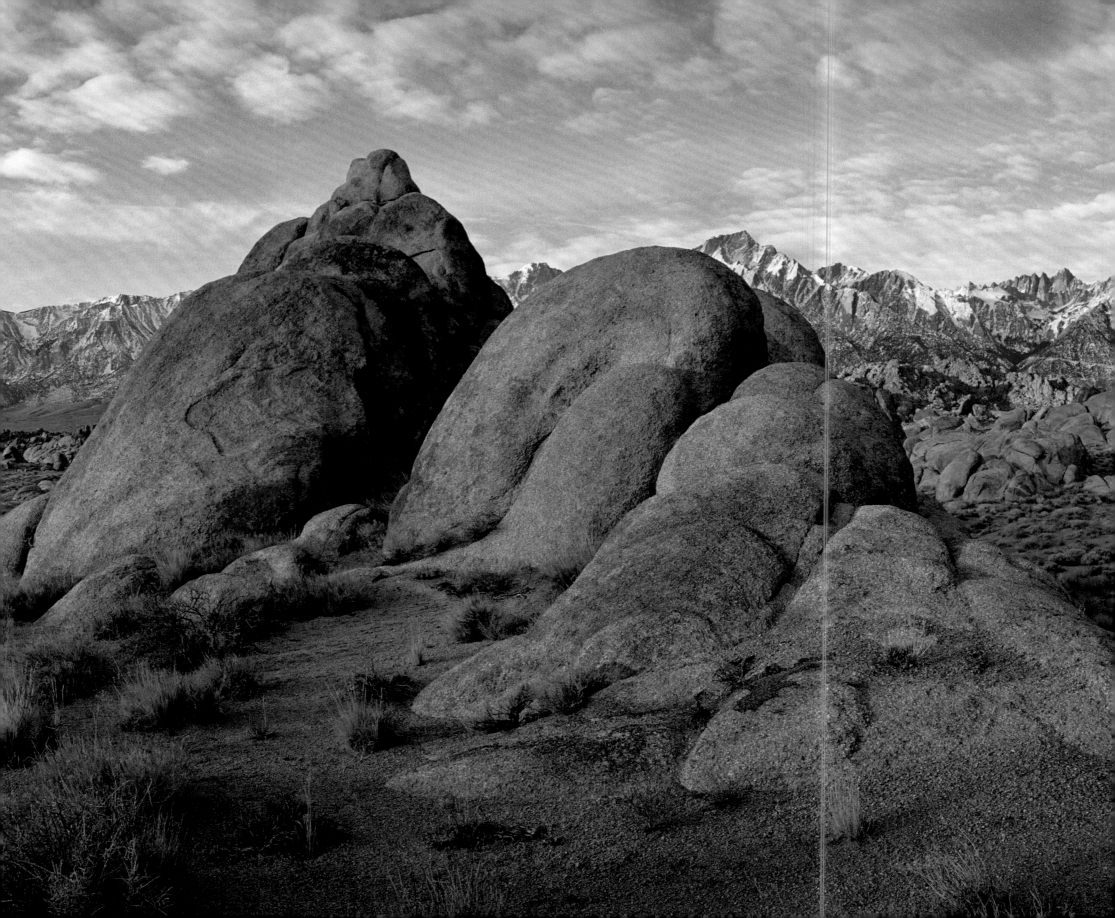

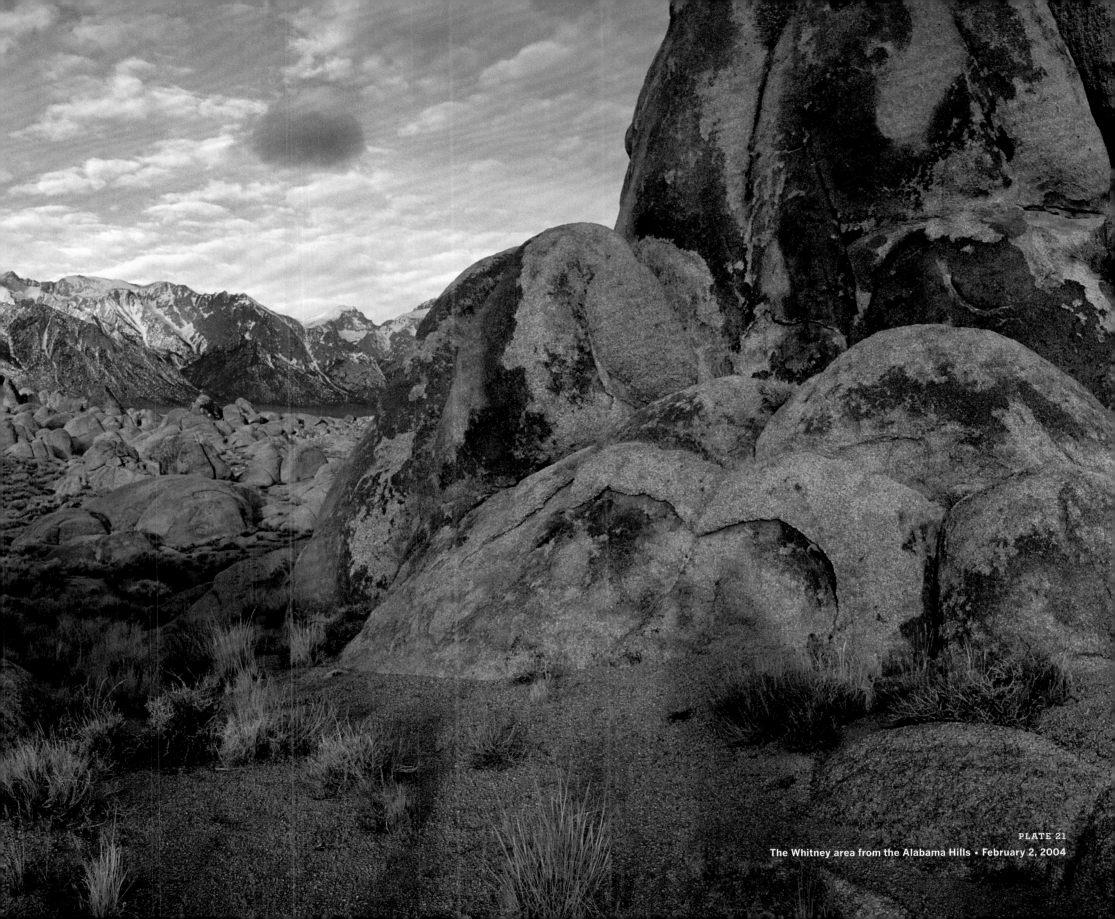

PLATE 21
The Whitney area from the Alabama Hills • February 2, 2004

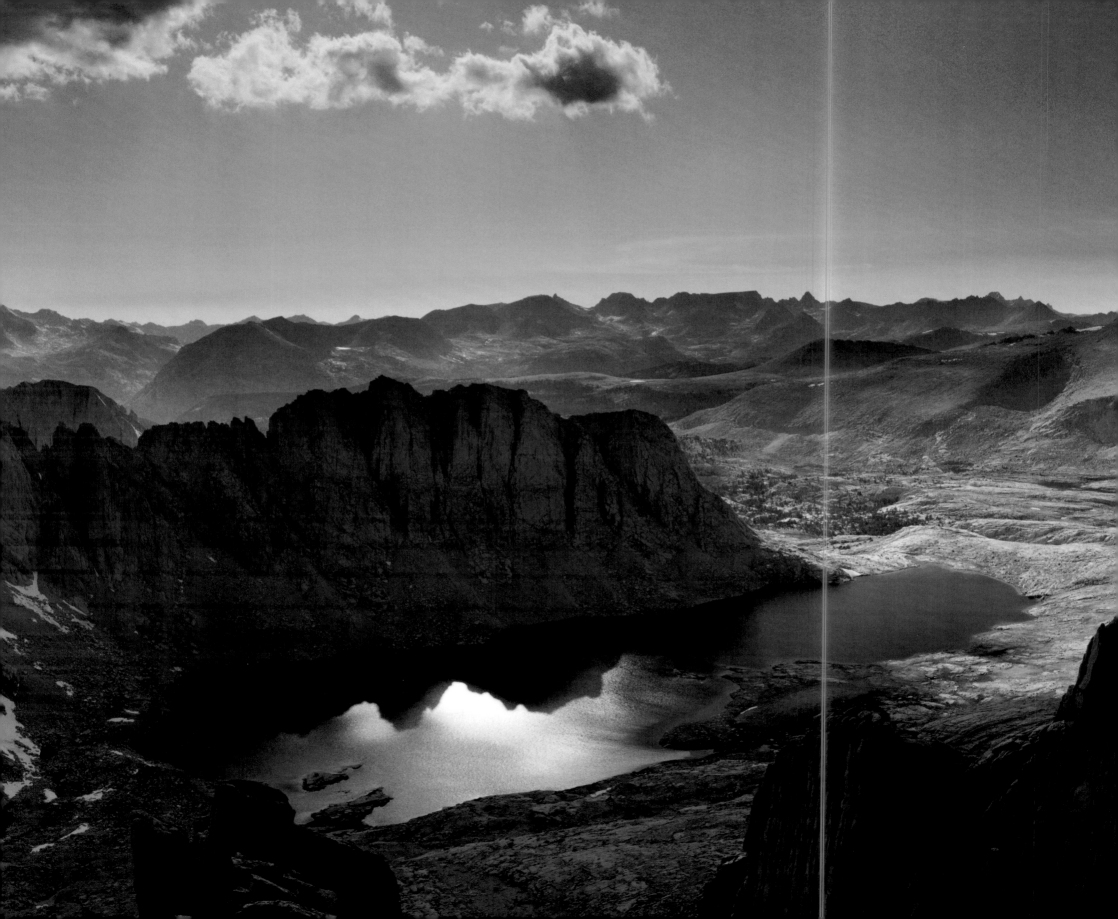

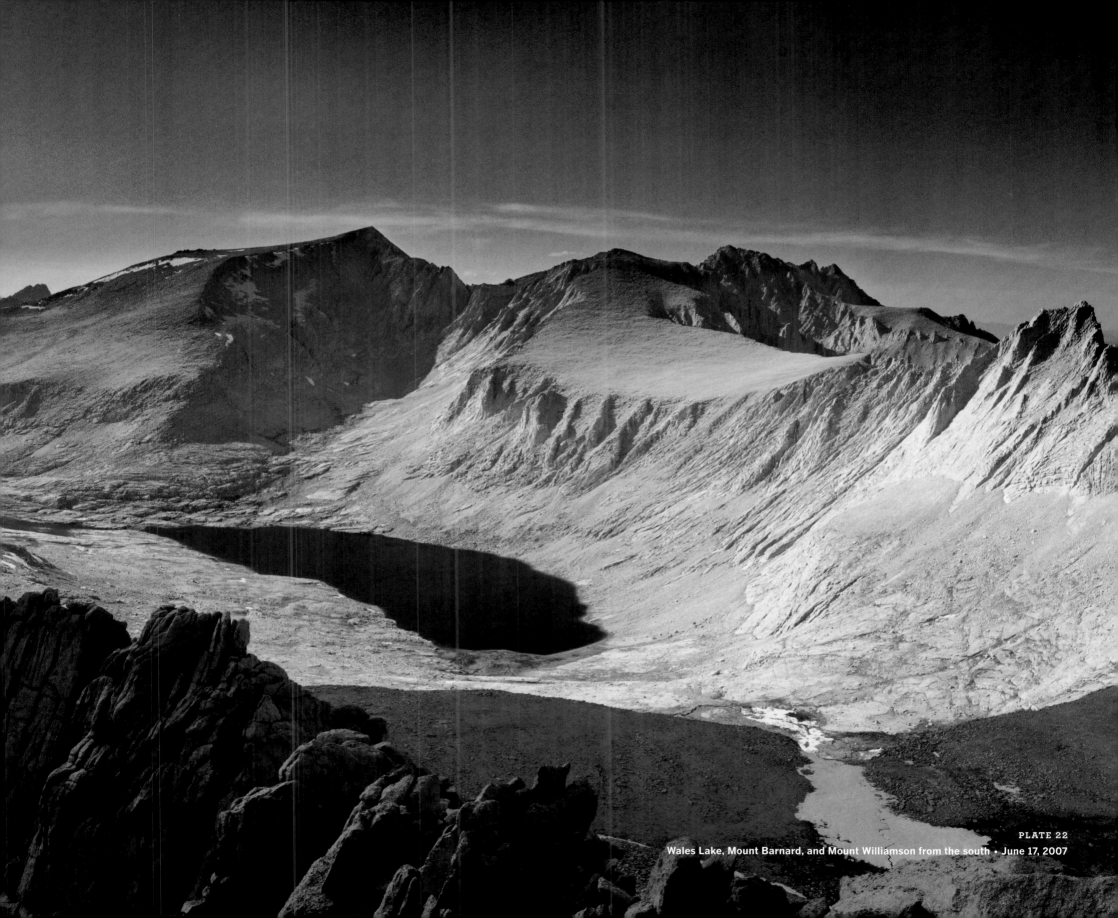

PLATE 22

Wales Lake, Mount Barnard, and Mount Williamson from the south · June 17, 2007

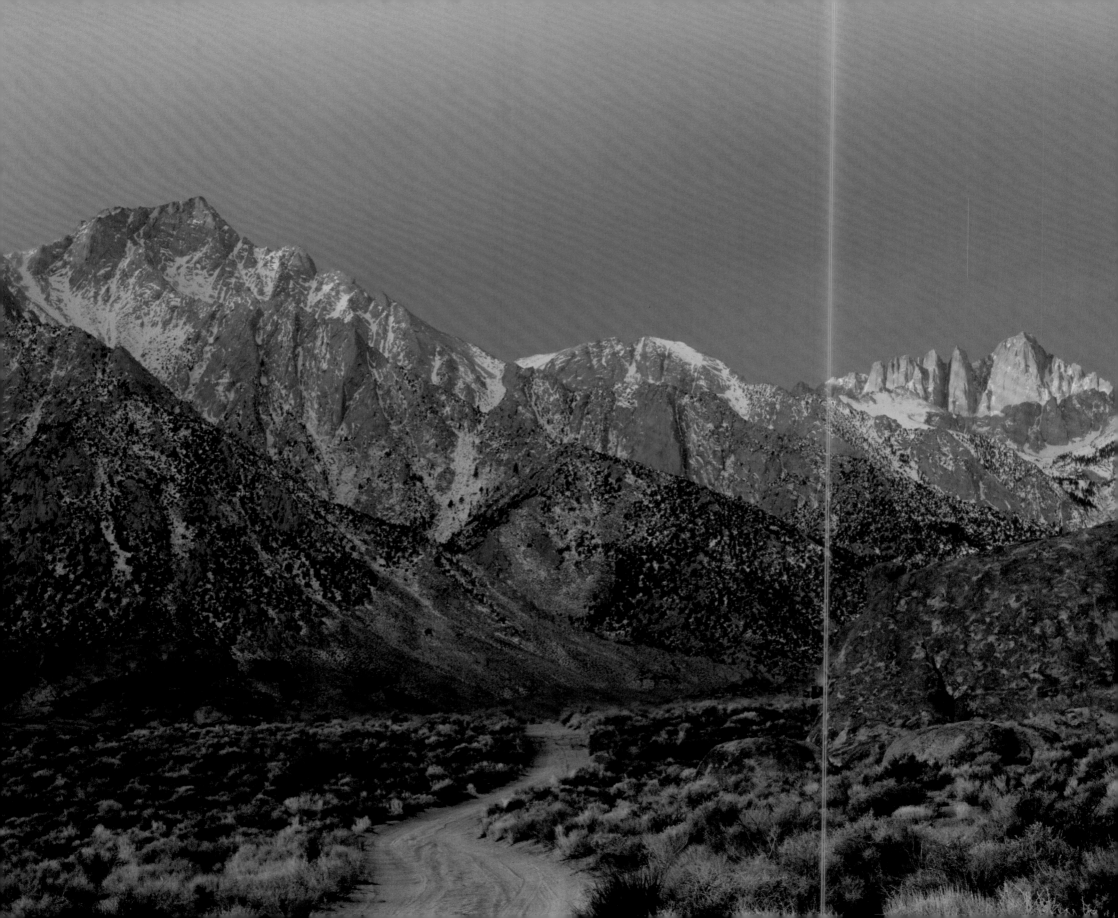

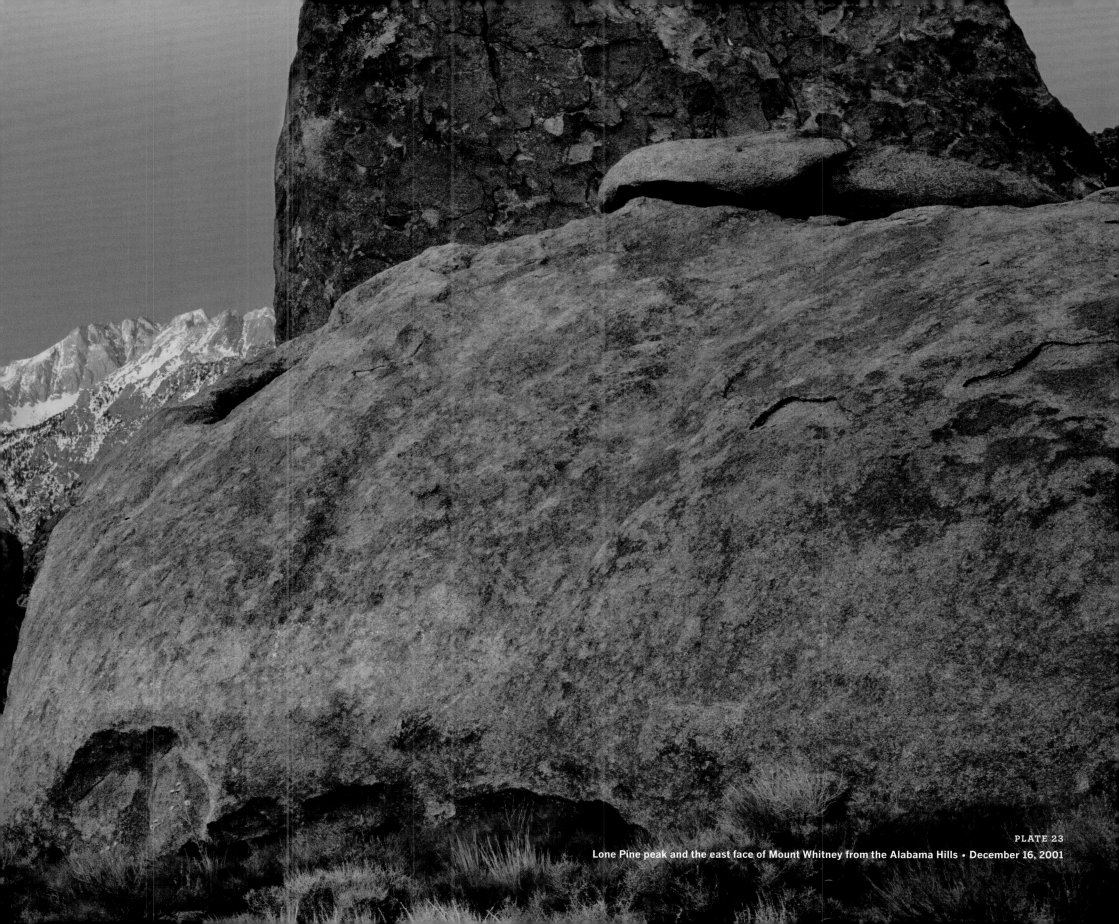

PLATE 23

Lone Pine peak and the east face of Mount Whitney from the Alabama Hills • December 16, 2001

arid regions are the prevailing forms, some of which persist in places even to timberline. Somewhat higher, mountain mahogany, piñon pine and juniper form an open growth, followed in turn by limber, white-back and foxtail pines that persist to timberline an elevation of somewhat over 11 000 feet above sea-level.

The range is a narrow one composed of a single uplifted ridge some forty miles in length that reaches its greatest elevation in White Mountain, little short of Mt. Whitney in height, as it attains an altitude of 14 242 feet. Although seldom-climbed, it presents no mountaineering difficulties, except that from whatever direction it may be approached the climber must be prepared for a "long drag" along the crest of the range or up steep slopes on either side of it, but the magnificent view that its summit possesses renders it a worthwhile undertaking for those accustomed to mountain-climbing and who do not begrudge the expenditure of energy necessary to complete it reach the top.

On one occasion a party of the Sierra Club, of which I was a member climbed it from the south, Turning eastward

# WHITE MOUNTAIN PEAK

For decades I have wondered why the name of California's third-highest summit, White Mountain Peak, is redundant. After all, many uplifts throughout North America are simply, if unimaginatively, called "White Mountain" or "White Peak." I suppose we should be glad we don't have a "Pikes Peak Mountain," or a "Mount Rainier Peak." As I was doing research for this essay, I was pleased to come upon these words from the famed botanist Willis Linn Jepson: "The term 'White Mountain Peak,' which is used for the highest point...seems especially awkward and unfortunate." This was written in 1917!

Located in the far western part of the Great Basin, White Mountain Peak (often shortened here to WMP) occupies a unique niche. Its "moonscape" flanks are so alien in appearance that many visitors can't believe they are high up among the mountains of the fabled Golden State, a place usually associated with sharp granitic peaks. Yet this "odd-man-out" peak, at 14,246 feet, is one of the state's most interesting Fourteeners to climb. I should say "hike," not "climb," for it's the easiest of the lot. A dirt road, off-limits to private vehicles, leads to the very summit, and if one is acclimatized and can handle a round-trip hike of fifteen miles in such a super-bright, skin-sizzling landscape, then the ascent is easy. I made the walk only once and had trouble, even though I had spent the previous two weeks guiding in the High Sierra, always above 10,000 feet. In splendid shape and thoroughly acclimatized, I thought the day would never end. Perhaps I was beat from my stressful job, but I was certainly beat and humbled after finishing WMP. I was twenty-nine!

Reading recent Internet trip reports, I have come to the conclusion that, easy though WMP can be, it turns back as many people as some of the more formidable Fourteeners. I have tried it several times when June snow, remnants of the previous winter, was too deep and mushy to allow easy progress. In midsummer I have been hit by heavy winds just after leaving the car, gusts that would have become fearsome higher up. But altitude is the biggest factor in defeating hikers. When one drives directly from the big seaside cities, or even from nearby Bishop, at 4,000 feet, to the trailhead, at 11,700 feet, and then begins the ascent—well, you had better be young and in shape if you want an easy day of it.

Though it can be seen from vast distances, the mountain itself is not impressive; it's simply the high point of a very long ridge, the relatively level crest of the White Mountain Range. This fifty-mile-long ridge, much of it lying above 11,000 feet, almost forms the border between California and Nevada, and in fact the highest spot in Nevada occurs at the far northern extension of the range. Boundary Peak, however, is not a separate mountain and is not Nevada's highest peak: it is simply a sub-summit on the ridge leading to California's higher Montgomery Peak. But, yes, Boundary is indeed the highest "point" upon which one can stand in Nevada. (If the border had been delineated only five hundred yards to the southwest, Nevada's highest spot would be partway up Montgomery's ridgeline—and what would those who seek a state's highest point have made of that? It's too bad that eastern Nevada's striking Wheeler Peak, the second-highest spot and only sixty feet lower than Boundary, couldn't have been uplifted a bit more.)

If White Mountain Peak is hardly the most dramatic California Fourteener, its surroundings make up for it. As mentioned, the austere moonscape of the hike itself is unique. This isn't Shasta or North Palisade. But far below the summit, on the approach road, lie the best reasons to visit this peak. Bristlecone pines, rarest of the genus *Pinus*, dot the landscape in profusion. The word "forest" doesn't describe a collection of bristlecone pines: "grove" is more appropriate—and "isolated grove" is even better. You'll never get lost wandering among the bristlecones. John Muir's favorite tree adjectives don't readily apply to this species, which isn't really "noble" or "glorious." The young specimens are nice-looking pines, but the ancient ones, the ones we gravitate toward without thinking, are simply awesome, offering the finest display of weathered wood on earth.

Found only in the Great Basin and parts of Colorado and New Mexico, and only on two dozen mountain ranges, the bristlecones' most noted characteristic—incredible age—is a fairly recent discovery. As late as 1950, little was known about the tree or its range; and virtually nothing about its age. Several reasons account for this lack of knowledge. The species' location, high atop remote desert ranges, kept it far removed from most scientists. Few maintained trails existed, so only hardy hunters and prospectors ever saw the trees. And these outdoorsmen, like many other folk, could hardly have told the subtle difference between a bristlecone and a limber pine, a far more common timberline tree. But in the early 1950s Edmund Schulman, an Arizona dendrochronologist (one who analyzes climate changes by looking at tree rings), visited the White Mountains, took core samples, and was undoubtedly thrilled. But, like any good scientist, he hesitated before informing the world of his research. It was in 1958 that his findings were published in an article in *National Geographic*. It must have stunned anyone interested in ancient trees, for Schulman had found bristlecones that were 4,600 years old (later research has added several hundred years to this figure). One might imagine that California's enormous redwoods or sequoias are the geriatric champions, but no, the humble bristlecones are by far the oldest living conifers on our planet.

As you drive up into the White Mountains and walk into a grove of bristlecones, probably the first thing you'll notice is that you're breathing rather hard; the trees grow mainly at elevations between 10,000 and 11,500 feet. Make your way across the white, rocky dolomitic "soil" to what appears to be a lifeless tree, one distinguished by its furrowed, golden trunk and the dozens of naked snags that jut up into the cerulean sky. Dead as a doornail, you think. Then you spy a single branch that sports lush green needles and even a few cones. At first you're mistaken, and you look around for a healthier, close-by tree that has sent a branch into this one's territory. Then you look again and follow the living part of the tree downward. A narrow, curving strip of bark is plastered against the trunk, snaking down to the ground in anything but a direct manner. In this unbelievably dry, cold, and windy environment, with few nutrients, this tree has sacrificed much of itself in order that a limb might live (the growing season is less than two months). These strip-bark trees, by definition more than 1,500 years old, rise all around you, once you have taken the time to look. It's a revelation to stand among these sentinels; you're seeing an example of perfect adaptation.

At what is now called the Schulman Grove, at the end of the paved road from the Owens Valley, the four-mile Methuselah Trail winds up and down through hundreds of magnificent bristlecones, a stroll that ranks with the nation's best. Somewhere along this trail, unmarked for obvious reasons, is the Methuselah Tree, often described as the world's oldest living conifer (older bristlecones undoubtedly exist, but do we really care which individual tree it is?).

Unlike in an art museum, where guards pounce if you even breathe on a Warhol, no ranger in the White Mountains is going to be upset if you test your knuckles against a 2,000-year-old bristlecone. Your knuckles will be the loser, for the wood is rock-hard, furrowed into sharpness by age and wind. Fallen trees dead for a millennium show not a trace of rot. By studying growth rings on living trees, standing dead trees, and fallen trees, those who pursue this eye-straining work can chart climatic fluctuations for the last 9,000 years.

To fully appreciate the bristlecones, visitors should leave their cars and get out and walk. The Methuselah Trail, mentioned earlier, is a must. Higher up, on the road leading toward White Mountain Peak, is the Patriarch Grove at 11,300 feet, and this requires only a stroll to see what might be the bulkiest tree of them all, the Patriarch itself, discovered by Schulman in 1953 and aged by him as "only" 1,500 years old. Needless to say, one can park along the road anywhere above 10,500 feet and hike cross-country to isolated groves, places that see only a few footsteps a year. One time I came across a crude rock shelter at 11,200 feet, perhaps the handiwork of Indians hunting bighorn sheep.

If the bristlecones form the unique flora of the region, surely the unique man-made sights one will see high on White Mountain Peak are the structures collectively known as the White Mountain Research Station. In 1948 the U.S. Navy (yes, the Navy) established a small site at 10,100 feet in the Whites to field-test high-altitude sensors associated with newly designed infrared-seeking missiles. Along with such classified projects, more mundane ones were accomplished: cosmic-ray and astronomical studies.

At the same time researchers at the University of California at Berkeley were becoming entranced with the idea of studying high-altitude physiology in pilots, flora, and fauna. What better place to do research than high on a remote mountain? Nello Pace, a Cal assistant professor of physiology, thought the summit of Mount Whitney, where a summit hut had existed since 1909, might be ideal. He wanted to establish a more complex site there, but the Sierra Club soon got wind of the project. According to Pace, Dave Brower and Dick Leonard, both soon to become famed conservationists, told him, "We're going to fight you. We don't think the top of Whitney ought to be desecrated by having a laboratory on it." Pace replied, "Well, I got permission from the Park Service....I'll see you in court." A compromise was reached in 1949 when Brower and Leonard suggested the White Mountains, where the Navy already had a station and where crude Jeep tracks led up to 13,200 feet. A perfect place, devoid of controversy, and located in a region not sullied by mankind. (An agreement in 1951 between the Navy, which shared control with Cal, and the Forest Service permanently prohibited private automobile traffic above the 11,700-foot level so as to better preserve the ultra-fragile environment, certainly an astute idea. The Navy was a full partner at the station until 1973.)

During the summer of 1951 work began on a huge Quonset hut at 12,470 feet, a site soon to become known as the Barcroft Laboratory. By June 1952 the station was in full operation, and, in Pace's words, was "a national facility open to any scientific investigator wishing to pursue research in the high-altitude environment." Other buildings soon went up, including one in 1956 solely for visiting female researchers—an idea certainly ahead of its time. By 1975 twenty-three men and women had earned PhDs for their research at the station.

Nello Pace was the first director of the station, a position he held for twenty-seven years. I knew him slightly, for he lived only four houses away from my childhood home. Sometimes he even played basketball with me at our garage hoop when he walked home from the nearby university. A fine scientist and an avid hiker, he was deputy leader of the 1954 California Makalu Expedition, where he constantly drew blood from exhausted climbers for his research. Famed mountaineer Willi Unsoeld, a member of the expedition, wrote in 1955 that "Dr. Pace's program was not only most ably conceived, but also relentlessly carried out—despite occasional strong protests from his reluctant subjects."

Around 1955 a small stone laboratory was built on the very summit of WMP. This blemish on the landscape is somewhat shocking to the summit climber, but valuable research has undoubtedly resulted from its presence. It is easy to ignore the structure as you take in the view of virtually the entire High Sierra crest, from Mount Dana to Mount Whitney, a distance of 105 miles. The aforementioned Willis Linn Jepson wrote that these peaks seemed "almost as if one were viewing them from the vantage point of a separate planet which had wandered near."

Between the summit and that jagged crest, and 10,000 feet below, lies the Owens Valley, said to be the world's deepest valley. In theory one can see this—actually the enormous morning and afternoon shadows—with the naked eye from the moon.

~~~~~~~~~~

If the moon had been inhabited by an advanced civilization armed with superb telescopes scanning the earth for centuries, then we might know something about the first ascenders of White Mountain Peak. Alas, we know absolutely nothing. Archaeological studies have found remnants of Indian encampments high in the range, and it would seem obvious that the summit could have been visited often during the past millennium. Why not?

As for recent history, no latecomer seems to have recorded a "first ascent," but by 1917 the U.S. Geological Survey had a benchmark atop the summit; this was the first mention of the peak in the journal of record, the *Sierra Club Bulletin*.

More recent ascents have at least been on the record. In 1934 a man named A. H. Marshall made what may have been the first traverse of the Whites, taking six days to wind up and down, back and forth, from U.S. Highway 6, in the north, to Westgard Pass, in the south. The first winter ascent of WMP was apparently made in March 1940 by four Sierra Club mountaineers, one of whom stated that "it would appear that White Mountain Peak in March is not a particularly good ski mountain, despite its name and height." A winter traverse of the entire chain was made in February 1974 by Galen Rowell and three others, a magnificent effort of sixteen days. Wrote Rowell, "Lack of shelter from the wind on the open slopes above timberline was the main hazard and we descended to timberline to wait out a severe four-day storm that recorded winds of over 100 mph. A nearby lodgepole pine, two feet in diameter, was broken off twenty feet above the base and flung more than forty feet from its stump."

Winter visitors, beware!

SOURCES AND FURTHER READING

The two comments by Willis Linn Jepson come from the *Sierra Club Bulletin*, Vol. 10, No. 3 (Jan. 1918).

Most of the information about the White Mountain Research Station comes from two sources: Nello Pace's "25 Years of High-Altitude Research," published by the University of California White Mountain Research Station (1973), and an oral history of Pace conducted in 1994, the year before his death (available at the U.S. Dept. of Energy's Office of Scientific and Technical Information website, http://www.osti.gov).

Marshall's note may be found in the *Sierra Club Bulletin*, Vol. 20, No. 1 (Feb. 1935). An unsigned note about the 1940 winter ascent can be found in the *Sierra Club Bulletin*, Vol. 26, No. 1 (Feb. 1941). Rowell's brief account of his winter traverse occurs in the 1975 *American Alpine Journal*.

Other than scientific treatises, little has been written about this obscure peak. The best guide can be found in a short chapter in *Climbing California's Four-teeners: The Route Guide to the Fifteen Highest Peaks* (1998), by Stephen Porcella and Cameron Burns.

More has been written about the magnificent bristlecones: the best of the lot is Michael Cohen's erudite *A Garden of Bristlecones: Tales of Change in the Great Basin* (1998).

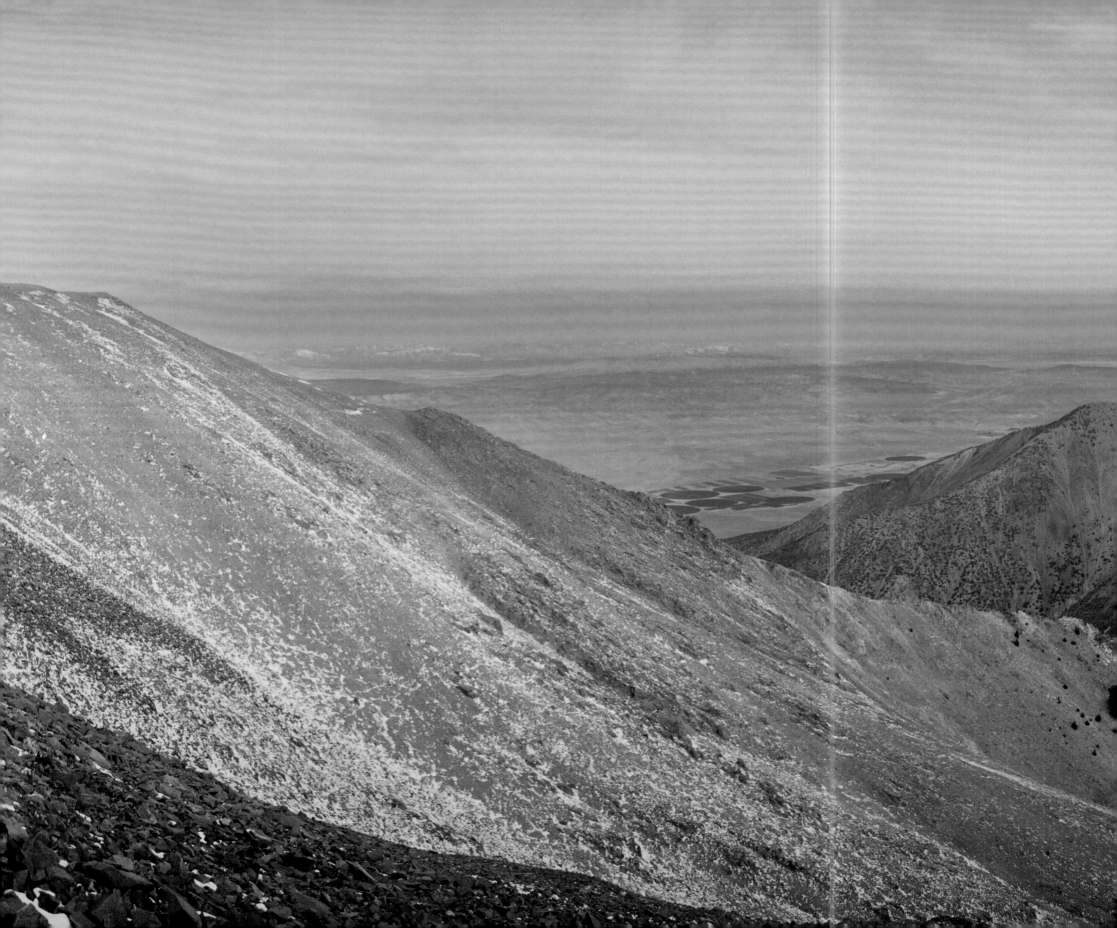

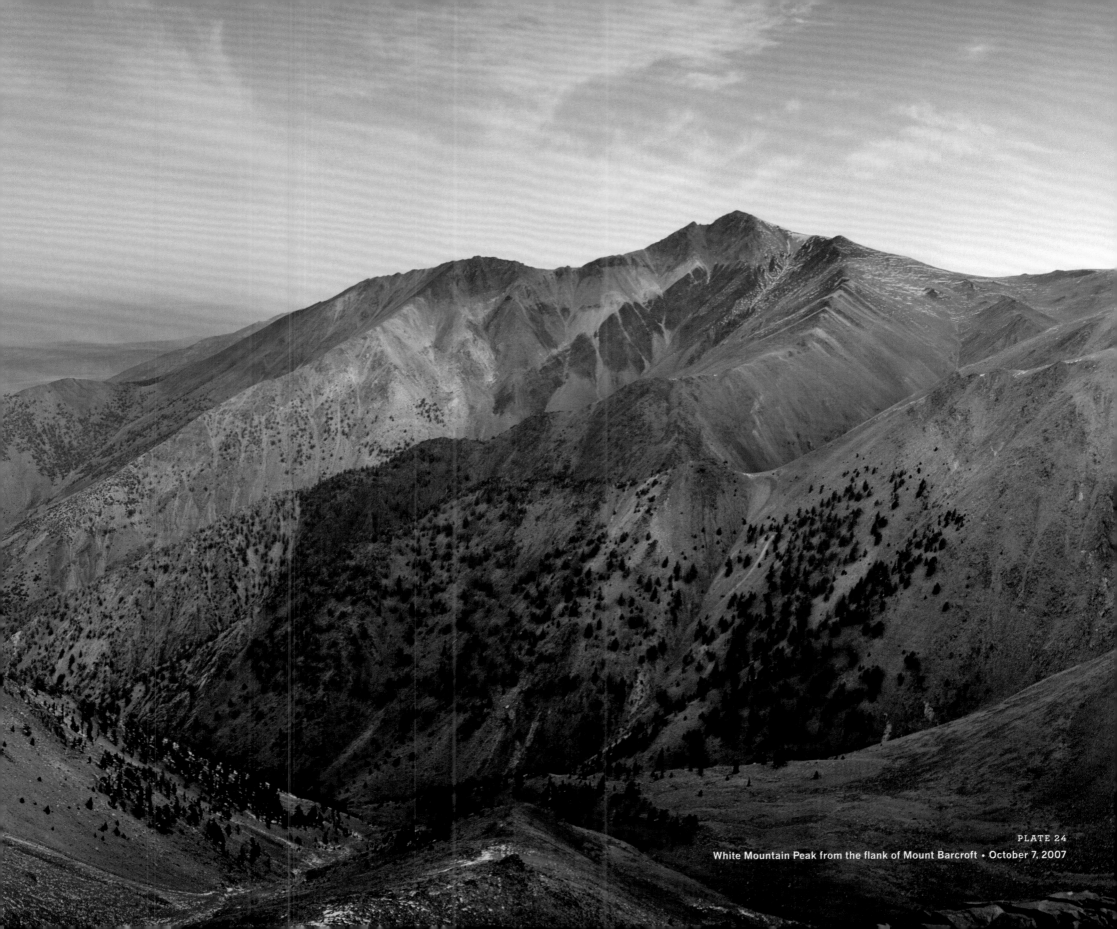

PLATE 24
White Mountain Peak from the flank of Mount Barcroft · October 7, 2007

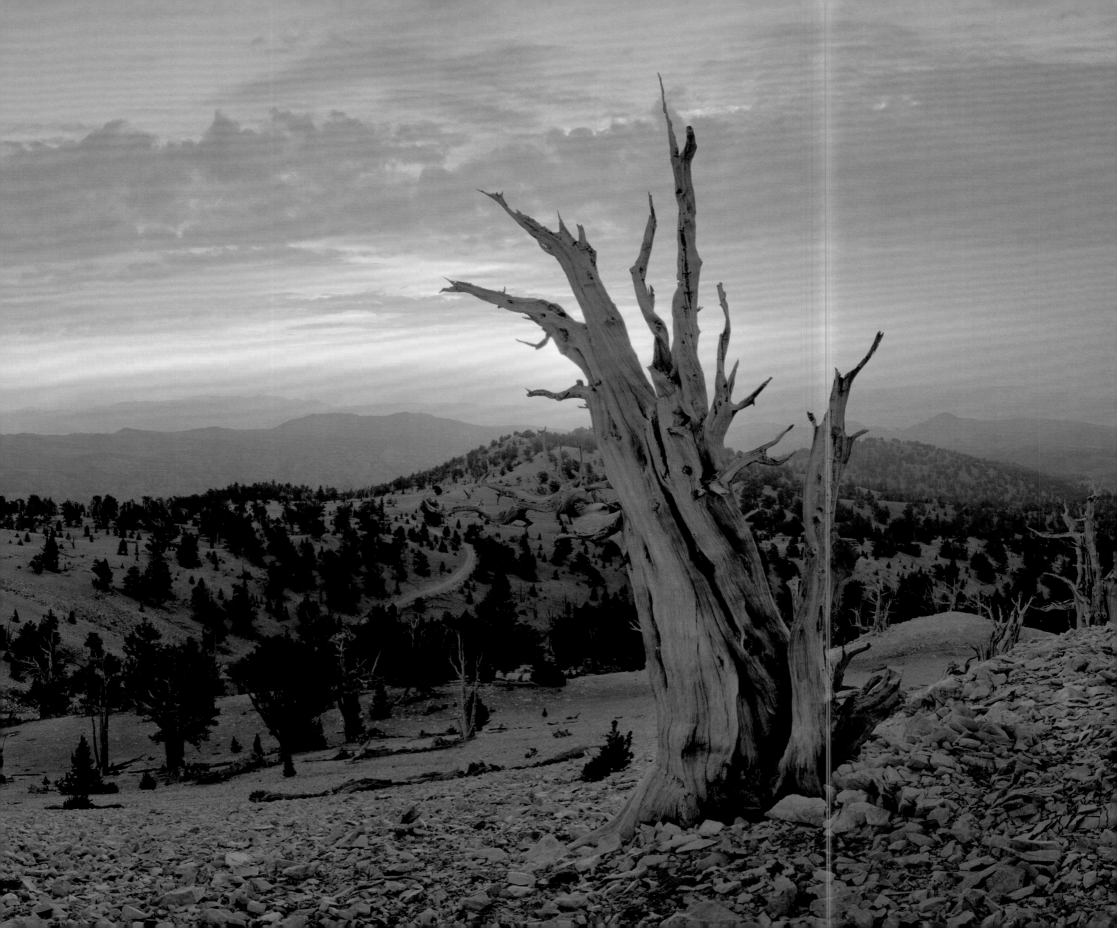

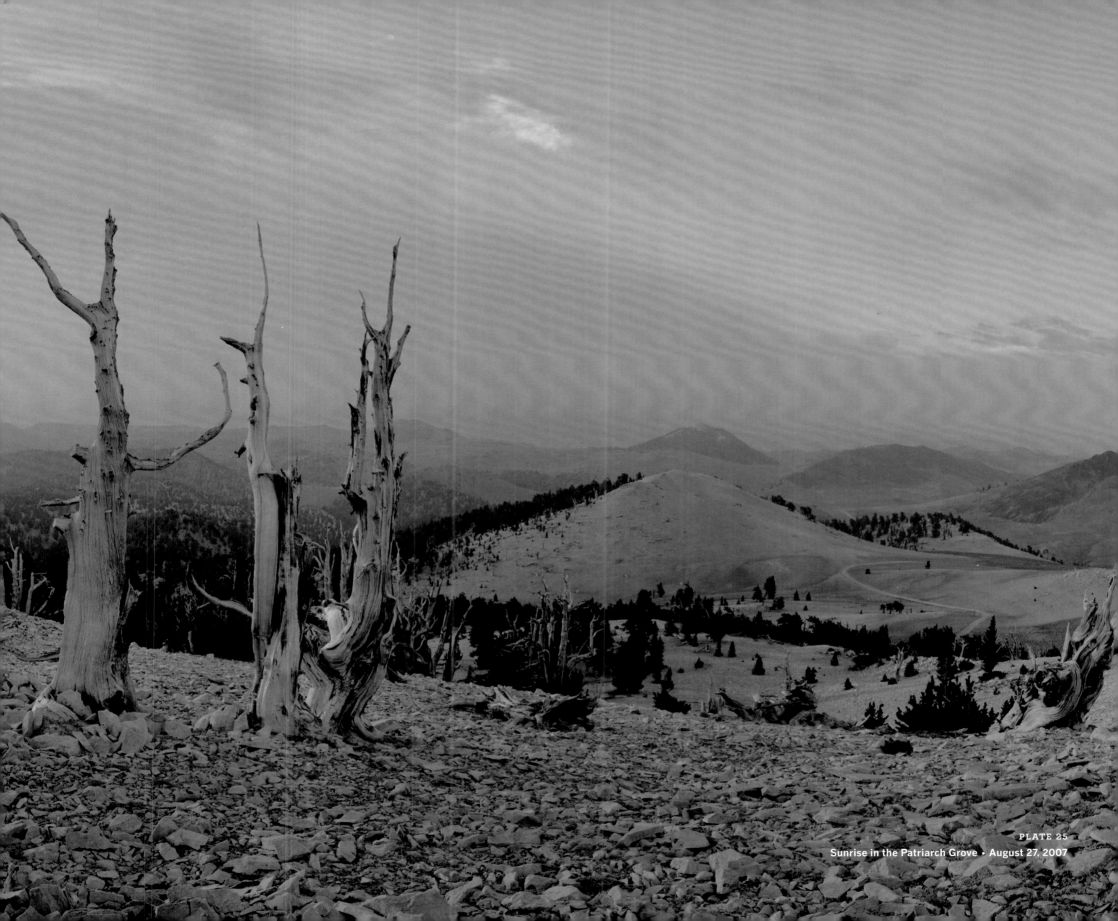

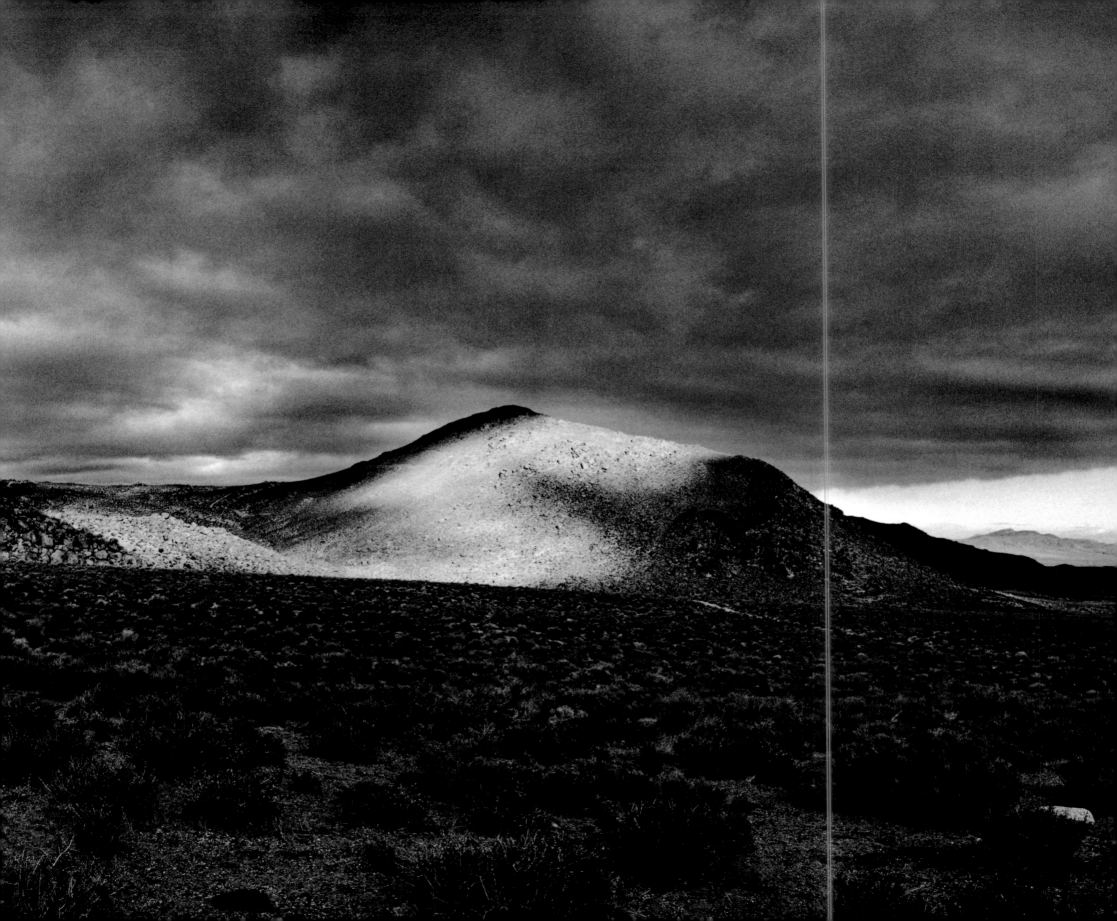

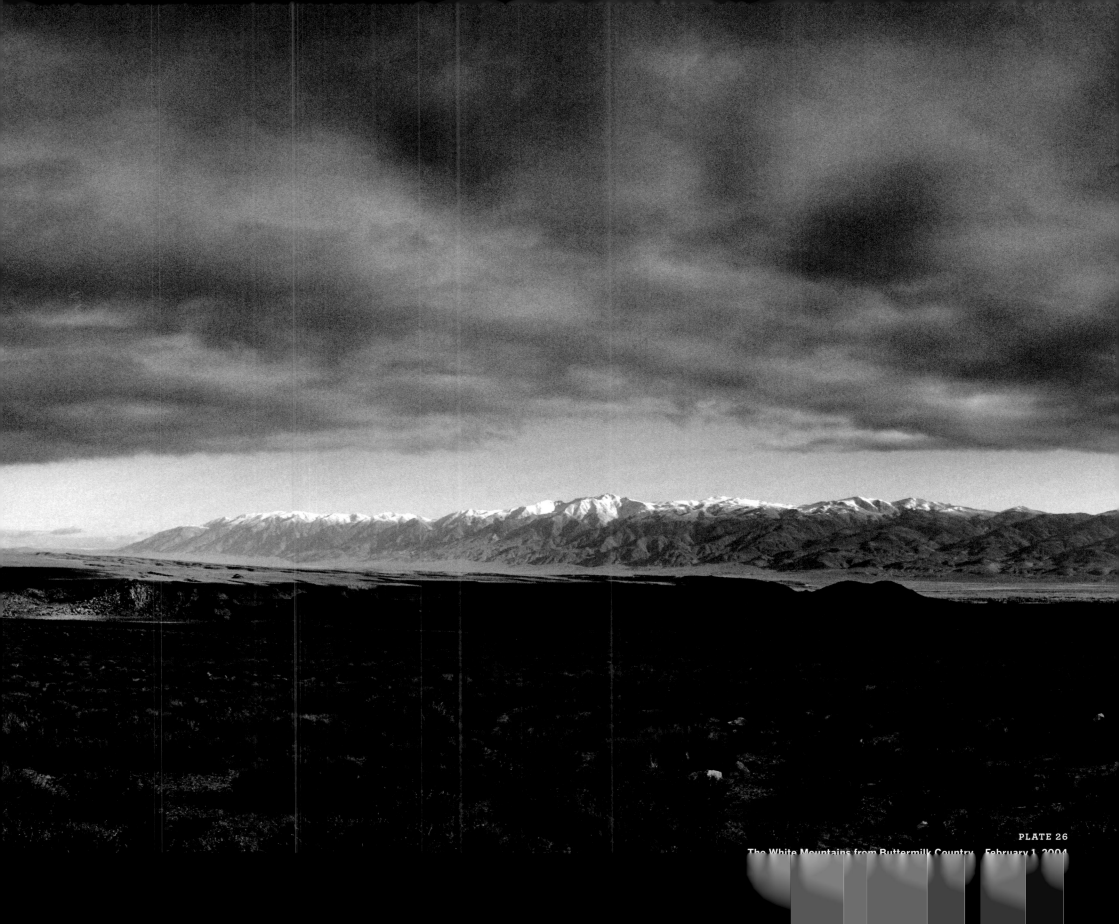

PLATE 26

The White Mountains from Buttermilk Country, February 1, 2004

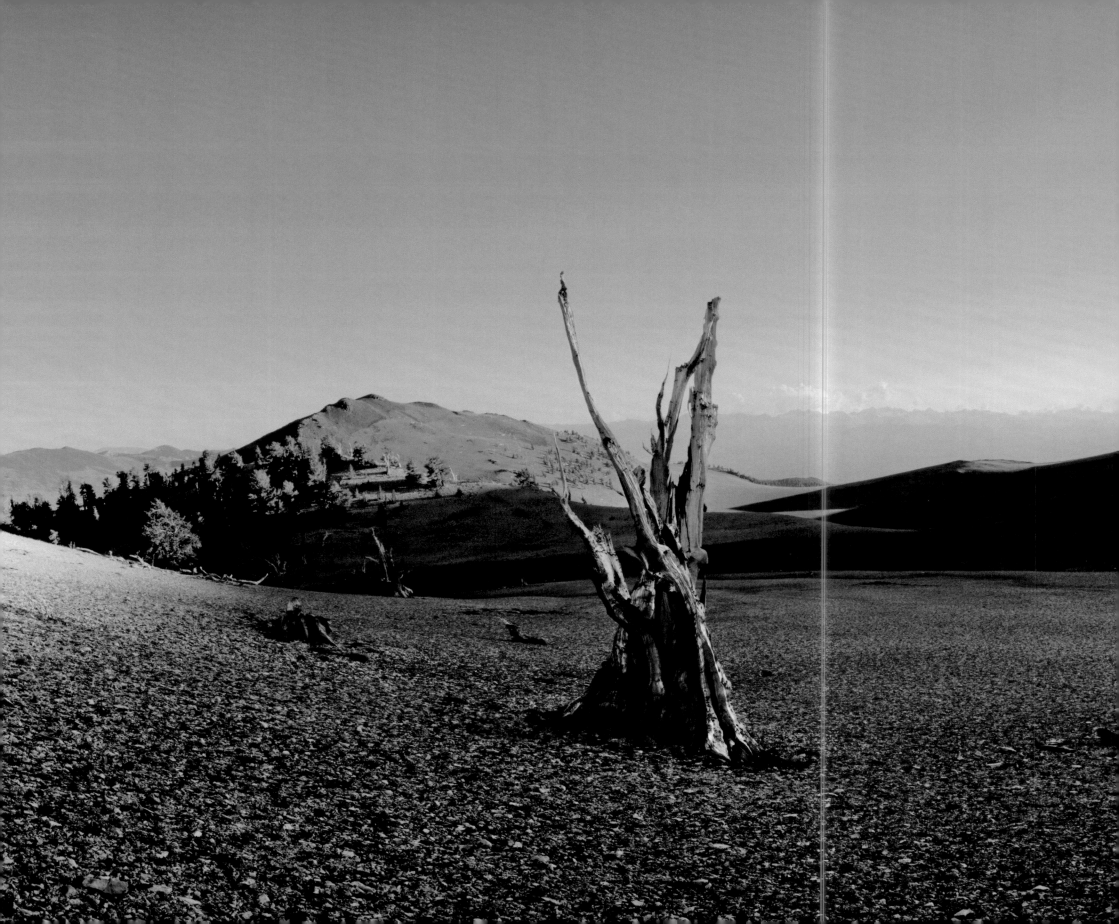

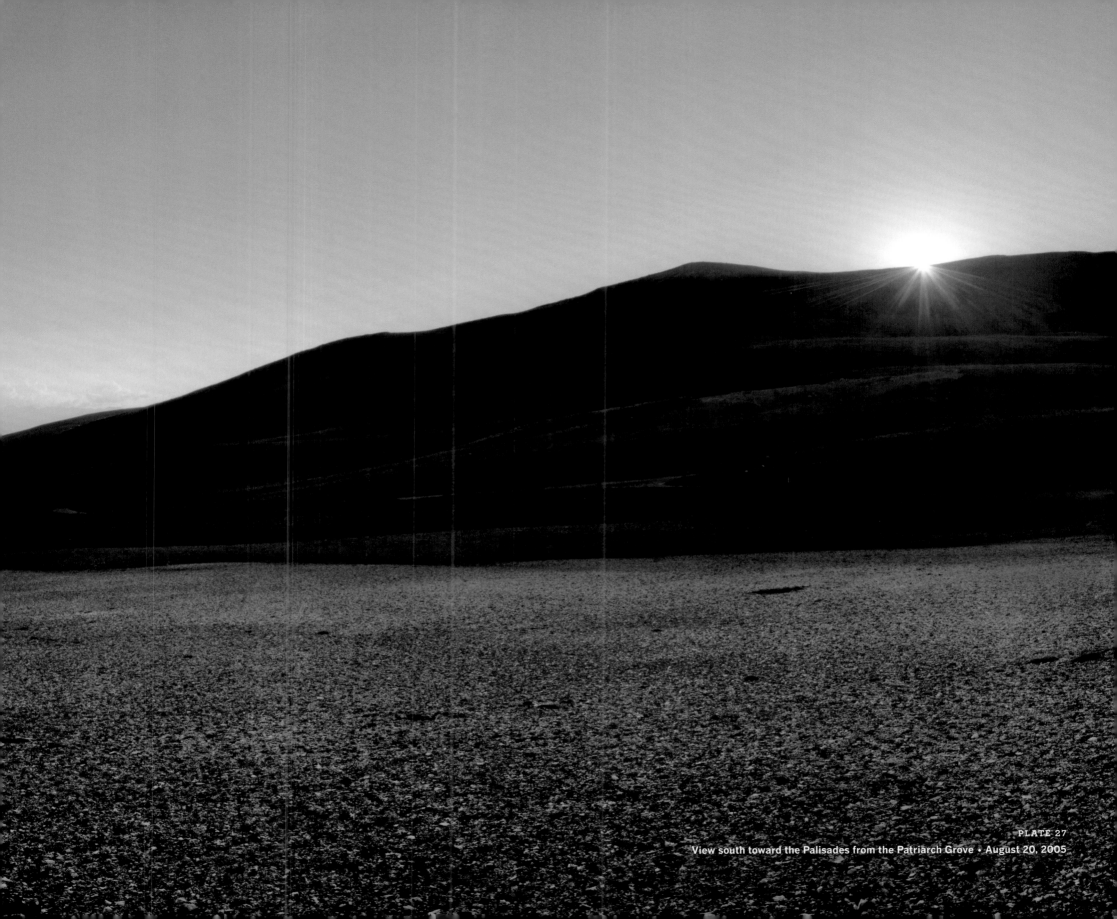

PLATE 27

View south toward the Palisades from the Patriarch Grove • August 20, 2005

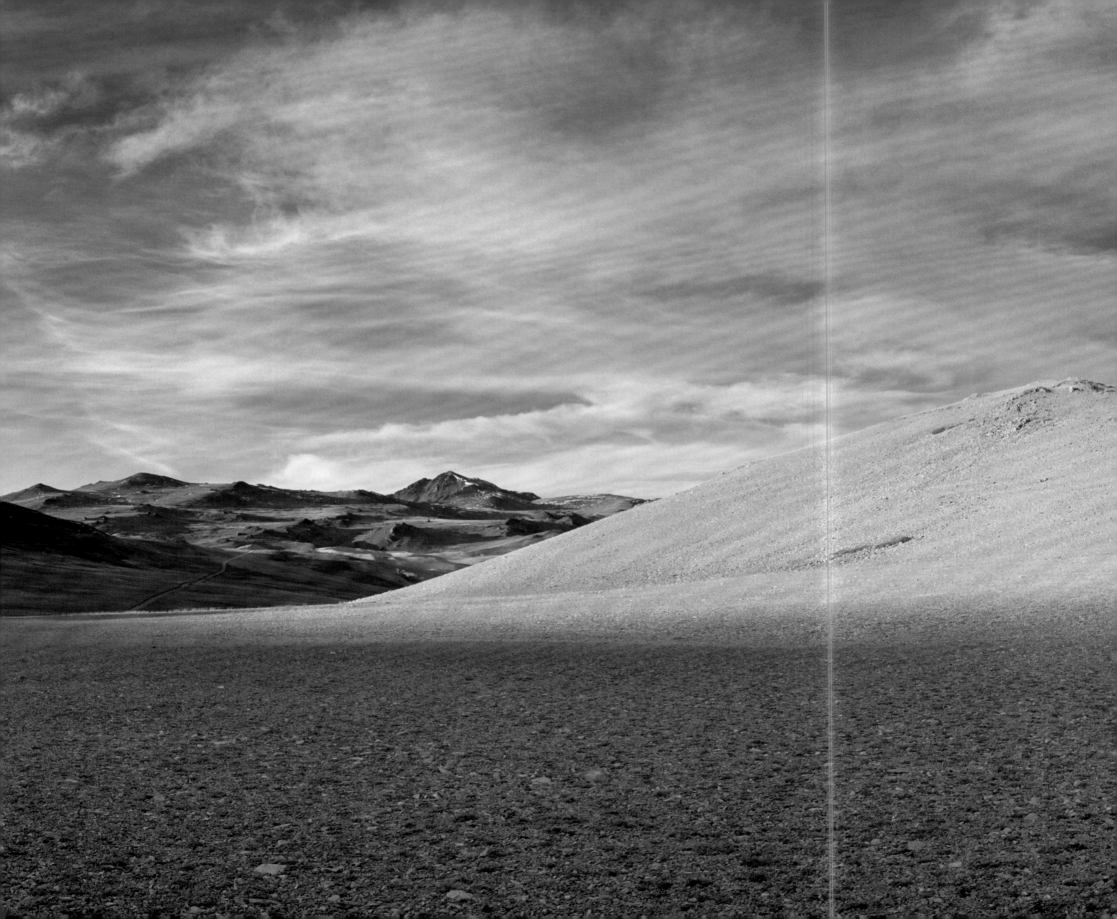

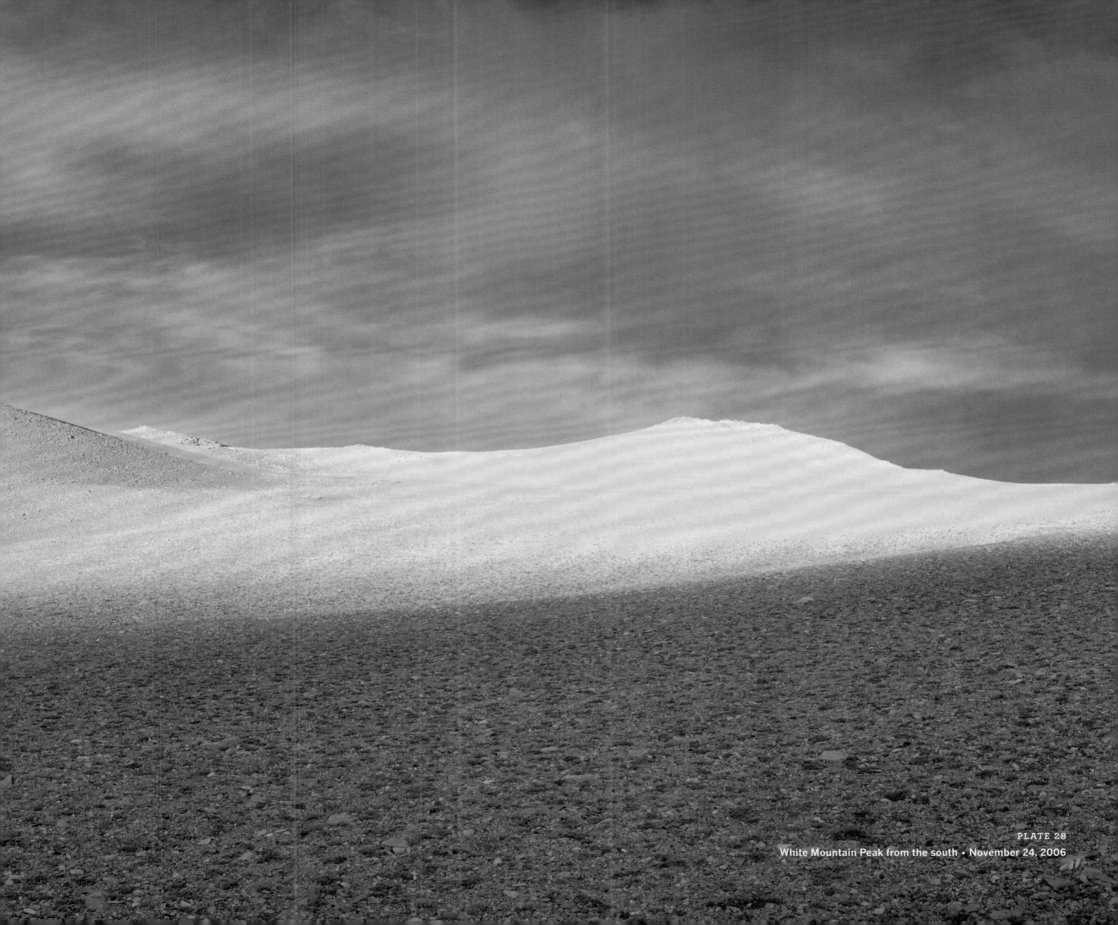

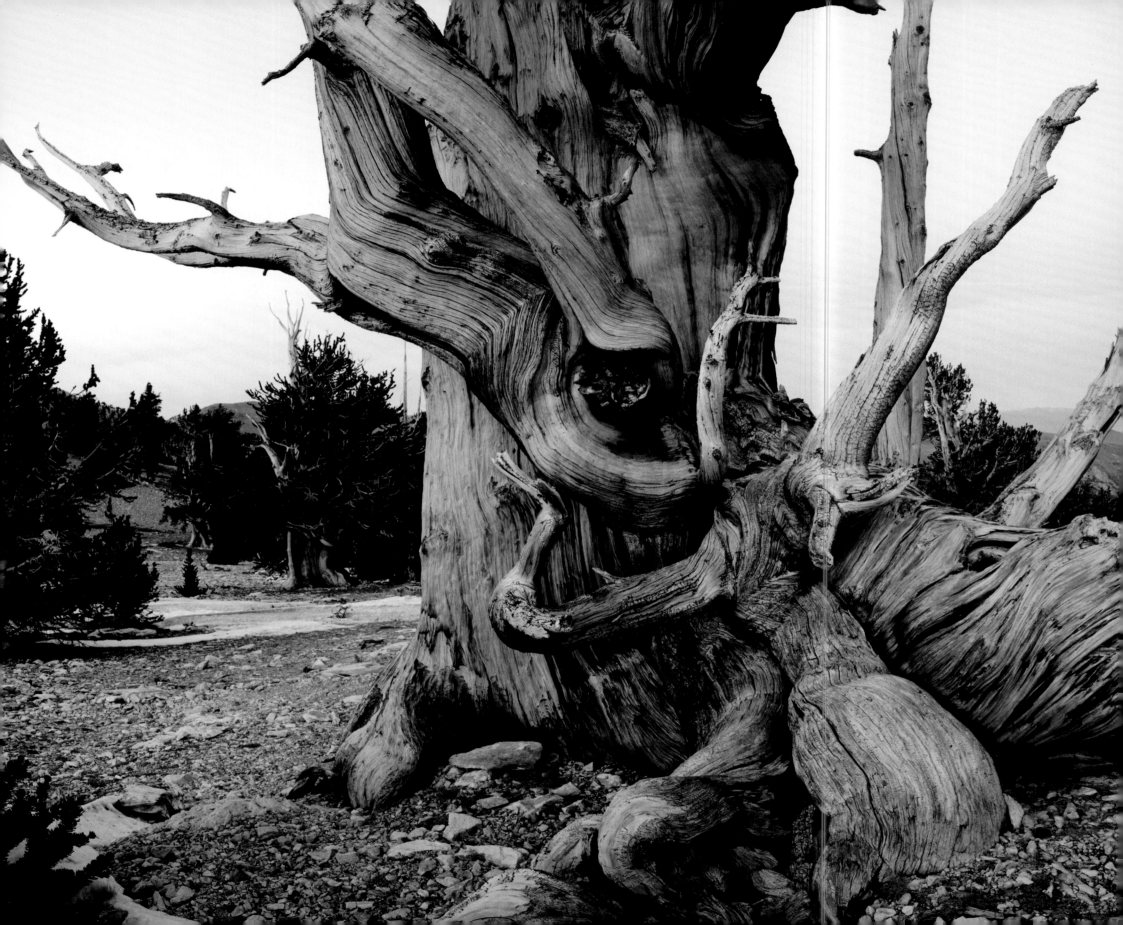

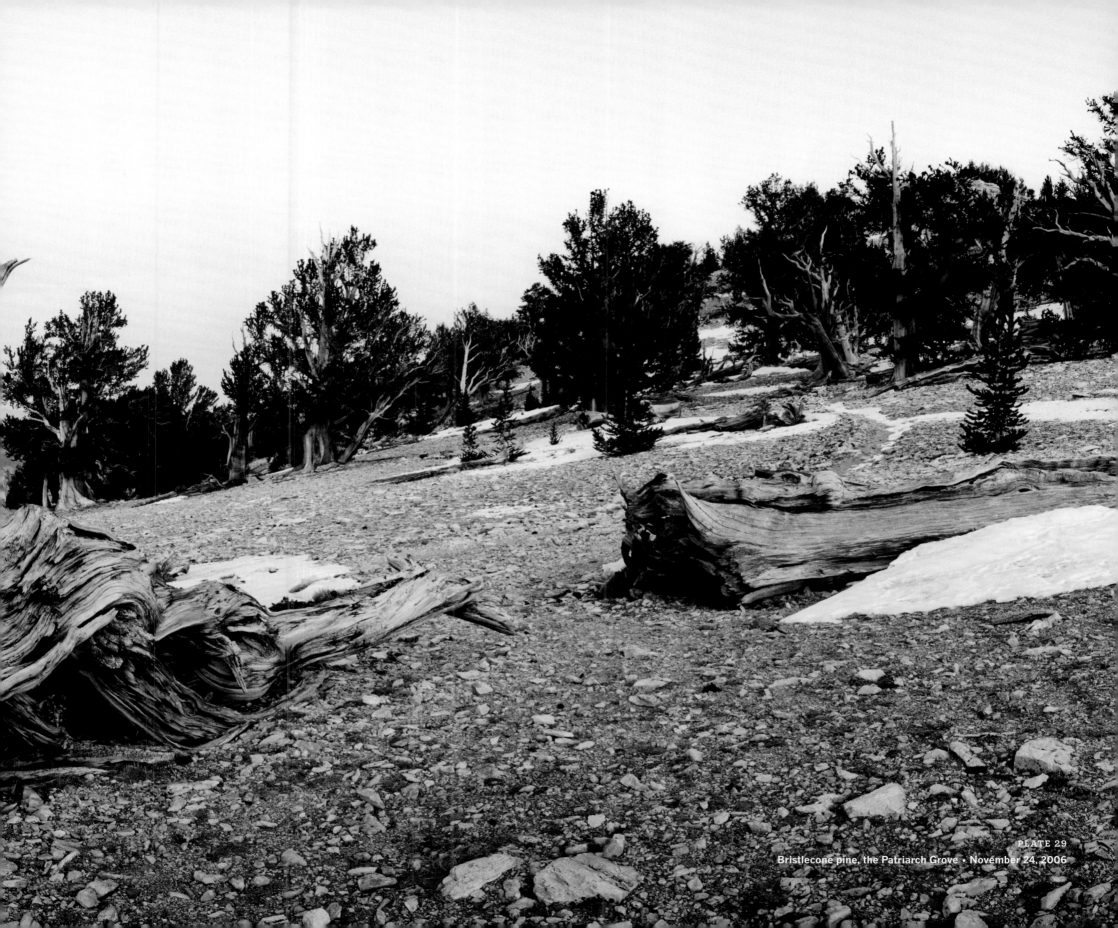

PLATE 29
Bristlecone pine, the Patriarch Grove · November 24, 2006

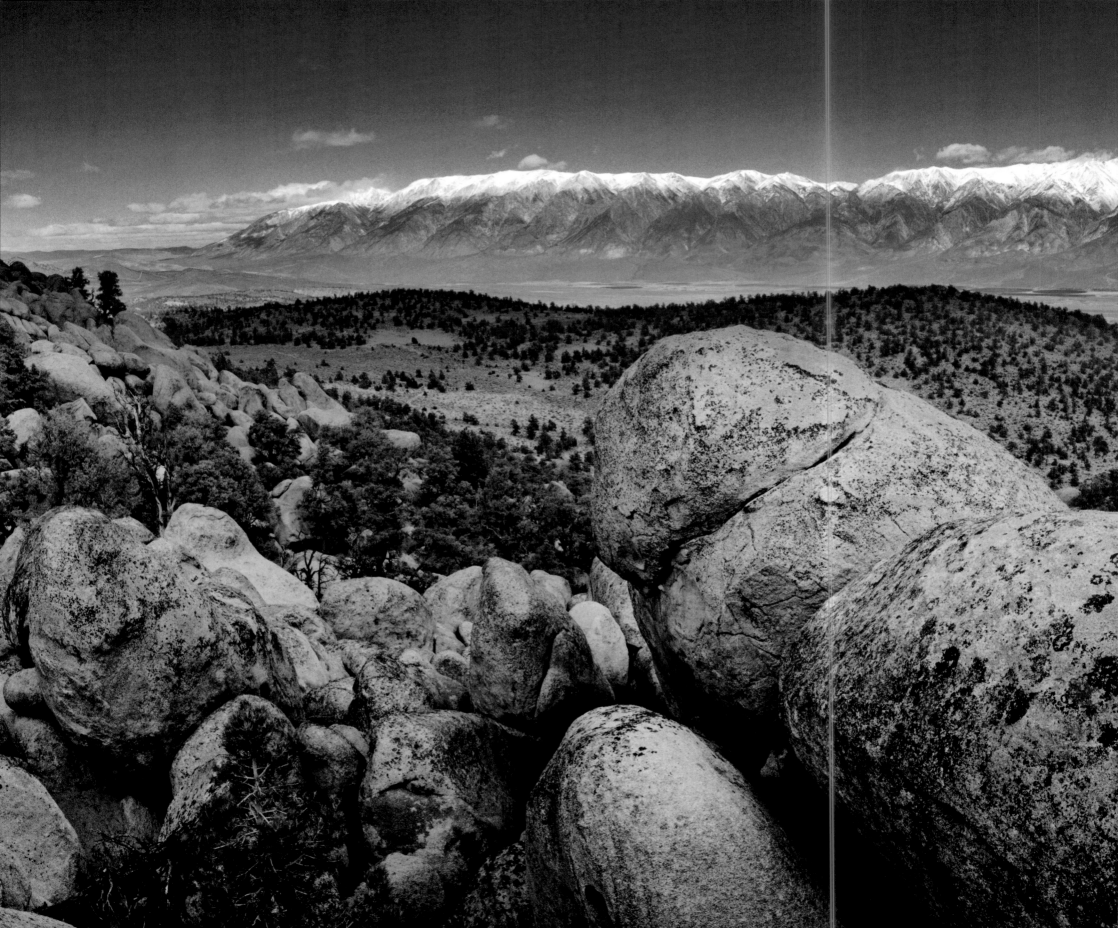

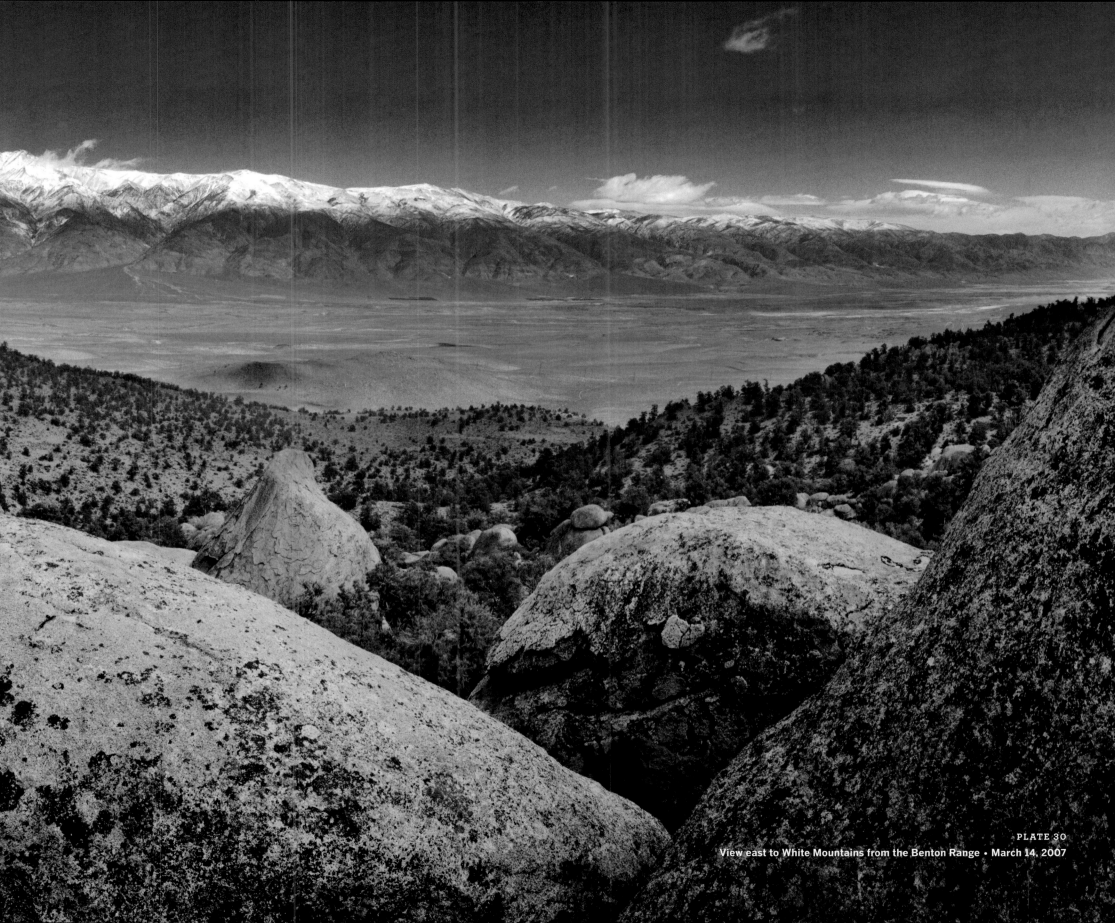

PLATE 30
View east to White Mountains from the Benton Range • March 14, 2007

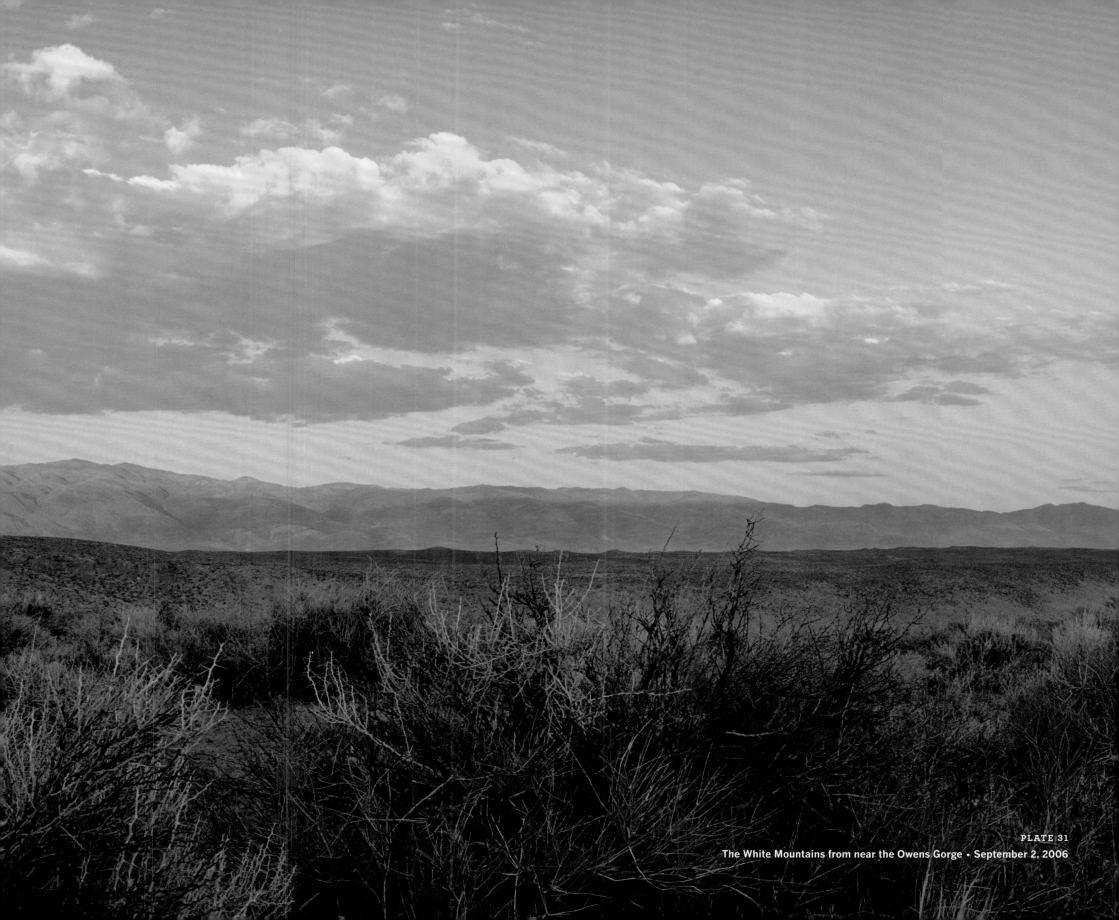

PLATE 31
The White Mountains from near the Owens Gorge • September 2, 2006

July 23

Moffitt, Hutchinson, Bob Pike, and I started for the Palisades. Helen & John went as far as the sheep pass, and then returned to camp. Crossed to 2nd pass and down Cataract Creek to Palisade Creek for noon. Ascended to Timber line for night.

July 24.

Attempted North Palisade from S.E. but failed, and climbed Mt Sill. Returned to timber line camp. ("First ascent" of Mt. Sill)

July 25

Successfully ascended the North Palisade from the west, together with Hutchinson and Moffitt Returned to timber line by 4, picked up Pike, and went on down to Palisade Creek for night. ("First Ascent" of North Palisade)

July 26

Up Cataract Creek and over the passes

reaching Lake Marion by 11:15 A.M. Rested in afternoon

July 27

Returned down Cartridge Creek, and made Fiskes by noon. Simpson Meadow in afternoon

July 28

Loafed in Camp.

July 29

Rested in Camp. Hutchinson and Moffitt left in the afternoon for Millwood.

July 30

Loafed in Camp all day. Bob & John went hunting but got nothing.

July 31

Loafed in morning. Cooked grand dinner in afternoon

Aug 1

Began arrangements for return

Excerpt from the journals of Joseph LeConte, used with permission of
The Bancroft Library, University of California, Berkeley: BANC MSS C-B452,
Carton 1, Vol. 19 (from "Record of Sierra Trips 1898–1903")

THE PALISADES

It's long been known that the Palisades, a ten-mile-long crest in the central High Sierra, comprise the finest group of alpine peaks in California. In 1896 Theodore Solomons, that articulate early explorer, wrote that "the Palisade country, I have reason to believe, is the acme of alpine sublimity on the American continent....There is here a very chaos of gorges of appalling depth and savage aspect." That this was a somewhat exaggerated view can be explained by the fact that few then knew about the spectacular mountains of Wyoming, Canada, and Alaska. But Solomons' words are right on when applied only to the Sierra Nevada.

I first climbed in this paradise in September 1959, when several of us college kids climbed Mount Sill by an easy glacier route. Having devoured the guide-book, I knew all the nearby peaks by name—and I was in eighth heaven. No storms, no altitude problems, no strife. Only beauty and joy at being in such a place. At least on the way up.

Soon after we began the descent, a serious rockfall, caused by one of us, almost snuffed half our little group. Immediately naming the perpetrator "Dangerous Don," we made him descend first the rest of the way. We weren't too upset by our narrow escape, for we considered ourselves immortal. A decade later I guided for several summers in this amazing place, ever fearful of the amount of loose stone. Clients constantly dislodged rocks, and with each rumble I was reminded of that afternoon in 1959. I soon learned that Palisade ridges were compact and fun but that the walls and couloirs below hosted tilted blocks patiently awaiting their turn to dive into the glaciers and moraines far below.

Along this ten-mile stretch of Sierra spine rise five of California's 14,000-foot peaks. Or is that seven? Two bumps, Starlight and Polemonium, are simply sub-summits of more mighty formations. In my humble opinion, the two should not count as Fourteeners, and until recently, mapmakers and guidebook writers thought likewise. Some now disagree, and for the purposes of this book we shall pretend they are separate summits. But you won't hear much about them here.

What makes this group an "acme of alpine sublimity"? Two words perfectly explain the concept: "shape" and "glaciers." The skyline itself, in many places, resembles rows of crocodile teeth. These are not normal Sierra peaks! Below these serrated ridgelines fall steep cliffs and swooping buttresses. Often these end in glaciers, small ones to be sure, though some have bergschrunds and steep couloirs. In early autumn the Palisades' couloirs, though not particularly steep, contain fabulous blue ice. Adventurous climbers then flock to these cold chutes. A warning: if radical climate changes persist, and if you read this book in 2010 or later, check to see if these beautiful couloirs still exist.

〰〰〰〰

When this fine collection of peaks was first named—by William Brewer in 1864—little was known about the region. Brewer himself was ten miles distant when he christened the group, which he called "very grand and fantastic in shape." Sheepherders had been close to the mountains, but they were not much interested in the heights, nor did they write down their impressions.

Prospectors also worked on the periphery, but these loners never put pen to paper either. Every summit was untouched, and the various glaciers that nestled under the northeast escarpments had rarely been seen.

Although the group is not far from the Owens Valley, obscuring foothills east of the crest hid all but two peaks, Mount Sill and Split Mountain, from the stagecoach roads that ran parallel to the crest. But mighty Sill was visible only for about a mile, and Split is an undistinguished mass, without glaciers. For the routine travelers of that era, the Palisades were invisible. As late as 1932 the Sierra historian Francis Farquhar mentioned that the ice fields were "by far the finest glaciers in the range, yet almost unknown to fame."

Virtually all the early Sierra mountaineers began their journeys from the west, since this was the gentle side of the range, easily accessible from the big coastal cities. Shepherds had established trails and camps up as far as timberline, often within a day's journey of the crest. The first adventurer to set his sights on Palisade summits was an engineering professor from the University of California, in Berkeley. Joseph N. LeConte had been going into the Sierra since he was a youngster, and he had often wondered about the mysterious Palisades. As his first exploratory goal, LeConte chose the massive southern outrider of the group, Split Mountain. Since he had thoroughly explored the great gorge of Kings Canyon, this easily reached locale was where he began his trip in the summer of 1902. Traveling the by-now familiar route from Kings Canyon across the Monarch Divide to the Middle Fork of the Kings, LeConte and his wife camped at lovely Simpson Meadow for a few days, savoring the scenery and the trout. On July 18 the couple and Curtis Lindley ascended alongside the Middle Fork until reaching Cartridge Creek. From this confluence they headed to Marion Lake, named on this trip by LeConte in honor of his wife of one year, Helen Marion Gompertz LeConte.

From the vicinity of Marion Lake the trio explored potential routes across the long ridge separating them from Upper Basin, the source of the South Fork of the Kings. None of the notches reached on July 23 proved passable on

their eastern sides, but on the following morning the undaunted threesome shouldered their packs and set off to reconnoiter the passes missed the previous day. Just when the venture seemed doomed, LeConte discovered what is now called Frozen Lake Pass, which he said was "the only point where the Cartridge Creek Divide can be crossed." Beyond this rocky 12,400-foot saddle lay Upper Basin, covered with tarns and tundra. And on its far side rose Split Mountain, at 14,042 feet.

The next morning's climb of Split was anticlimactic, for the mountain proved to be one of the easiest LeConte had ever climbed. A thirty-degree talus slope on the north flank proved trivial. From the top he marveled at the complexity of the terrain: "For eighteen miles to the south and eighteen miles to the north not a single one of the countless giants of the Main Crest has ever been climbed. We were in the heart of the High Sierra."

The main chain of the Palisades loomed to the northwest, but LeConte realized that their provisions had nearly run out; the dark cluster of summits so dominating the skyline would remain untouched for the time being. From their camp at Marion Lake, however, LeConte and Lindley dashed to the north to climb a mountain they soon named appropriately, Observation Peak. From this vantage point the highest crags of the Palisades rose dramatically, only five miles distant. LeConte mapped the area as best he could and vowed to return the following year.

In July 1903, James Hutchinson, James Moffitt, John Pike, Robert Pike, and the two LeContes retraced the previous year's route as far as Marion Lake. Leaving Helen LeConte and John Pike to tend camp, the four others struck north. Skirting Observation Peak, the group dropped nearly 3,000 feet to an idyllic glade at the 8,800-foot level of Palisade Creek. This place, according to LeConte, was "absolutely untouched. Not since the creation of the forest reserve [in 1893] had human foot trod this glorious wilderness, and even before that time the sheepmen who visited the valley must have been few indeed, for

not a blaze, monument, nor corral did we see, and there were but few signs of old sheep-camps."

That night's camp was established at timberline on Glacier Creek, not far below the mysterious peaks. Early on July 24 the men left camp and continued up the stream, traversing meadows, talus, and finally snowfields. Here they encountered acres of sun cups, a phenomenon familiar to all who venture into the subalpine world. LeConte described them succinctly: "The unequal melting of the snow cut the whole mass up into a labyrinth of great knife-blades, which were sometimes four feet high and two or three feet apart. We were forced to step from blade to blade, balancing on the sharp edges, and often falling into the spaces between."

In spite of these obstacles, the well-conditioned men soon reached the main Sierra crest, astonished to see, just below them, the largest glacier in the range, complete with crevasses and a mile-long bergschrund. (This was near the end of the "Little Ice Age," when the Sierra had much more snow than it does today.) Greatly impressed with this unexpected sight, they turned toward the highest peak—North Palisade—and gasped. The jagged, half-mile ridge leading over to its summit appeared impossible. Hutchinson carefully traversed toward the brink of a huge gash—now called the U-Notch—and verified the prognosis. The disappointed men scrambled up a consolation prize to the east: Mount Sill, a massive peak that LeConte had seen, and named, seven years earlier. To LeConte, the view from this 14,162-foot summit was "unparalleled in grandeur and extent." But there was no question in anyone's mind that the view was flawed in one respect: by the image of nearby North Palisade, eighty feet higher and still unclimbed.

The next morning, unwilling to abandon their primary objective without a serious effort, LeConte, Hutchinson, and Moffitt set off from camp once again, with, in LeConte's words, "rather doubting hearts and very sore arms and legs." From what is now Potluck Pass they gained an excellent view of North Palisade's 1,500-foot-high southwest face, an imposing escarpment riven by steep chutes.

Choosing the most prominent of these, the three climbers worked up it until stymied by steepening cliffs. Since these appeared unclimbable, it seemed the trio must fail once again. But as LeConte peered down the chute they had just ascended, he spied a narrow ledge snaking around a corner. This proved to be the key to the ascent, for the sloping shelf led to an easier chute, which eventually ended near the 14,242-foot summit. The highest of the Palisades—soon referred to as simply North Pal—had been vanquished, and the geography of yet another remote part of the High Sierra was better understood.

Concepts of what is "impossible" in climbing change with each generation. LeConte can hardly be faulted for the following observations he made from the top of North Palisade. "The knife-edge to the north of the summit was frightfully gashed, making an ascent from that side wholly out of the question. An approach from the east might be possible, though very doubtful. We had already satisfied ourselves that the southern knife-edge was beyond our powers, so the route up the western front seems to be the only feasible one."

LeConte ended his article about the first ascent of North Pal with these words: "I have no doubt that others will follow our track to the summit....Doubtless, also, scores from the [Sierra] Club's Outings will climb or be pulled and boosted up its rugged face; but never again will any one feel the inspiration, the excitement, and the glory of success that we three experienced when the first ascent was made." LeConte, over two summers, had made the first ascents of three of California's Fourteeners.

〰〰〰〰〰

Several miles southeast of North Pal lies a serrated section of crest unusual for its length. Its northern ramparts are plastered with several pocket glaciers and one fairly large one that lies underneath the highest summit, Middle Palisade. This peak is not especially distinctive, for it has many sub-summits spread over some 2,000 horizontal feet. Still, at 14,040 feet, it's the high point of the central section of the Palisades. By 1921, nearly two decades after North Pal's first

ascent, Middle Pal had seen only one attempt. This period—1903 to 1921—was certainly a time of "climbing doldrums" in the Sierra, and in many of the other mountain areas of the United States as well. Automobiles had been invented, yes, but there were few mountain roads—and few established trails. The pioneers of the turn of the century were now gainfully employed, raising families, and getting older. The High Sierra had been fully explored and mapped by 1908, and, with most peaks ascended, mountain climbing was not a popular activity. And then, of course, World War I intervened.

Francis Farquhar, a thirty-three-year-old accountant not long out of Harvard, had hiked extensively in the Sierra and in 1921 decided that the mysterious Middle Palisade would be his. Farquhar (later to shine as the preeminent historian of the Sierra Nevada, as president of the Sierra Club, and as editor of the *Sierra Club Bulletin* for two decades) teamed up with Yosemite's park naturalist, Ansel Hall, and they set off in August for the southwest side of the massif.

Partway up the peak they found, to their chagrin, a series of stone cairns leading upward. And just below the summit they spied a large cairn at the very top. "Increasing our speed," Farquhar wrote later, "we reached the top at half-past nine, and looked upon a sight that filled us with mixed emotions. The view was spectacular enough, but it contained a quite unexpected element; for not only were we not the first to reach this point, but there, standing clearly before us only a short distance away…was another peak unmistakably higher." They had not climbed Middle Palisade! It was 1,000 feet distant horizontally and some 100 feet higher.

Searching the summit cairn, the men found a can with a note dated two years earlier. Part of it read: "We hereby christen this summit Peak Disappointment." The ridge leading over to Middle Palisade had seemed impossible to the 1919 party, and Farquhar and Hall agreed. They descended. But a crazy plan formed. Could they still attempt Middle Pal that day, tired and after dropping more than 1,000 feet down knee-rending terrain? Yes!

After their descent from what is now called Disappointment Peak, they traversed talus for a few hundred yards to the northwest, then started up the correct peak. After a few hours of scrambling up steeper and steeper rock, Farquhar found himself in a bind: "Presently I became unnerved and thoroughly scared. The longer I looked at the enormous depth below the worse I felt…. At length I pulled myself together, subdued my fears, and began to concentrate my attention on the firm granite close at hand, paying no heed to what was below." The duo reached the top without further incident. "With a shout we greeted the summit as its first visitors."

~~~~~~~~~~

Around 1920, following the death of his young wife, a scholar of the classics began a climbing rampage. Three decades later Norman Clyde was the veteran of perhaps a thousand ascents, of which 125 were either first ascents or new routes up previously ascended mountains. In a letter to an acquaintance in 1925, he wrote: "I sometimes think I climbed enough peaks this summer to render me a candidate for a padded cell—at least some people look at the matter in that way." If, as a mountain pundit once said, the mark of a true mountaineer is his willingness to repeat climbs, then Clyde qualifies as few others are ever likely to do. He had numerous "most favorite" peaks and would climb them year after year (he ascended lofty Mount Thompson, just north of the Palisades, about fifty times).

During the 1920s and 1930s, the period of his most prodigious climbing, Clyde served as a guide on the annual outings of the Sierra Club, thus becoming a well-known figure to many high-country travelers. An unhurried eccentric, he transported a ninety-pound pack from one campsite to another, and watching him set up camp was always a thrill. Out of the bottomless pack would appear a pistol, an axe, a cast-iron frying pan, several heavy pots, three fishing rods, archaic camping gear—and *The Odyssey* in its original Greek!

Clyde's first love was the Palisade chain, and for decades he served as the winter caretaker of Glacier Lodge, a commercial establishment at 7,800 feet just below the peaks on the east side of the range. During summers he climbed everywhere in the Sierra (and occasionally elsewhere in the West and in Canada), but for virtually every year of his mountain career he managed to climb in the Palisades, mostly solo. To him goes the credit for opening up many of the east-side routes. (Although we think of the Sierra as a north-south range, it tilts some 30 degrees northwest off that convenient axis. Furthermore, the Palisade chain itself shoots even more radically northwest, with the result that many "east-side" escarpments are in fact northern, which of course helps explain the Sierra's largest glaciers.)

During the late 1920s and early 1930s, Clyde made several important first ascents in the region, including the U-Notch route on North Pal (an intimidating 40-degree snow couloir, complete with bergschrund and afternoon rockfall); the climb of the northwest summit of North Pal, now known as Starlight Peak; the north face of North Pal; and the northwest face of Mount Sill. All these routes were done from the little-known glacier side of the northern Palisades—and all were done solo. One stands in awe of this man, born in 1885, climbing alone, living alone, perhaps only at ease when challenged by the mountains.

When Clyde died, in 1972, his friend Tom Jukes wrote that Clyde "had lived as every alpinist wants to live, but as none of them dare to do, and so he had a unique life. When he died, I felt that an endangered species had become extinct….He was large, solitary, taciturn and irritable—like the North Palisade in a thunderstorm, and he could also be mellow and friendly, like the afternoon sun on Evolution Lake."

Clyde's 1931 ascent of Thunderbolt Peak was an historic one, since an all-star cast made the climb in less than ideal conditions. The story begins in the summer of 1931 with the arrival in California of Robert Underhill. As mentioned earlier, it was Underhill who introduced the techniques of rope climbing to California at the behest of Sierra Club members. It was not long before Norman Clyde became involved—and of course he suggested heading to his favorite area, the Palisades. After a few ascents of various peaks, Clyde must have mentioned an unclimbed, unnamed northern outrider, not considered a 14,000-foot peak, given the state of surveying back then. On August 13, 1931, seven men, Underhill and California's best, set out in clear weather to try for the top. They made the climb in good order, but the descent was epic. One member, Francis Farquhar, recalled: "Clouds gathered rapidly, and shortly after the party reached the summit a violent thunder-storm drove all precipitately to a place of safety. So rapidly did the storm gather that [Jules] Eichorn, last man to leave the ridge, was dangerously close to a lightning flash that appeared to strike the mountain. The importance of immediate retreat as soon as the rocks began to 'sing' was strongly impressed upon the members of the party. After half an hour of huddling on a ledge, in the face of hail and snow, the storm permitted us to return."

The men quickly came up with an obvious name for their peak: Thunderbolt. But it was not until the early 1950s that the mountain achieved Fourteener status. Prior maps had shown it as 13,900+ feet; the new topo sheet indicated that it was 14,040+ feet. Years later Thunderbolt Peak was downgraded to 14,003 feet, barely making the grade for this book. (A mapmaker's change can infuriate those who collect "special" peaks. For instance, Mount Barnard, in the southern Sierra, was 14,003 feet for many decades. Sought after by thousands during its exalted heyday, this slag heap has slipped to 13,990 feet and is rarely climbed nowadays.)

〰〰〰〰〰

One young Thunderbolt climber, Glen Dawson, wrote a few months later that "Because of the increased safety by the use of the rope, Sierrans can make more difficult climbs. More and more we are becoming interested in new routes and traverses rather than in the ascents of peaks by easy routes." A new era was beginning. With all the summits now gained, climbers rushed for new routes and traverses. For the next thirty-five years or so, numerous but relatively minor new routes were established.

In the late 1950s a schoolteacher/climber named Larry Williams had an idea: establish a guide service in this magnificent locale. This was a bold step, for California had never had true mountain guides, the tradition being that people went on Sierra Club outings (with poorly paid leaders available, to be sure) or else explored the peaks on their own. Williams was modestly successful, regarding his summers in the mountains as more of a hobby than a business. Then, in 1967, at age thirty-eight, he died in a plane crash.

The guide service soon changed hands and a new cadre of extremely talented guides arrived. Foremost among these was Don Jensen, veteran of superb Alaskan ascents. During the next few years he established, with clients and fellow guides, many fine routes, on the highest peaks as well as on "lesser" ones, such as the stunning formation known as Temple Crag. Jensen also came up with the concept of long crest traverses, the most popular of which became the Thunderbolt to Sill beat-out, done in a long day by strong climbers.

The first traverse of the central Palisades came in 1979 during a six-day epic by John Fischer and Jerry Adams. The pair began at Southfork Pass and first climbed Middle Pal, then went on to lesser but very difficult crest peaks, ending with Sill, North Pal, and Thunderbolt. They stayed on the crest the entire time, using pre-placed food and water caches. Later climbers have done amazing speed traverses.

What are the routes to do when climbing in the Palisades? This, of course, depends on your expertise. Remember that this section of the Sierra crest is a dangerous place, with loose rock, high altitudes, icy couloirs, and sudden storms. If you are inexperienced or timid, avoid this region! For those competent with ropes, crampons, and ice axes, it might well be the "acme of Sierra sublimity."

## SOURCES AND FURTHER READING

Theodore Solomons waxed eloquent about the Palisades in the June 1886 issue of *Overland Monthly*.

Joseph N. LeConte's comments about Split Mountain, Mount Sill, and North Palisade come from his articles in the 1903 and 1904 annual issues of the *Sierra Club Bulletin* (Vol. 4, No. 4, June 1903 and Vol. 5, No. 1, Jan. 1904).

Francis Farquhar's recollections about the first ascent of Middle Palisade can be found in his article in the 1922 annual issue of the *Sierra Club Bulletin* (Vol. 11, No. 3). His comment about the "finest glaciers in the range" comes from a note he wrote in the 1932 annual issue of the *Sierra Club Bulletin* (Vol. 17, No. 1).

Norman Clyde wrote many a "mountaineering note" in the back pages of the *Sierra Club Bulletin* during the 1930s and 1940s. A fascinating glimpse into Clyde's adventures can be found in *Norman Clyde of the Sierra Nevada: Rambles through the Range of Light* (1971). This book is hard to find, however. See also *Norman Clyde: Legendary Mountaineer of California's Sierra Nevada* by Robert C. Pavlik (Heyday Books, 2008).

Tom Jukes' obituary of Norman Clyde appears in the 1973 *American Alpine Journal*.

The guidebook of choice is *Climbing California's Fourteeners: The Route Guide to the Fifteen Highest Peaks* (1998), by Stephen Porcella and Cameron Burns. Seventy routes in the Palisades are described; many of these are technical climbs.

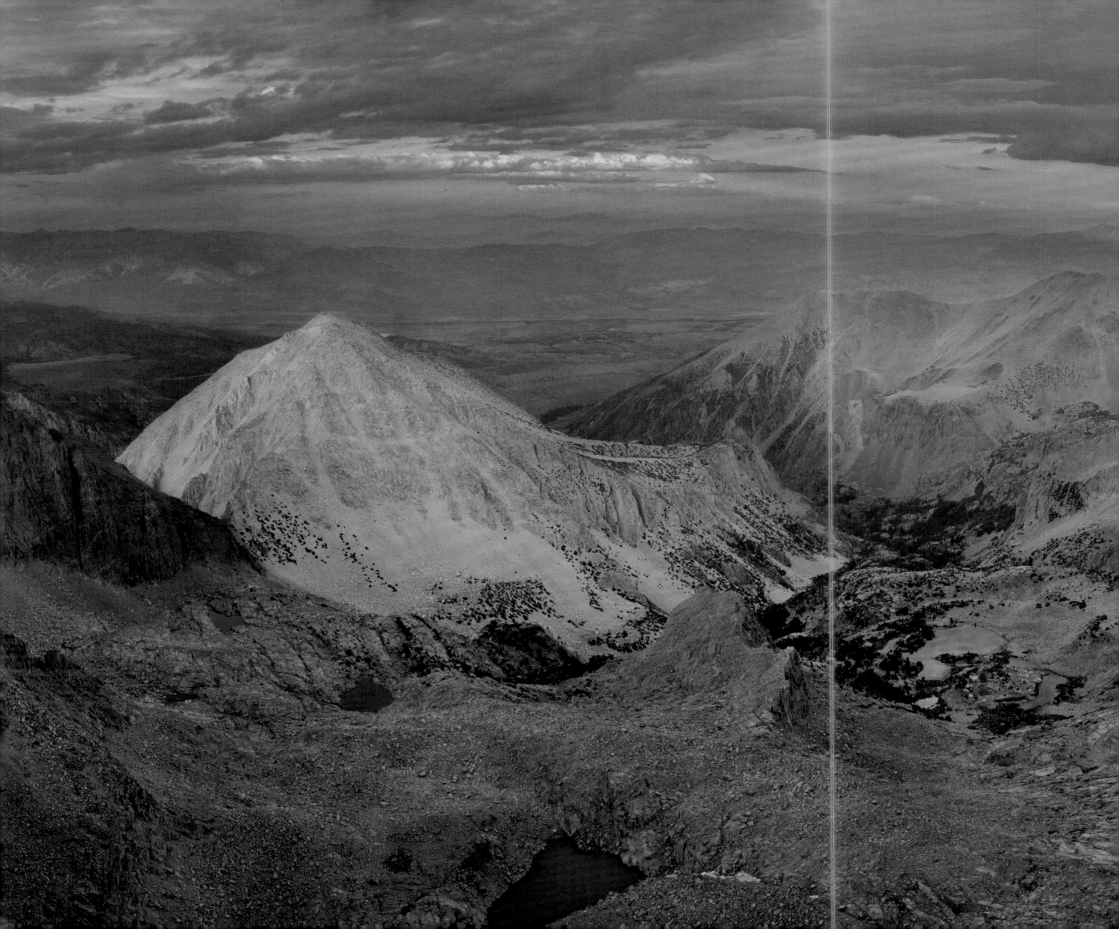

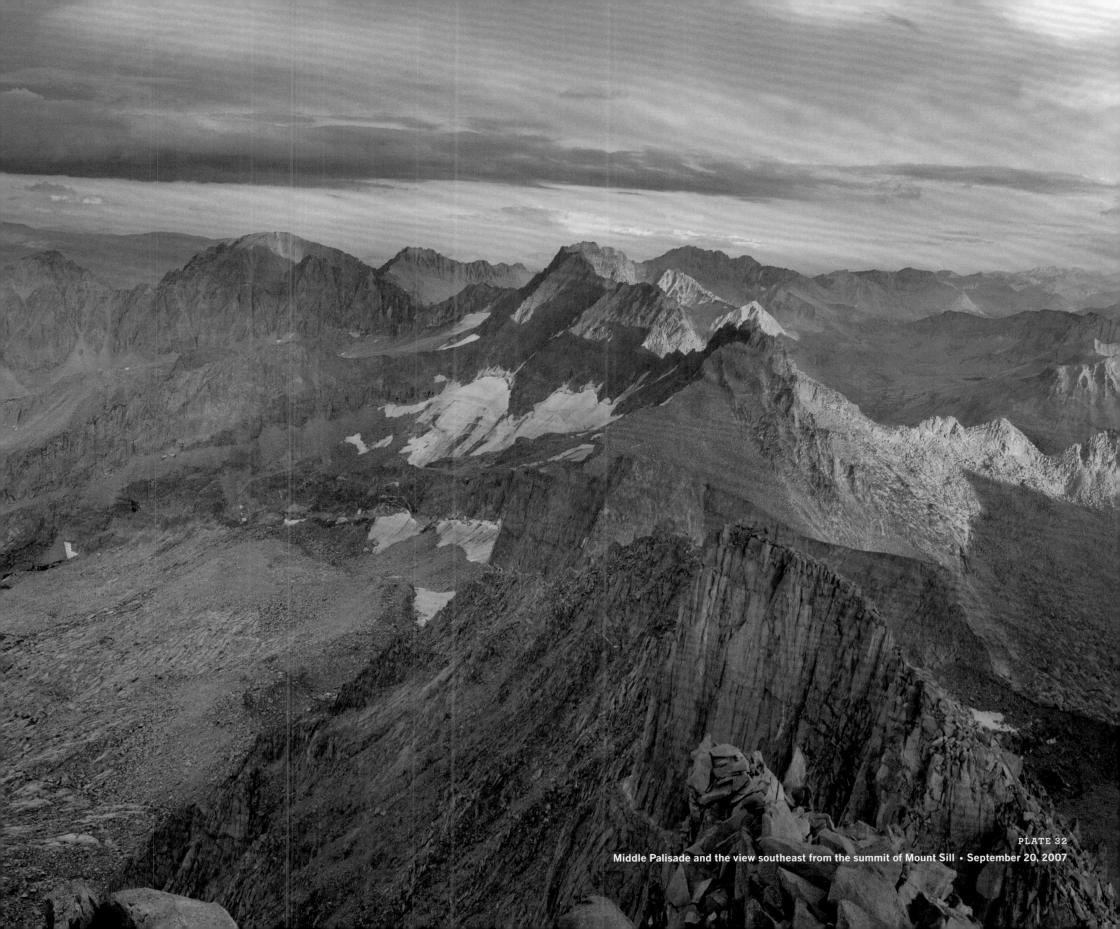

PLATE 32
Middle Palisade and the view southeast from the summit of Mount Sill · September 20, 2007

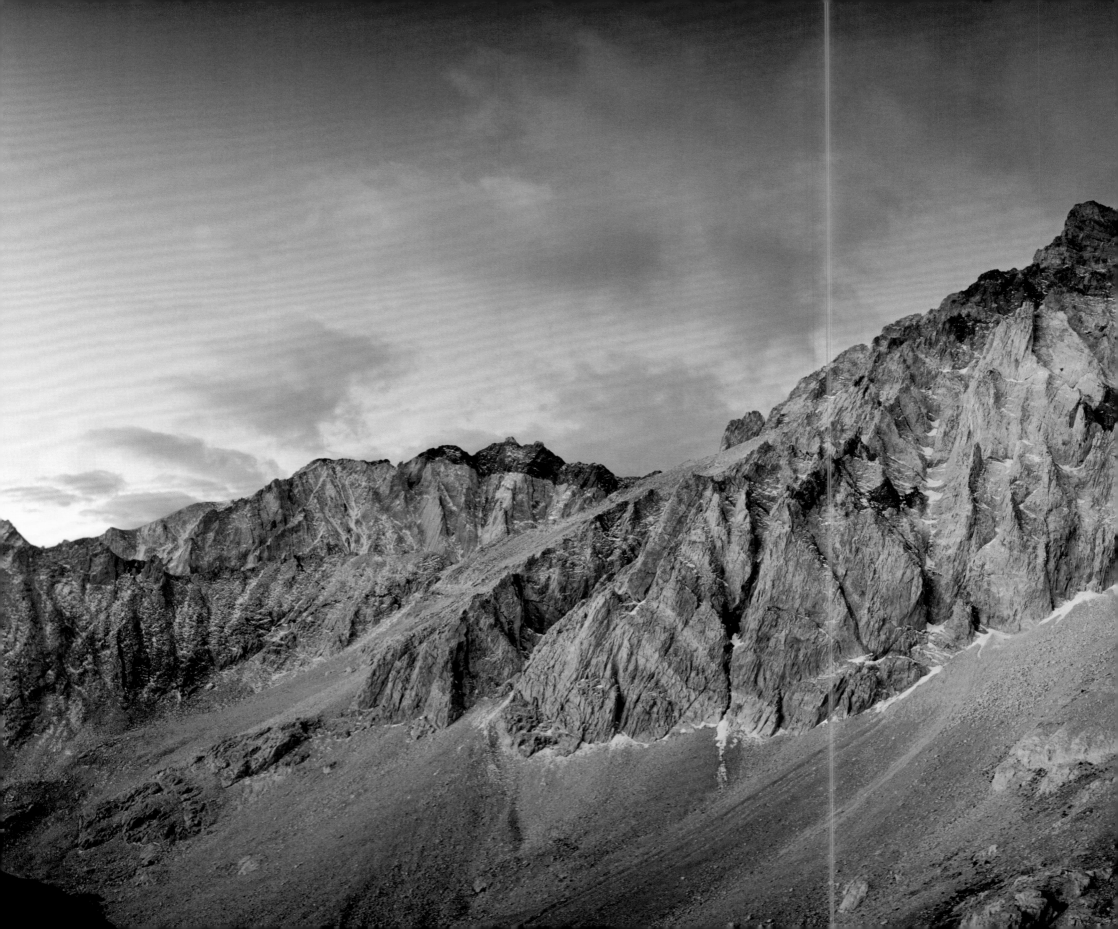

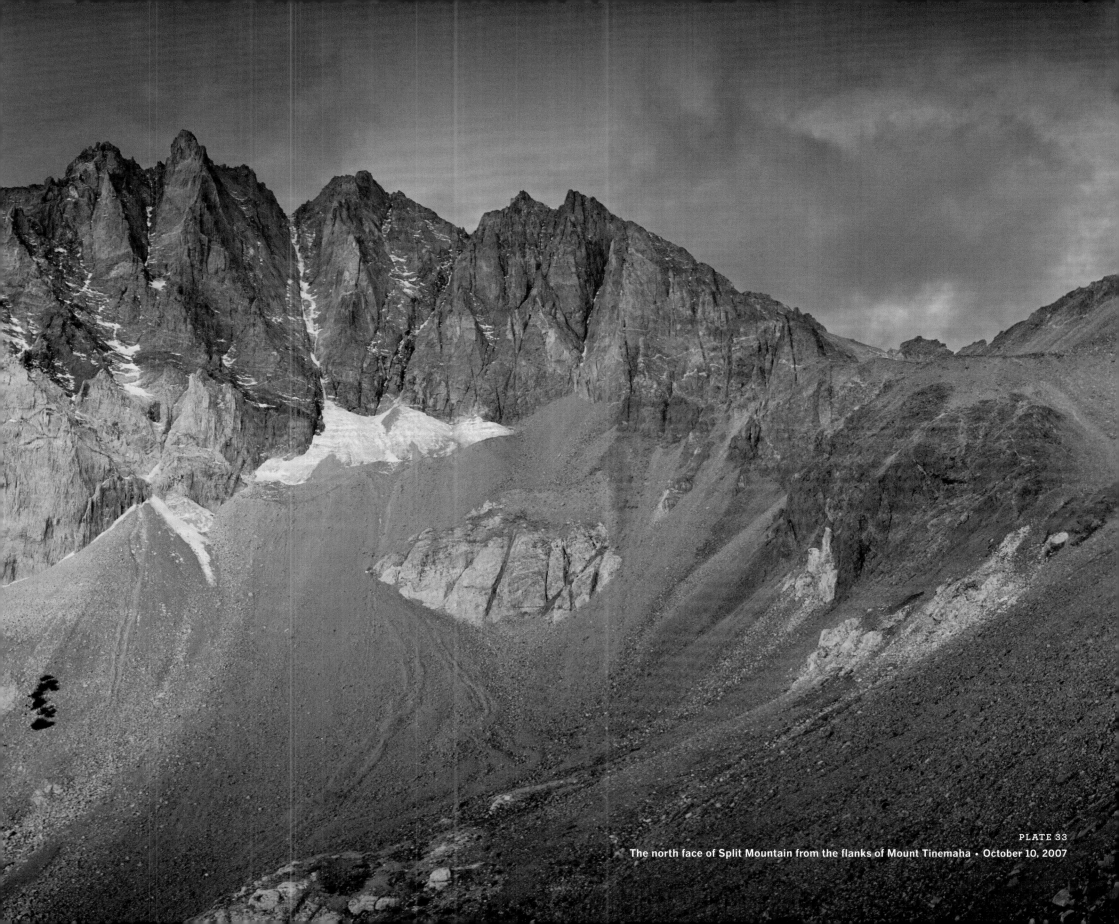

PLATE 33
The north face of Split Mountain from the flanks of Mount Tinemaha · October 10, 2007

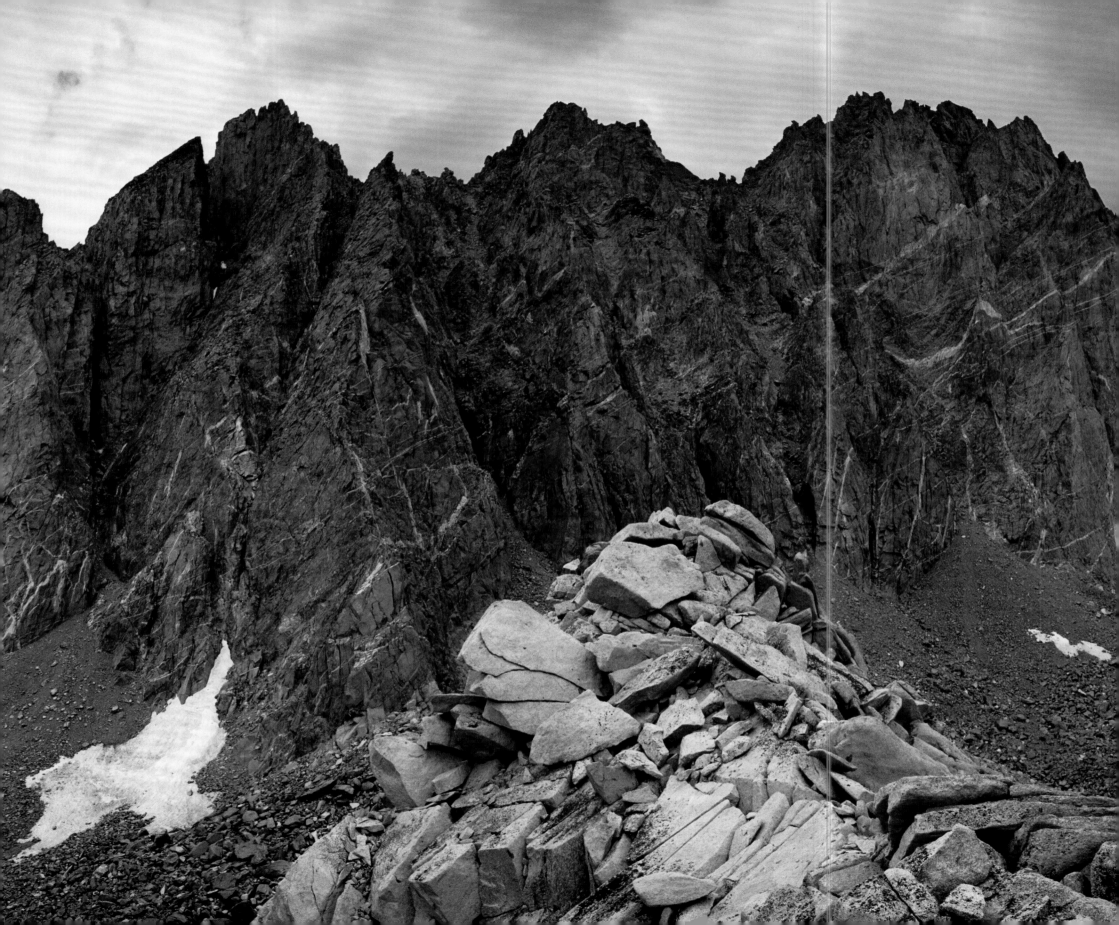

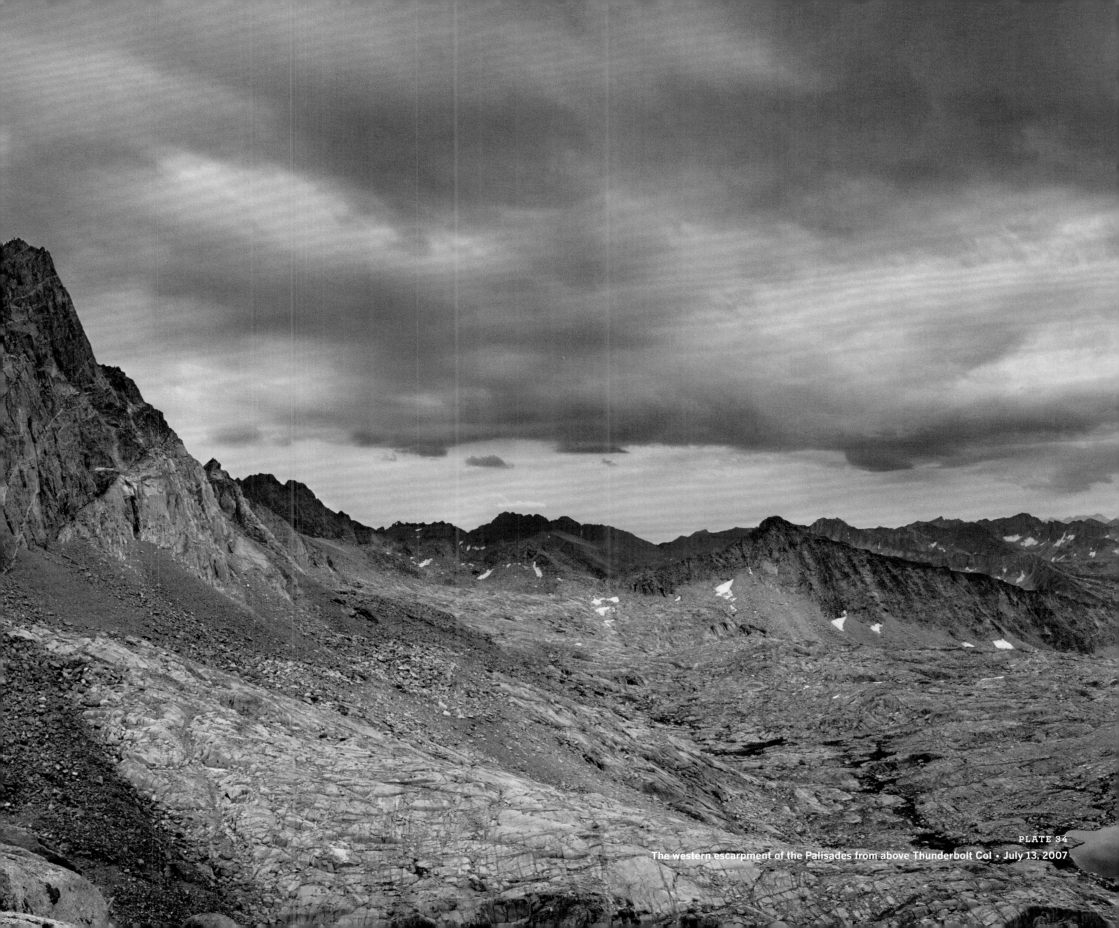

PLATE 34
The western escarpment of the Palisades from above Thunderbolt Col • July 13, 2007

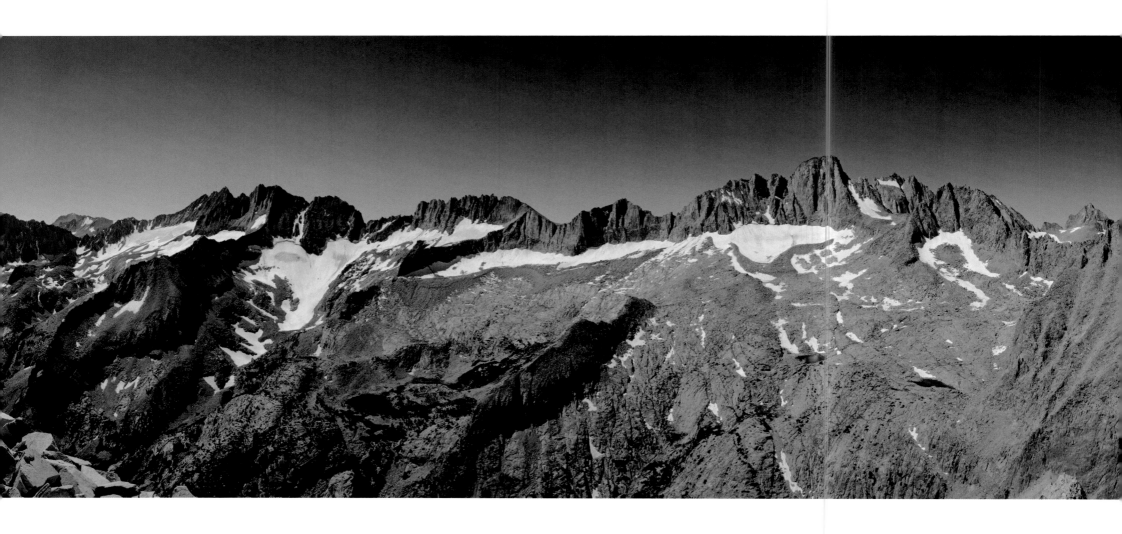

PLATE 35

The crest of the Palisades from the east • August 28, 2006

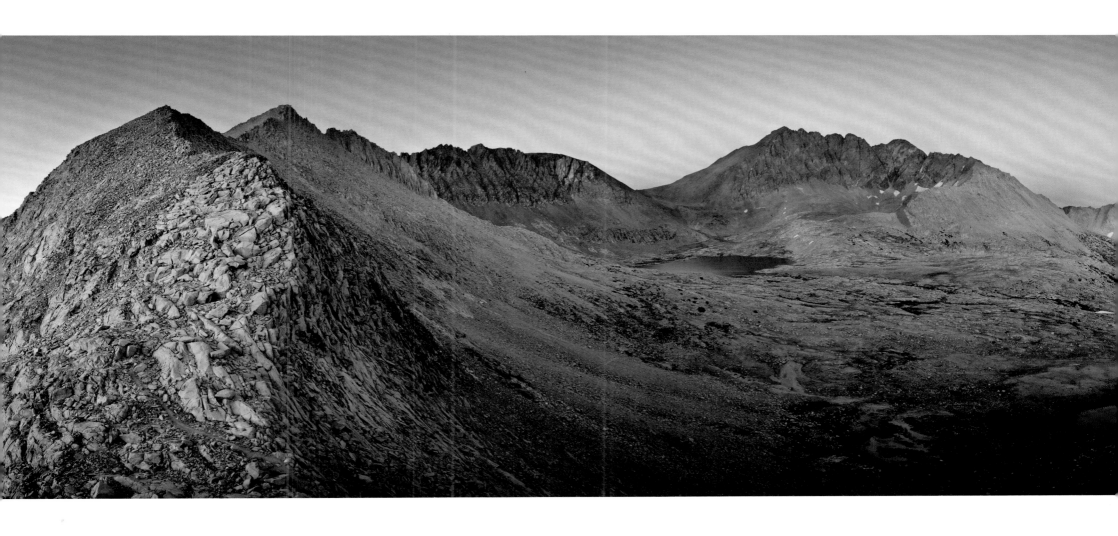

PLATE 36

Mather Pass and Split Mountain from the west • July 12, 2007

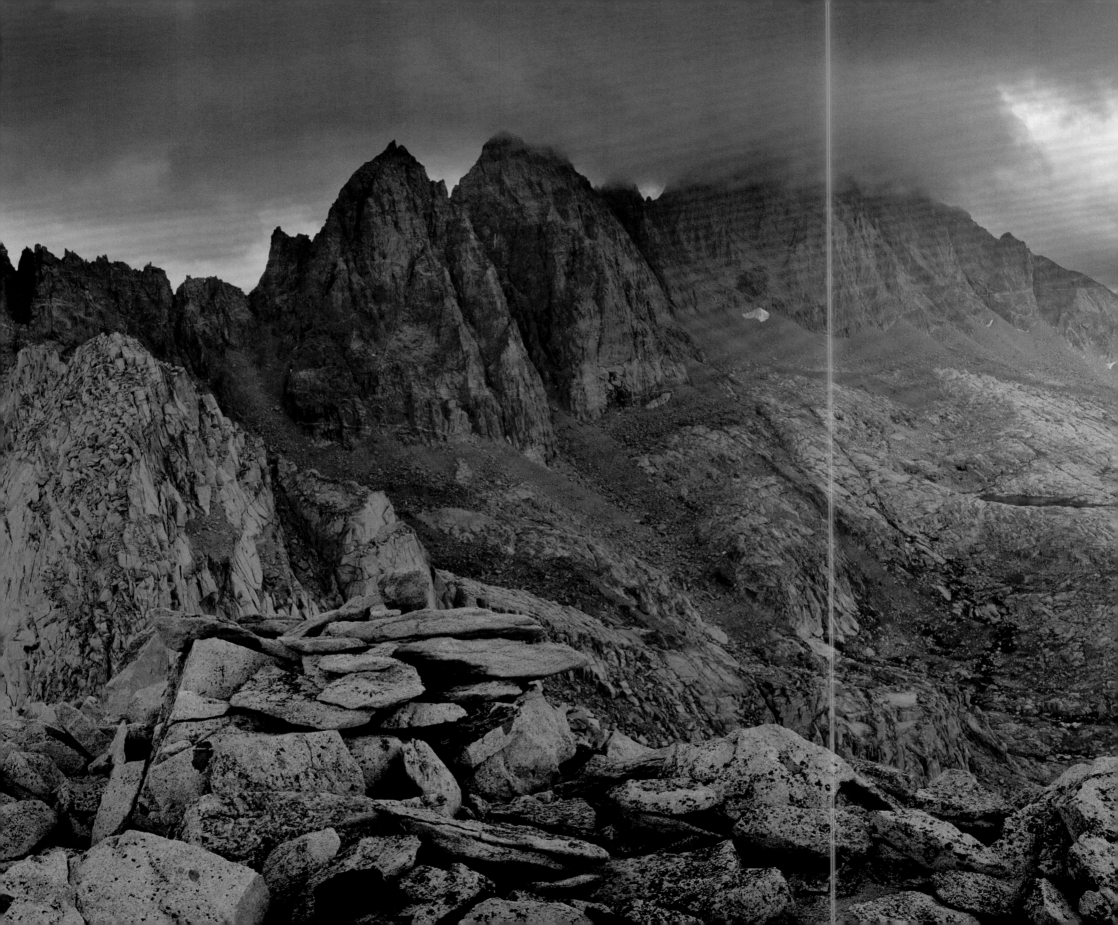

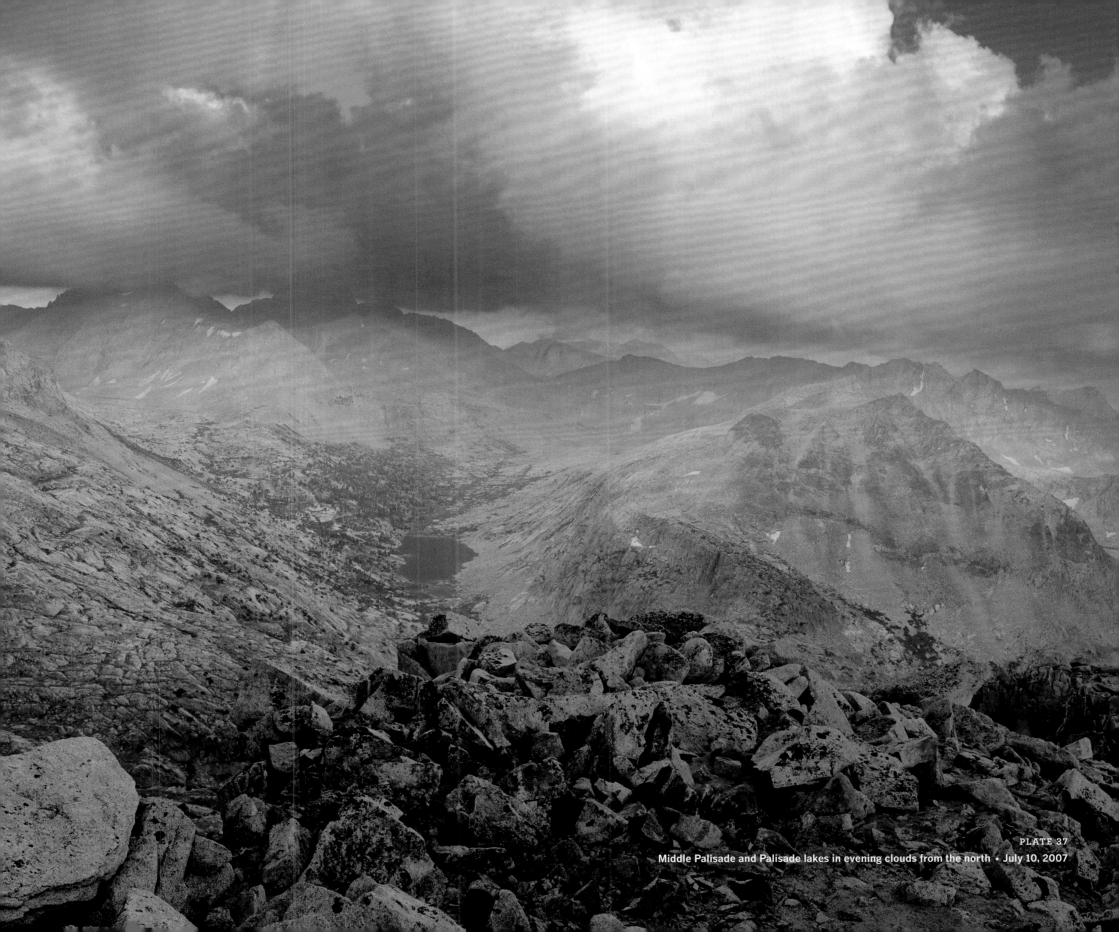

PLATE 37
Middle Palisade and Palisade lakes in evening clouds from the north · July 10, 2007

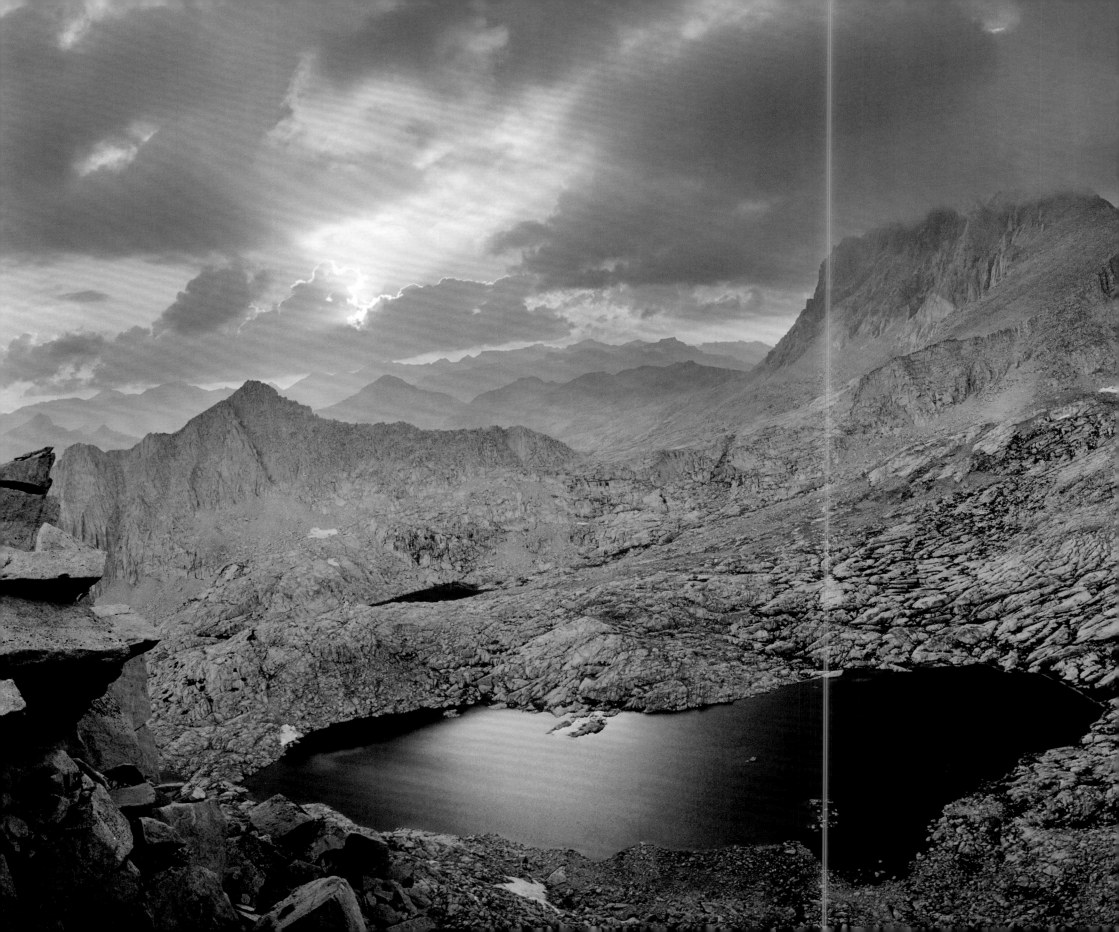

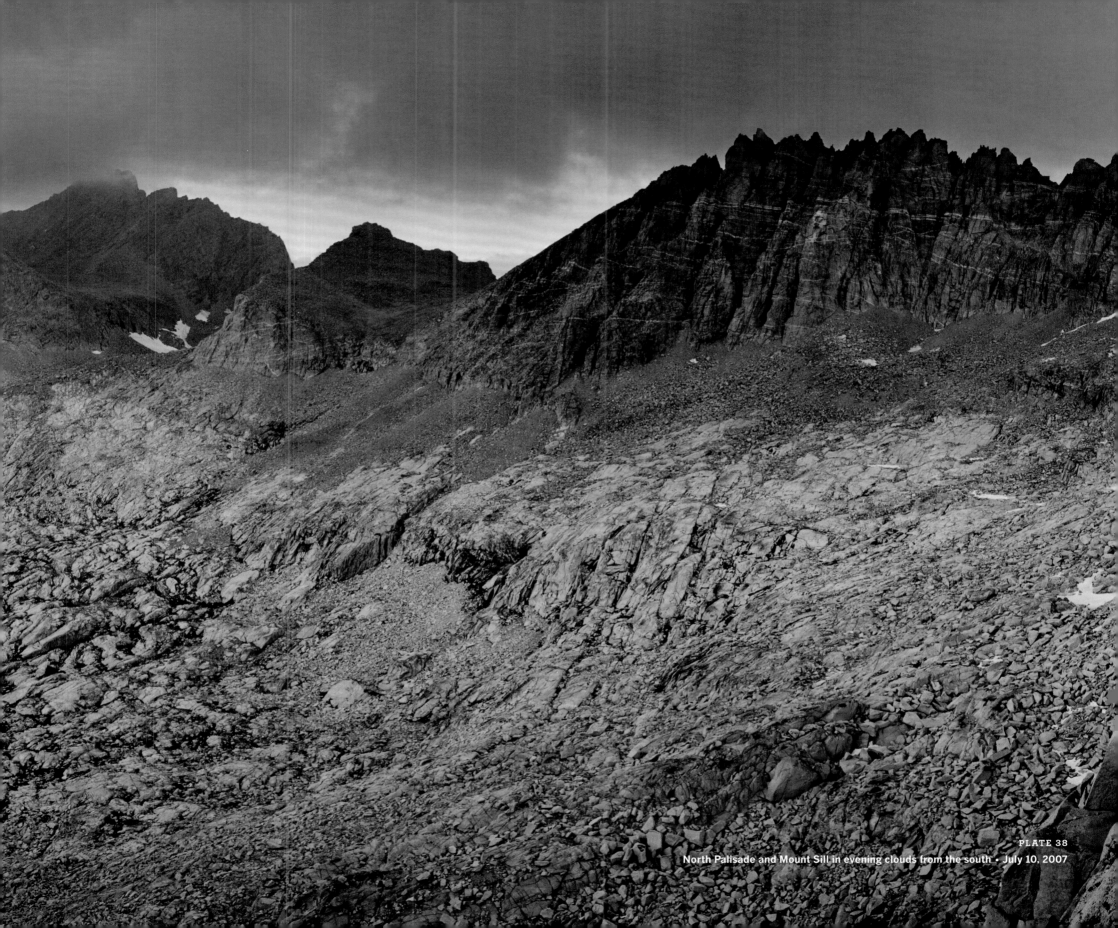

PLATE 38

North Palisade and Mount Sill in evening clouds from the south · July 10, 2007

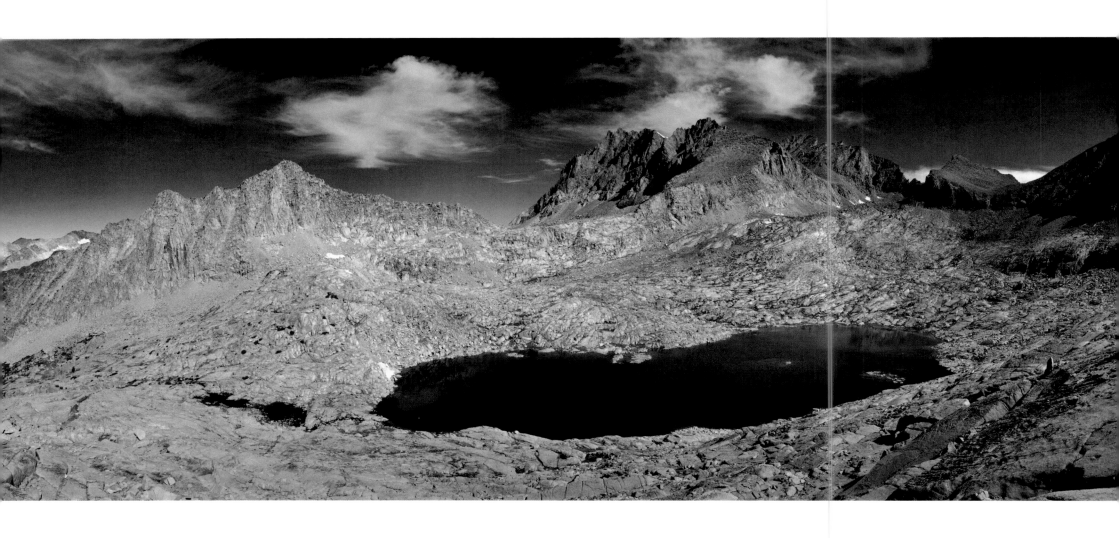

PLATE 39

**Potluck Pass and North Palisade from the south • July 11, 2007**

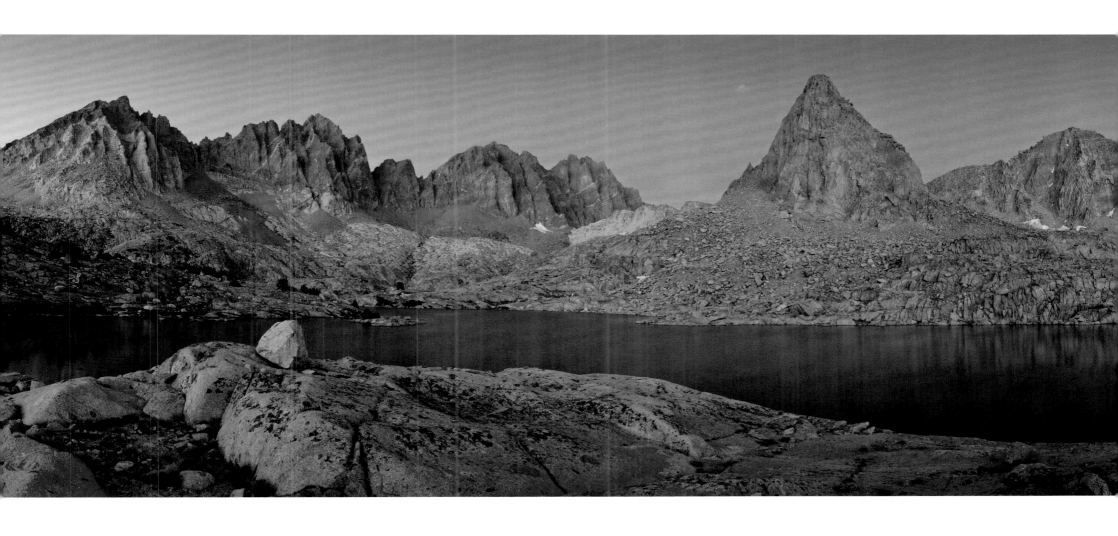

PLATE 40

Isosceles Peak and the Palisades from the Dusy Basin • July 9, 2007

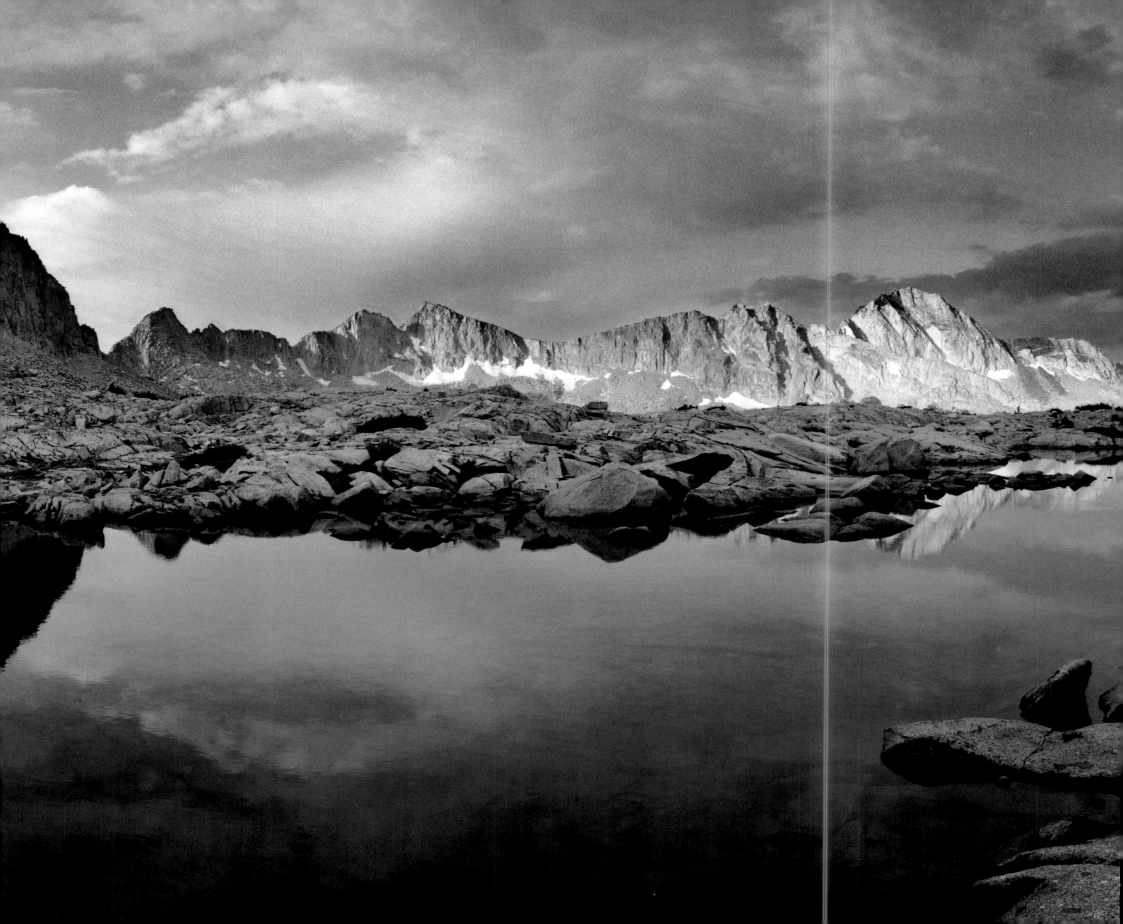

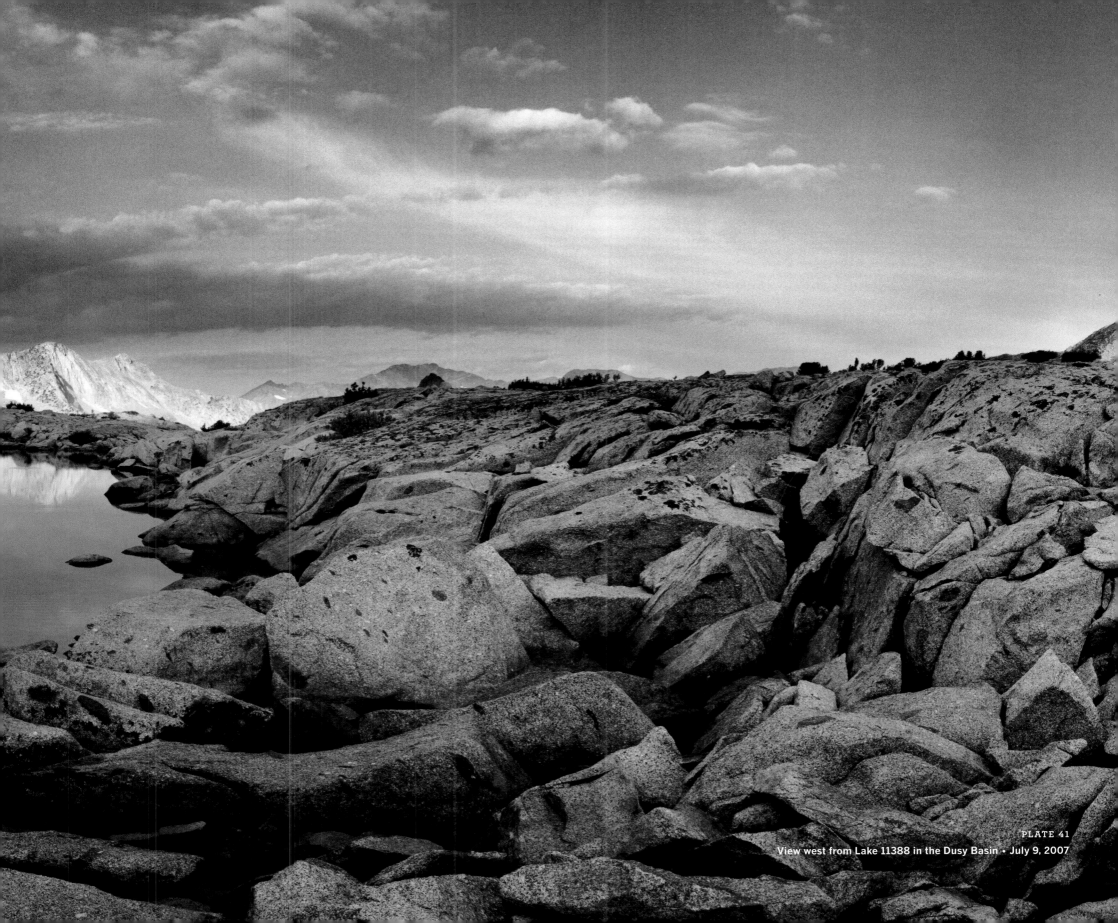

PLATE 41

View west from Lake 11388 in the Dusy Basin · July 9, 2007

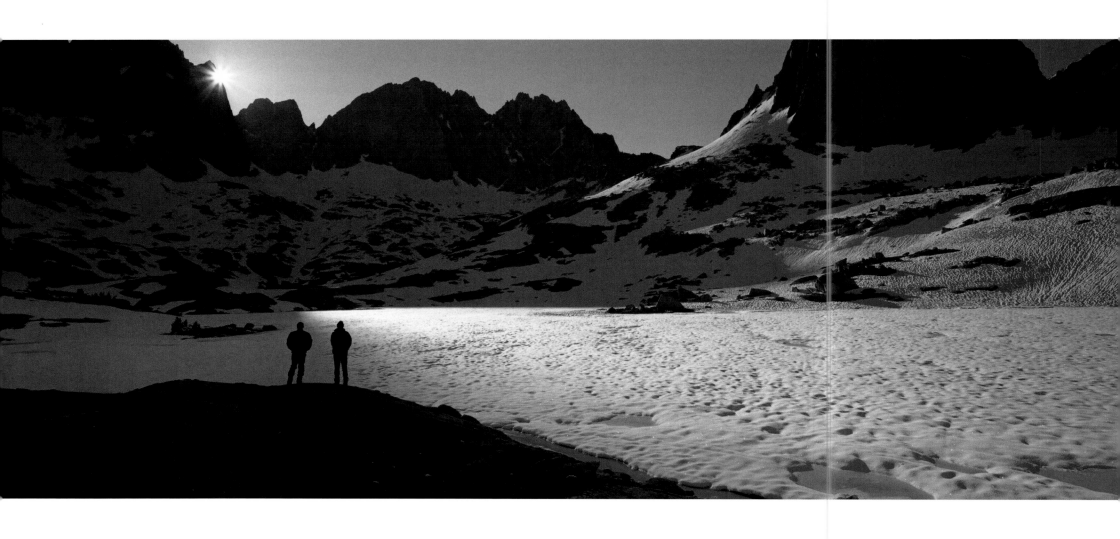

PLATE 42
**Sunrise over the Palisades • June 26, 2005**

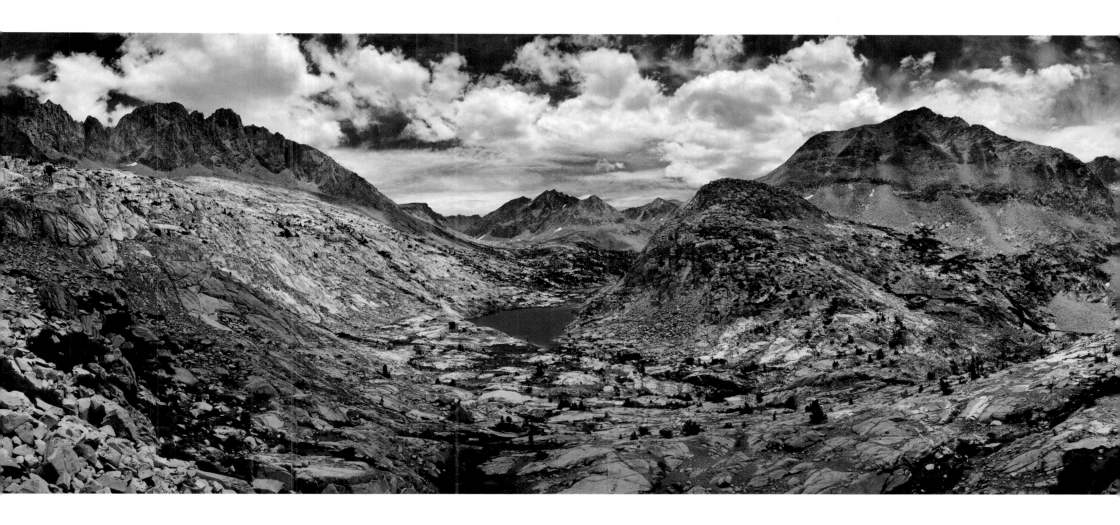

PLATE 43

Middle Palisade and Palisade lakes from the west • July 13, 2007

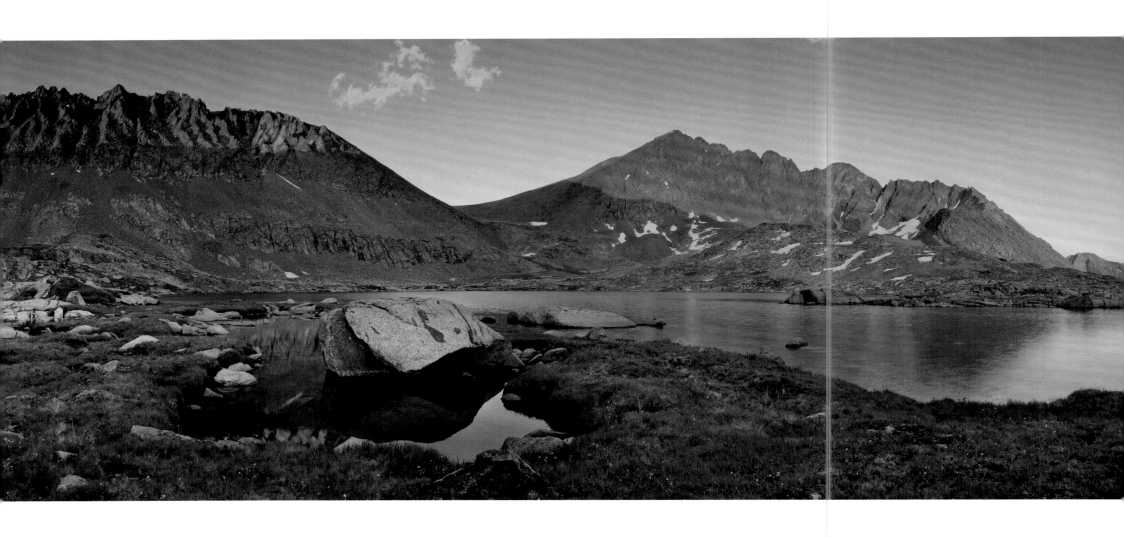

PLATE 44

**Split Mountain from the west** • July 20, 2004

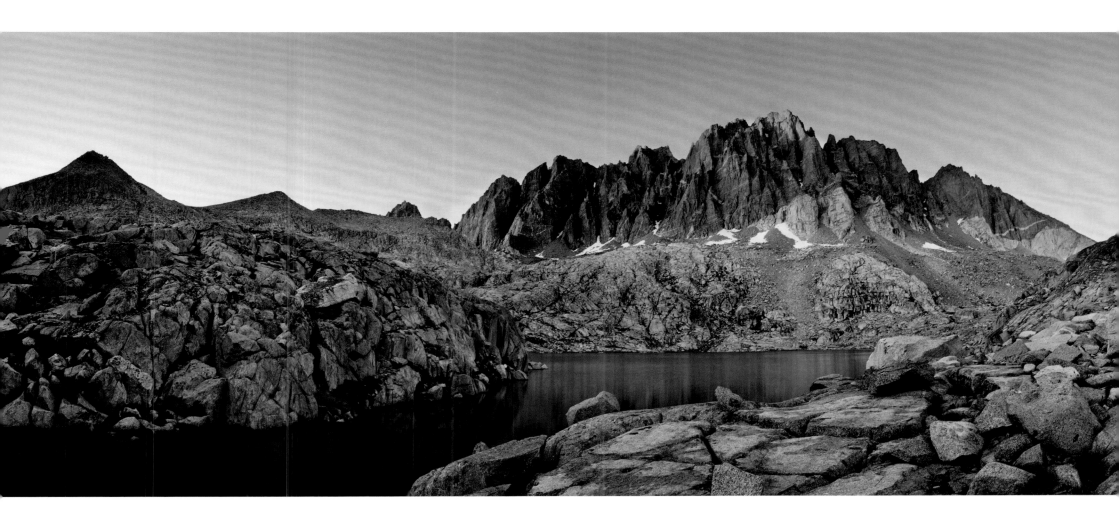

PLATE 45
North Palisade and Barrett Lake in the Palisade Basin • July 20, 2004

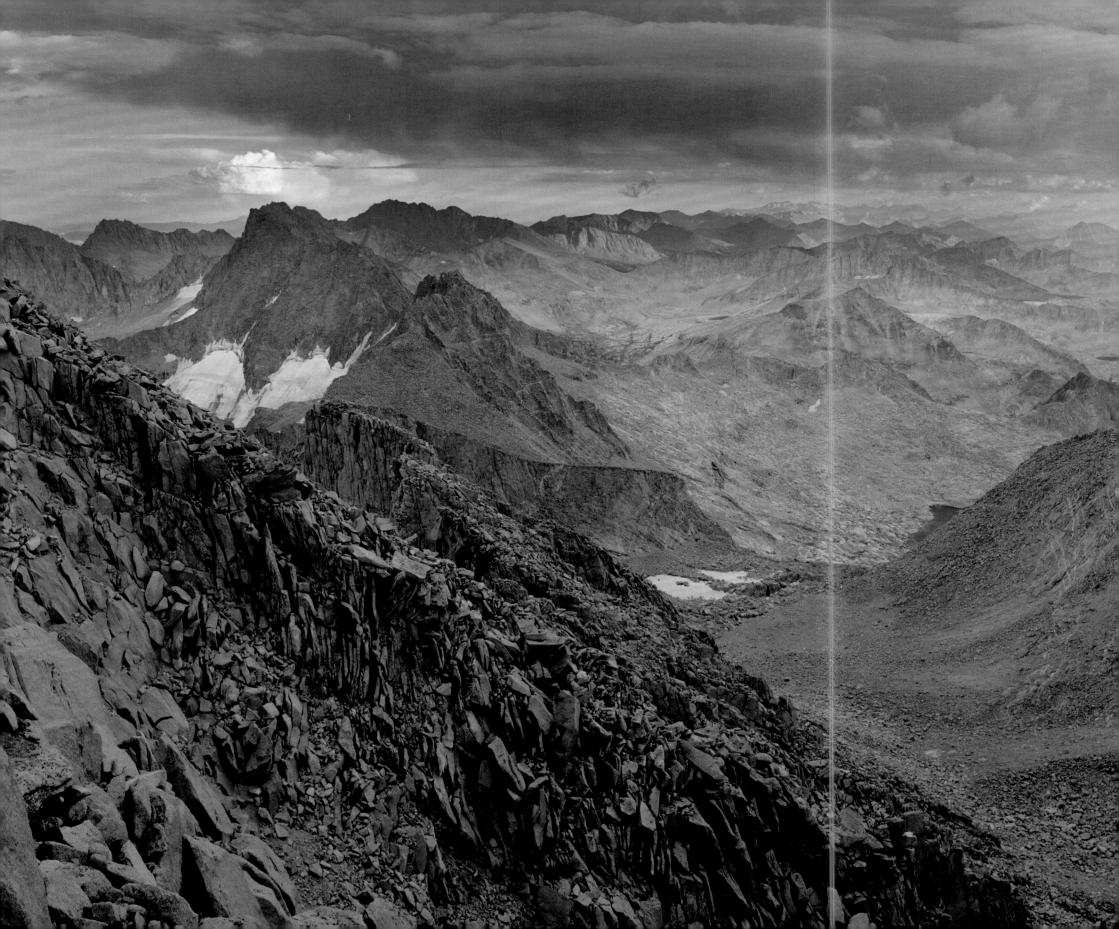

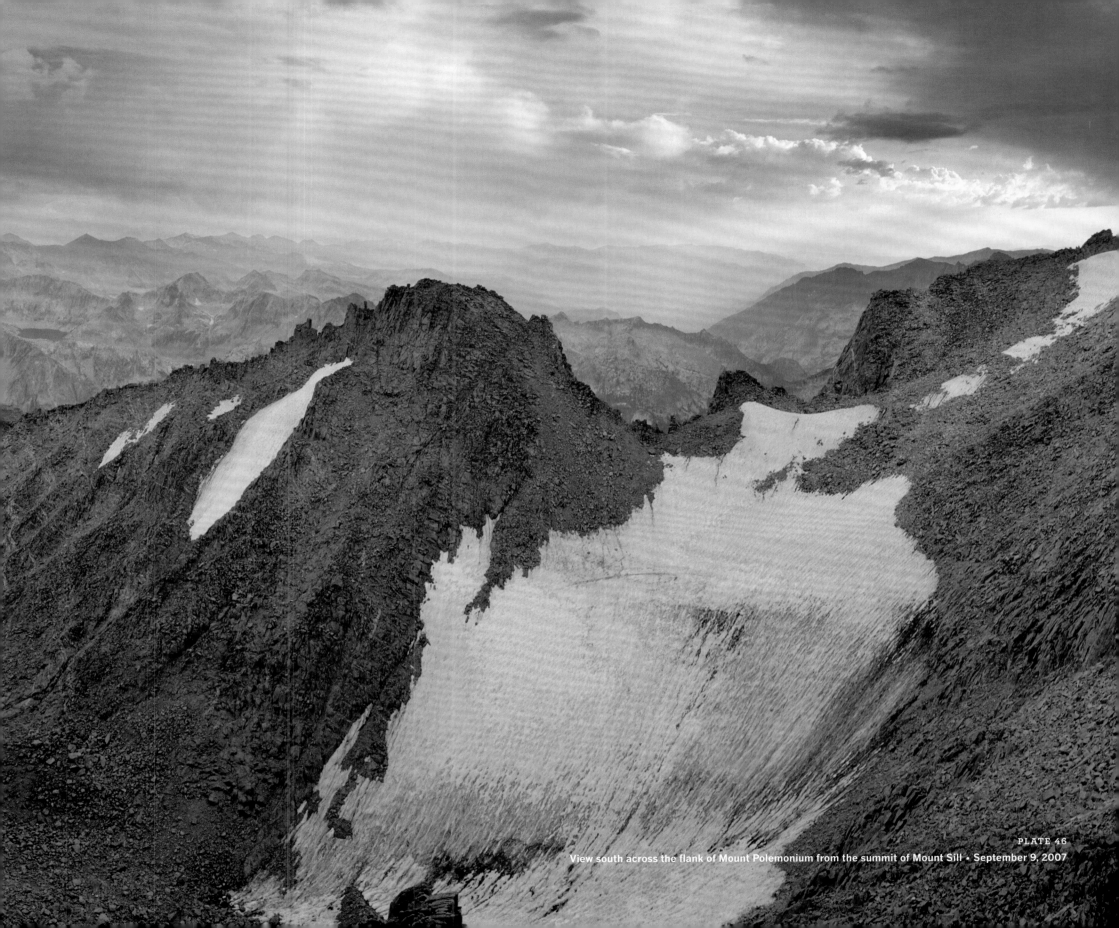

PLATE 46

View south across the flank of Mount Polemonium from the summit of Mount Sill · September 9, 2007

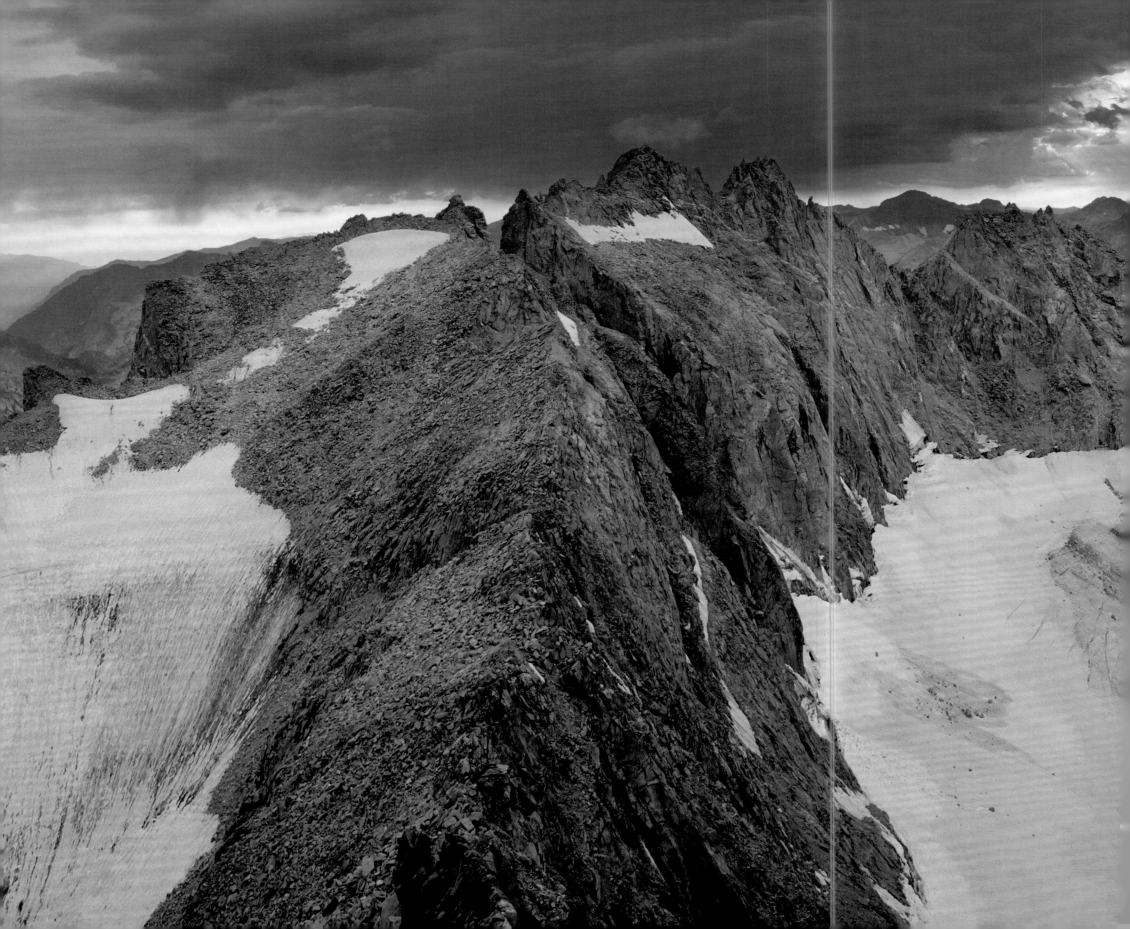

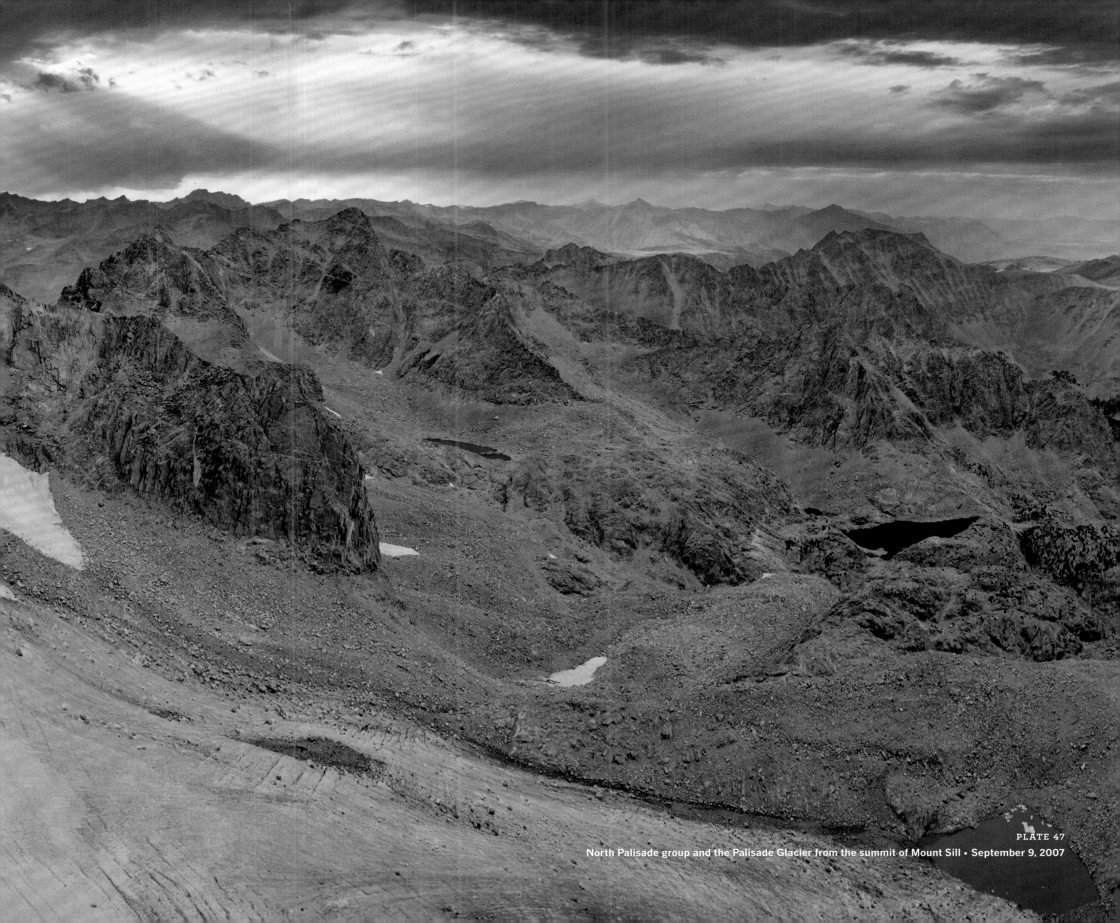

North Palisade group and the Palisade Glacier from the summit of Mount Sill • September 9, 2007

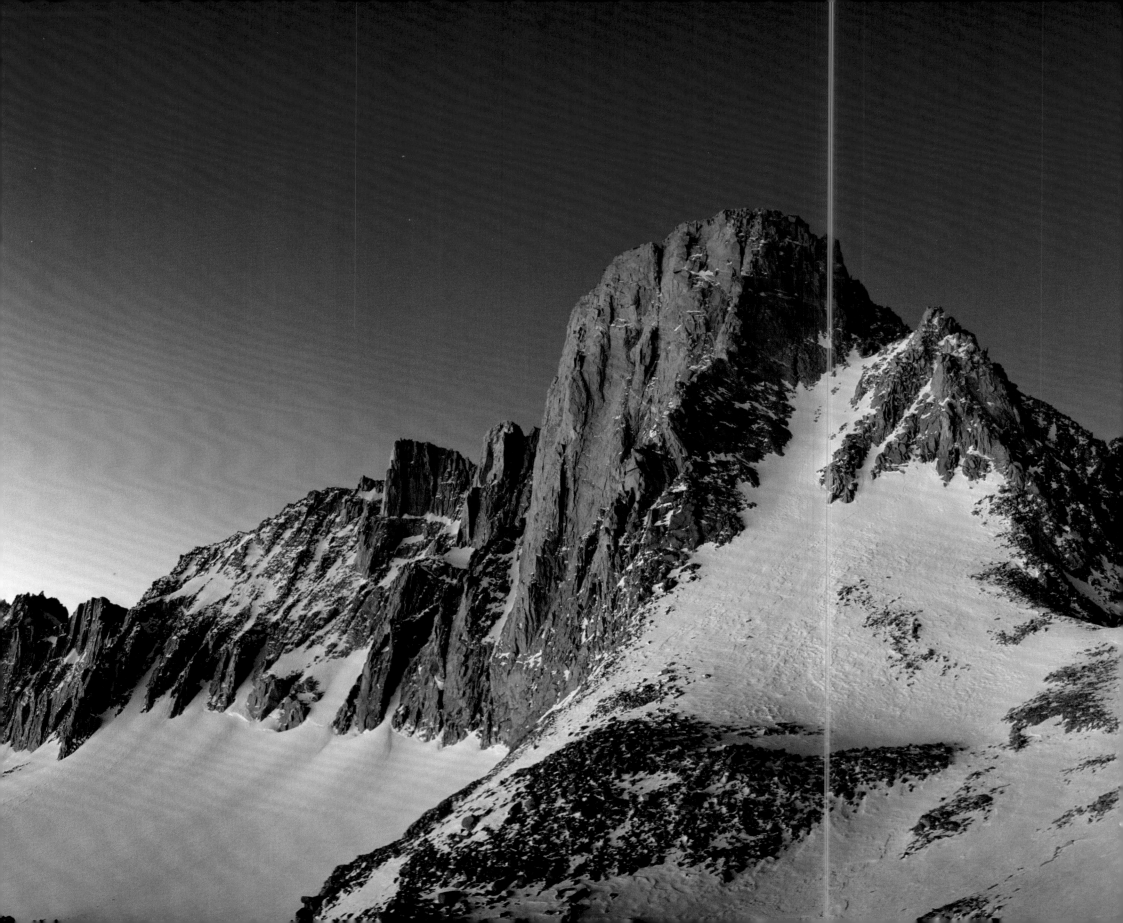

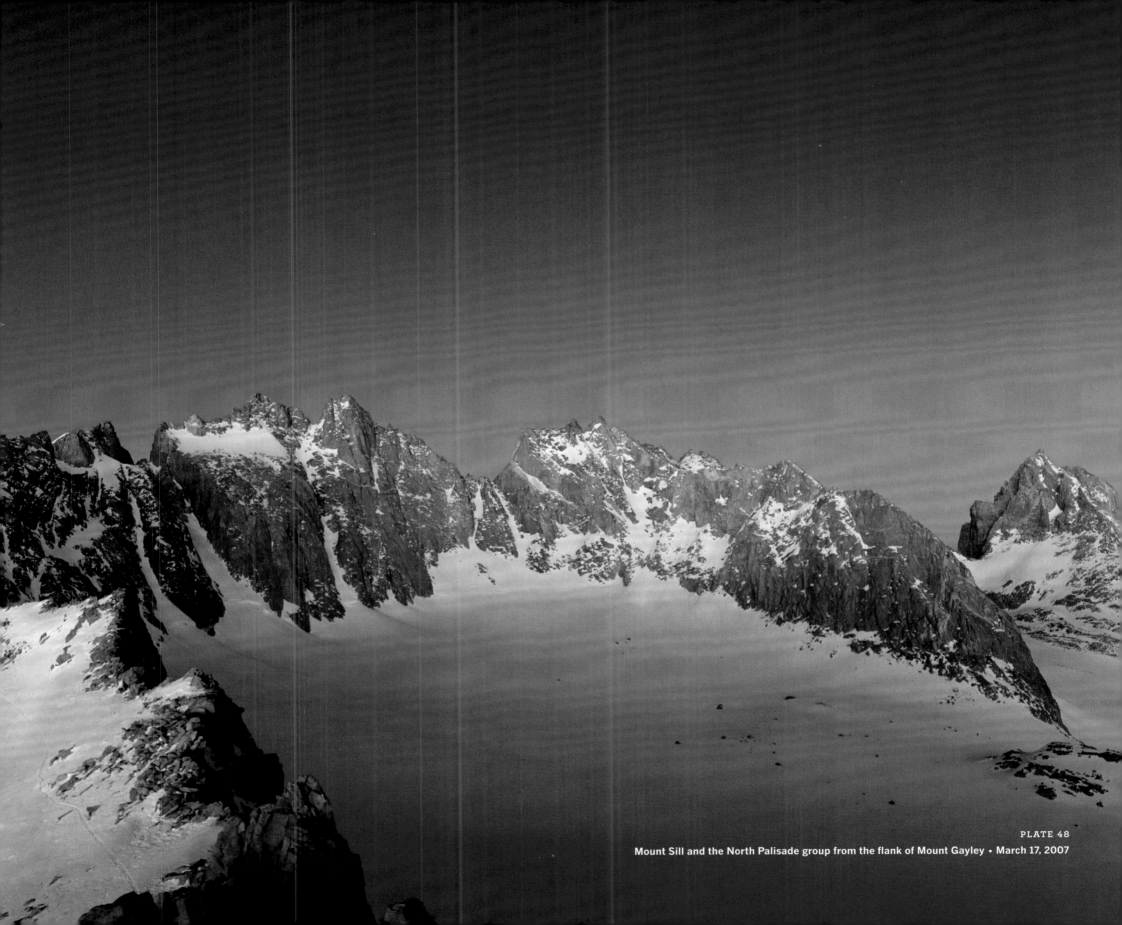

PLATE 48

Mount Sill and the North Palisade group from the flank of Mount Gayley • March 17, 2007

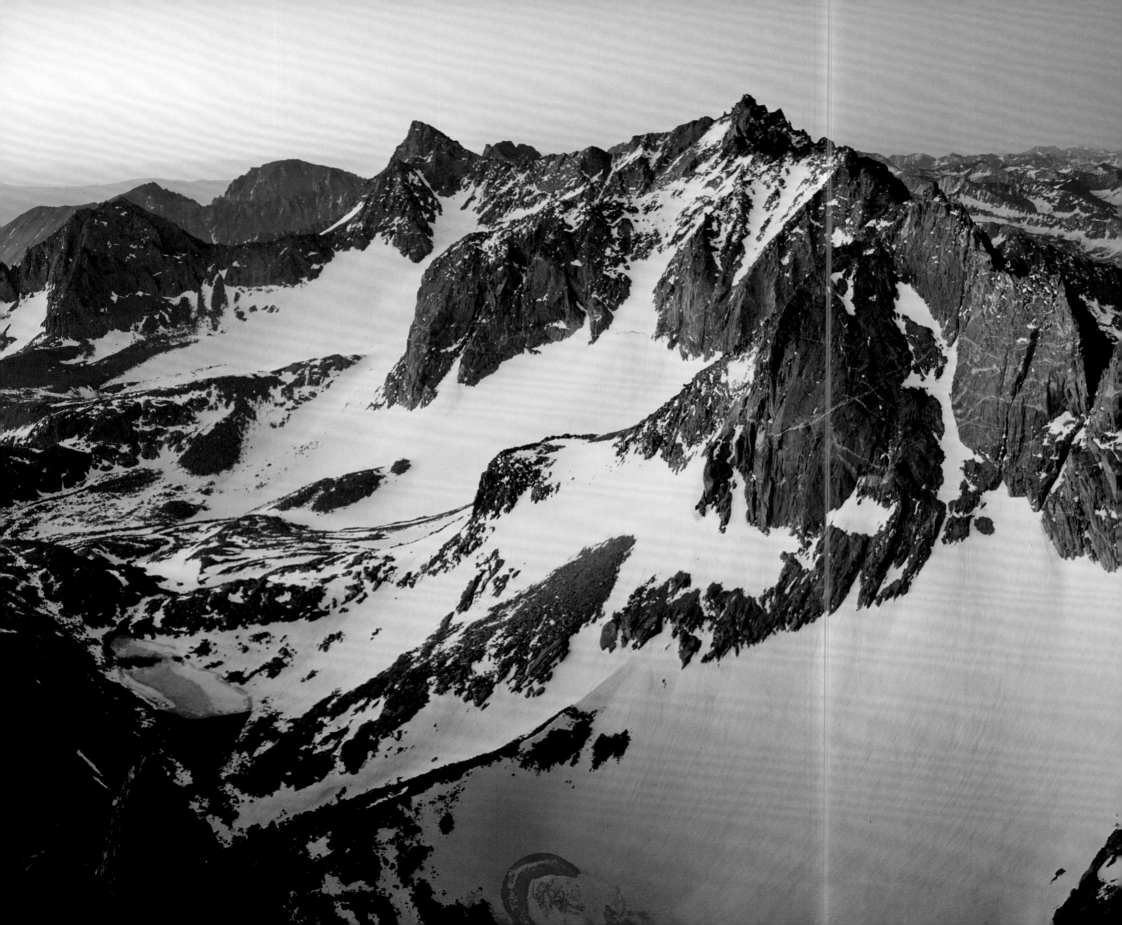

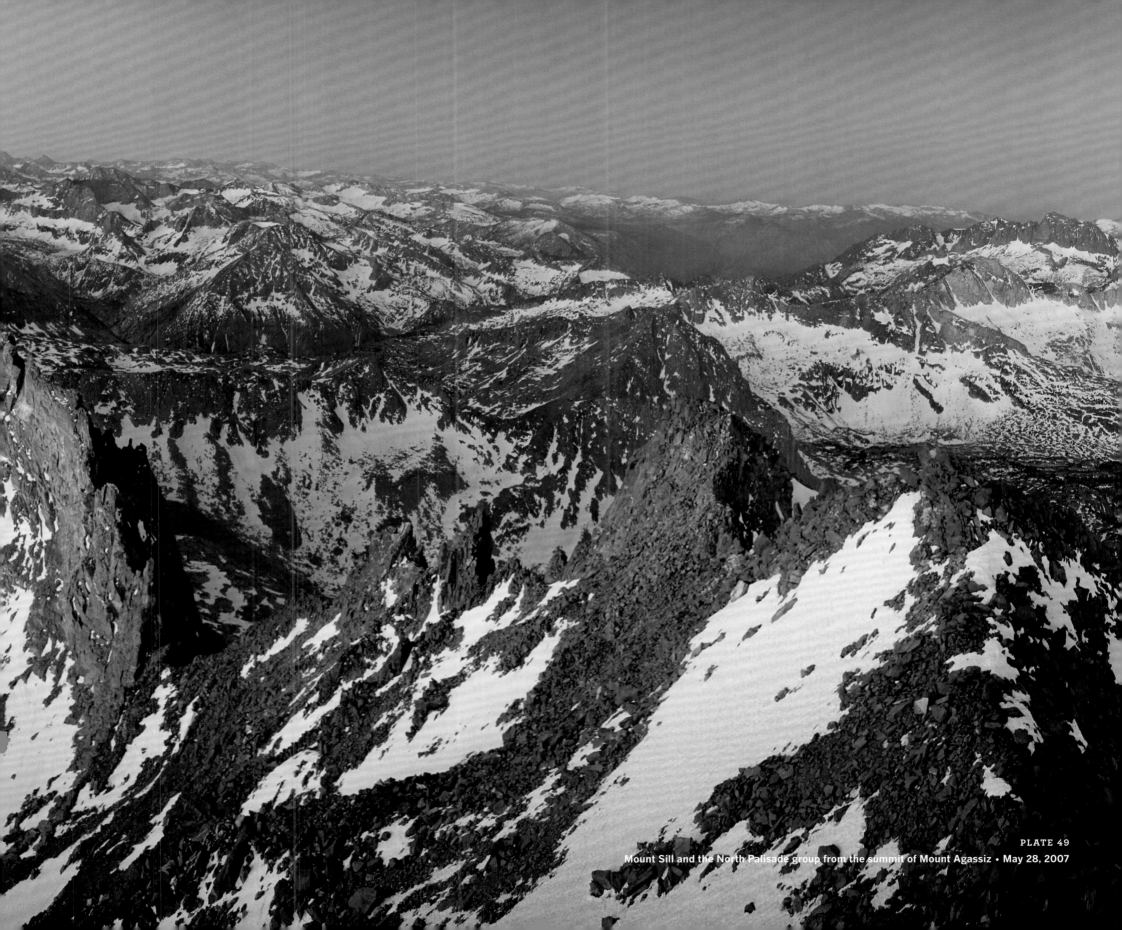

PLATE 49
Mount Sill and the North Palisade group from the summit of Mount Agassiz • May 28, 2007

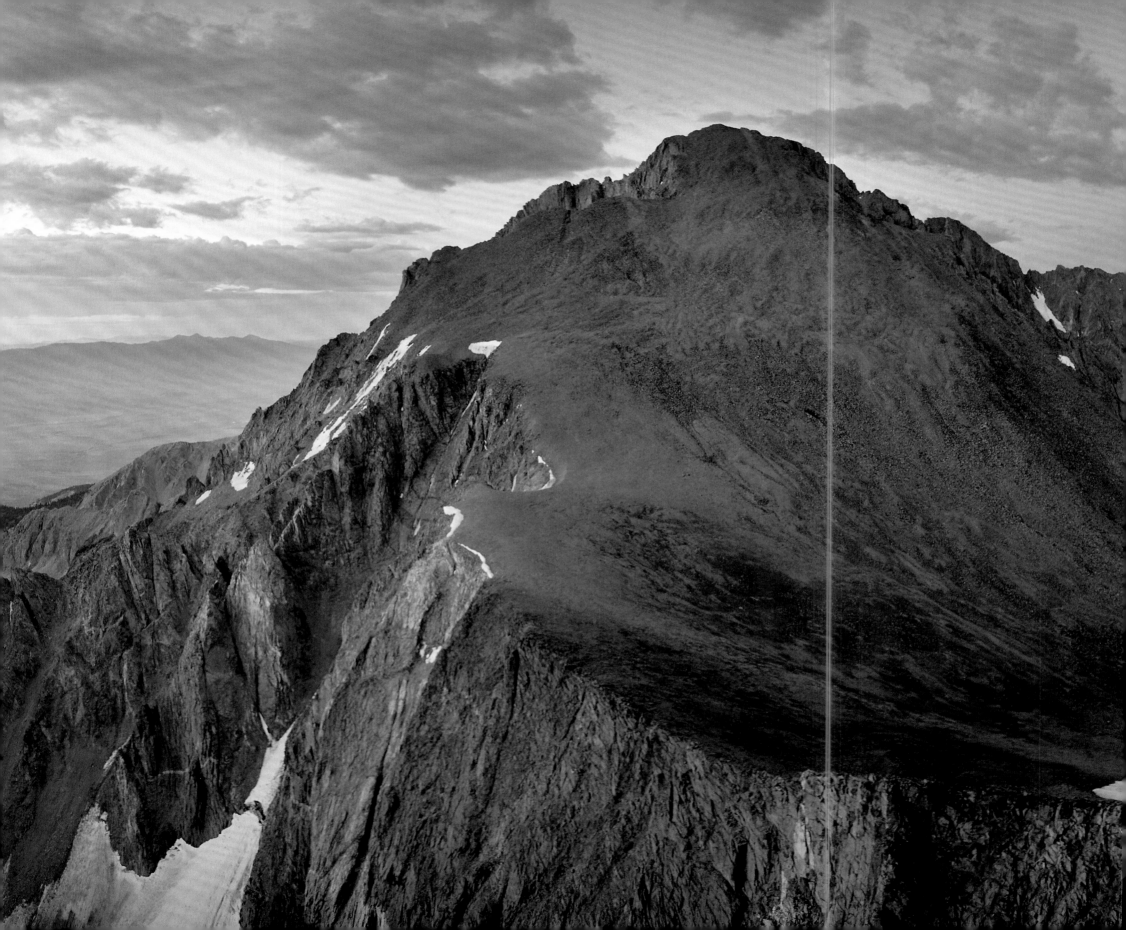

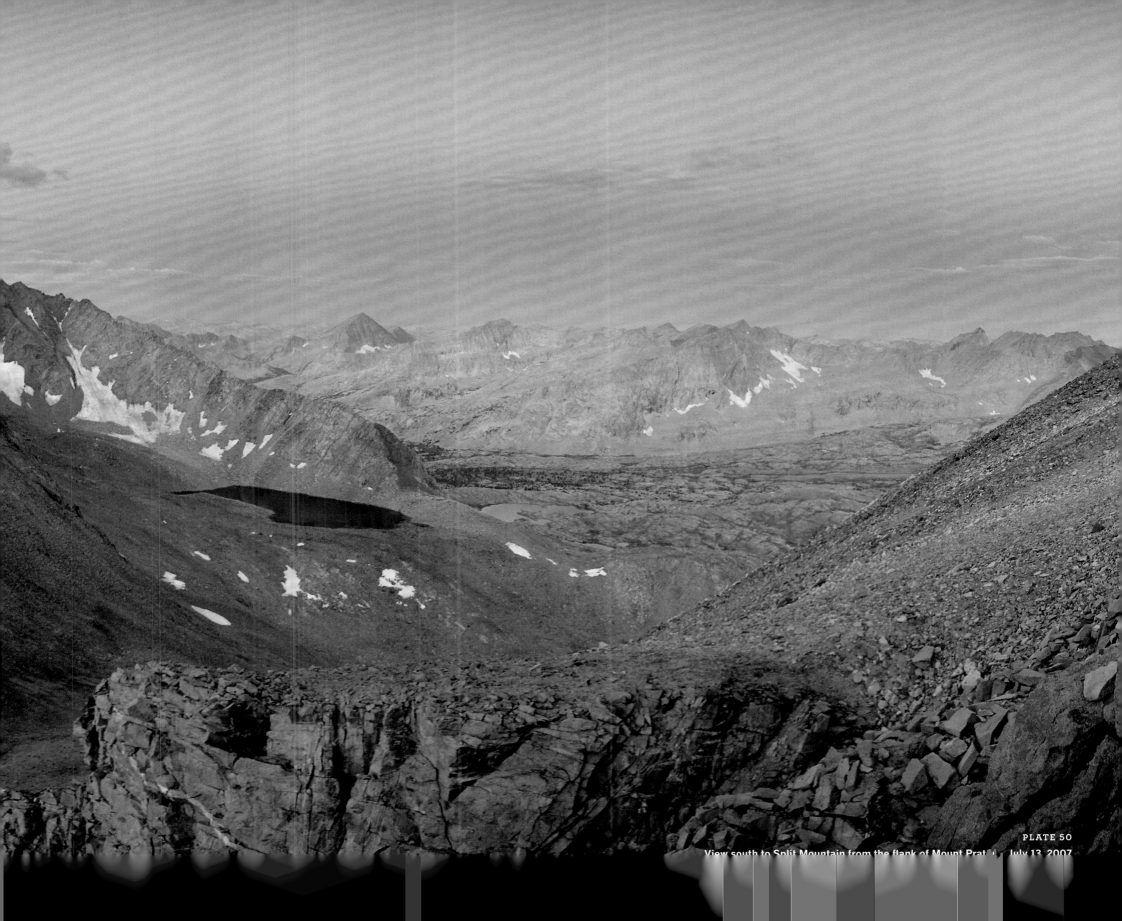

PLATE 50

View south to Split Mountain from the flank of Mount Prater, July 13, 2007

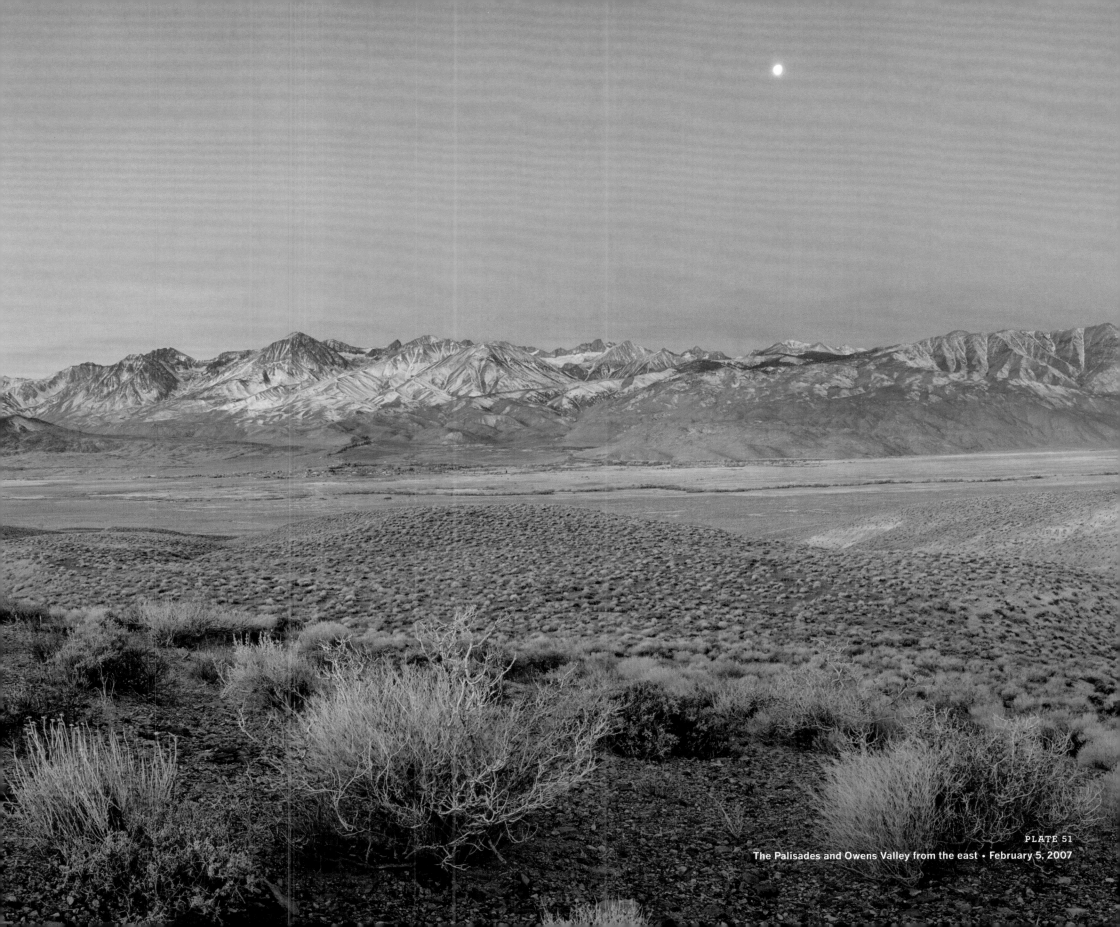

PLATE 51
The Palisades and Owens Valley from the east • February 5, 2007

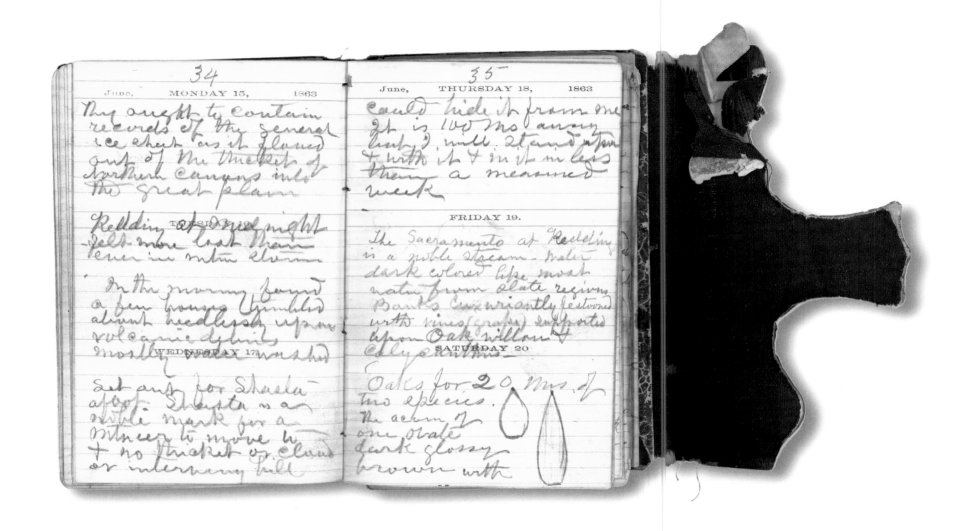

# SHASTA

Forty years ago, in the second issue of the Sierra Club journal *Ascent*, a brash youth wrote the following in a guide to northern California's dominant mountain: "At times, Shasta is the ugliest mountain imaginable. Climbers usually see the peak at its worst—in August, from U.S. Highway 99. None of the...glaciers are visible; in fact, little snow is present at all, and one thinks, 'Now there's a crud heap if I ever saw one.' True enough, in August, from Highway 99."

That paragraph has often been quoted to show that the author was a blithering fool. Now I get a chance to respond, for I wrote those controversial words. But my critics never revealed the next sentence: "There are other months, though, and other highways." I had gone on to extol the beauty of the mountain in the autumn, from other directions, where "bare ice glistens in the morning sunlight." So I still stand by my impressions of 1968: Shasta in August, as seen from the major western highway (now known as Interstate 5), is hardly a noble mountain. It certainly isn't Mount Rainier, splendid all year, from any direction. But Shasta, seen in winter and spring, or in summer from the north or east, is a marvelous peak—and one not to be taken lightly if you intend to climb it from any direction. I found this out on my first attempt, in July 1954, on the "crud heap" side of the peak, when hideous winds forced us to our knees at 13,500 feet. We turned tail, our bodies tilted at absurd angles into the cyclone. During the next fifteen years I managed, in far better conditions, to reach the summit four times. Shamefully, all these ascents took place on the standard route, not the more challenging ones.

~~~~~~~~~~

At 14,162 feet, Shasta is the highest peak in the long skein of Sierra/Cascade mountains between the Sierra's Thunderbolt Peak and Washington's Mount Rainier, a distance of 670 miles. The volcano rises far, far above its neighbors and, dormant for now, itches to explode. Faint fumaroles only 150 feet below the summit loft sulfuric gases upward, the breath of a sleeping dragon patiently awaiting the big show.

Seven glaciers blanket the peak (all sides except the west), but these are rather meek compared to the tortuous ice ribbons on the Cascade peaks farther north. All, by definition, sport bergschrunds by midseason, but these rarely cause problems for climbers. Only the Whitney Glacier, on the north side, offers major crevasses and tame icefalls. This ice stream, originating near the saddle between Shasta and its 12,330-foot western satellite, Shastina, drops 4,000 feet in some two miles before fading into complex moraines.

Indians lived below the mountain for centuries, long before its "official" discovery. They undoubtedly knew the mountain's secrets (caves, springs, natural shelters, game paths, edible plants), and it doesn't take much imagination to envision native lads standing many a time on the summit, little knowing what disruptive times were to come.

Beginning in 1817, nonnative explorers passed by the peak, wrote about it, and bestowed an array of names: Jess María, Mount Sastise, Shasty, Wai-i-ka,

Shaste, Shastl, Tsashtl, and Shasta Butte. For a brief moment the origin of the present name was thought to come from the French word *chaste,* meaning "pure." By the 1860s locals were calling the peak by its present name, undoubtedly corrupted from some ancient Indian word. Most of the natives who might have told of such names were gone, killed or dead of smallpox. A sad American story.

The first recorded ascent of this massive volcano (some twenty-seven square miles lie above timberline) was made in 1854, and local adventurers soon followed. One of these was the soon-to-be-well-known poet Joaquin Miller, who around 1858, at age sixteen, was hired to guide several missionaries who wished to deposit religious tracts upon the very summit. "I led and fed and watered and groomed their horses. I watched while they slept, spread their blankets beneath the trees on the dry soil, folded and packed them, headed the gorges, shunned the chaparral and bore on my own shoulders all the toils, and took on my own breast all the dangers of the day. I found them the most selfish, sour, and ungrateful wretches on earth. But I led them to the summit—two of them only—panting, blowing, groaning at every step."

In *Unwritten History: Life amongst the Modocs,* published in 1873, Miller reported his payment: prayers and printed sermons. Nineteen years later, in a new edition, he quietly eliminated this particular story, saying (in the book's preface) that he "had cut off all…fictitious growth, and confined its leaves to the cold, frozen truth." Many libraries catalog his book under "fiction."

In 1862 members of the California Geological Survey climbed to the top, making the first official reconnaissance of the peak. William Brewer, leader of this small expedition, said later: "Shasta was then supposed to be the highest point in America. I then collected all the information I could for two years regarding it. Many told us that it could not be ascended; others told us that it was perfectly easy; one man said that grass grew nearly to the top." The ascent proved to be easy, but the altitude had an effect: "It was curious to note the effect of the thin air and fatigue on the men. All were more or less drowsy and

sleepy, all complained of headaches, eyes were bloodshot and red. My lips and fingernails were of a deep blue.…But no one bled at the nose, as is common."

Brewer wittily described the first littering of the summit of a California Fourteener: "There was a liberal distribution of 'California conglomerate,' a mixture of tin cans and broken bottles, a newspaper, a Methodist hymn book, a pack of cards, an empty bottle, and various other evidences of a bygone civilization." Brewer and his comrades also estimated Shasta's elevation: 14,440 feet.

Clarence King, a newcomer to the California Geological Survey, climbed the peak in 1870, finding the ascent trivial. "There is no reason," he wrote, "why anyone of sound wind and limb should not, after a little mountaineering practice, be able to make the Shasta climb. There is nowhere the shadow of danger, and never a real piece of mountain climbing—climbing, I mean, with hands and feet—no scaling of walls or labor involving other qualities than simple muscular endurance. The fact that two young girls have made the ascent proves it a comparatively easy one."

During the course of this trip King discovered large bodies of ice on the northern flanks of the peak. Observing them carefully, he saw to his amazement that they were glaciers, the first ever described in the United States. He named the largest of these after his boss, Josiah Whitney. (One wonders why the 1862 expedition didn't discover the glaciers. Brewer wrote that "immense quantities of snow fall on it in the winter—[but] no glaciers form." His party climbed from the southwest, the present normal route, and the various glaciers are not obvious from this side of the peak—or from the summit.)

King was not the only well-known person to climb Shasta during the late nineteenth century. The earlier-mentioned fumaroles play an interesting role in the human history of Shasta, for it was none other than that eloquent bard of the mountains, John Muir, who endured an epic night at 14,000 feet in late April 1875. He had already climbed the peak once, the year before, in the remarkable time of four hours and ten minutes from timberline, averaging 1,500 feet per

hour. His next trip, however, was done in winter conditions—cold and snowy. Caught near the top in a blizzard in late afternoon, Muir and his companion spent a thirteen-hour night at the summit fumaroles, alternately being scalded and frozen. Muir, observant as always, ignored this suffering and noted that "we can hardly fail to look forward to its next eruption."

Shasta became more noticed by the public when the Southern Pacific Railroad was constructed nearby in 1887. But of the estimated 9.5 million passengers who passed by the peak during the next forty years, few saw anything but momentary glimpses of the enormous mountain. This was soon to change.

〰〰〰〰〰〰

In early 1922 a Sierra Club philanthropist named Hall McAllister conceived the idea of building a stone shelter at "Horse Camp," a timberline spring at the 7,880-foot level on the southwest flank of the peak, the start of the traditional climbing route. Incredibly, this "Shasta Alpine Lodge," as it was grandiosely called (it consisted of one stark room of 450 square feet), was constructed in a mere ninety days at a cost of $6,725, most of which was put up by McAllister himself. Adventurers soon flocked to this timberline structure, either to climb the peak or simply to gaze upon its upper slopes. It was not easy to reach, for the winding road from Sisson—now the town of Mount Shasta—ended after only three miles, and one had to walk a path for five miles and ascend 3,200 vertical feet just to reach the Sierra Club's stone cabin. (The present Everitt Memorial Highway, built around 1937 by the CCC boys, passes fairly close to the cabin. It has shortened the hiking mileage to the present 1.7 and reduced the elevation gain to a mere 930 feet.) The first summer caretaker of the building was Joseph Macatee Olberman, known to all as "Mac." He was an erudite fellow, having translated one of Ibsen's plays into English. What led him from such pursuits to becoming the custodian of an obscure stone hut is unknown. In his first season, 1923, he reported that 453 individuals had signed the lodge's register, and that about 150 had made it to the top of the peak. On one splendid July day a record 33 persons stood on top.

Hall McAllister, by this time chair of the Sierra Club's Shasta Alpine Lodge Committee (another grandiose title!), reported in the 1924 *Sierra Club Bulletin* that "the Forest Service has promised a horse-trail for two miles from [the lodge, toward the summit]. At Thumb Rock also a lodge should be erected. The cost is estimated at $3,000. Someday we should like to see yet another lodge at the summit." Thumb Rock, a bump on a southerly ridge close to the normal route, stands at about 12,900 feet. One wonders why plans for these two "lodges" were abandoned, but I think most climbers today are thankful they were never built.

Olberman, paid at first a princely $100 a month, must have had plenty of time on his hands, for over several summers he (and volunteers) built a "causeway" partway up the mountain. I well remember being inspired by this gradually ascending, 950-yard-long set of huge "flagstones" on my 1954 trip. Mac also performed another thankless task during his tenure, measuring with surveying chains the distance from lodge to summit. The result: 21,320 feet, or 4.04 miles.

The caretaker made a fascinating discovery in August 1926: at 14,000 feet Mac stumbled upon a carcass he supposed was a mountain sheep. He took the skull and bones down with him. Later, San Francisco scientists proclaimed the animal to be a pronghorn, the famed "antelope" of the American West. Olberman described his find, concluding, "under what circumstances this animal climbed so high, only to become overcome and lost, can never be ascertained." One wonders if Ernest Hemingway read this, for his epigraph to "The Snows of Kilimanjaro" (1936) contains this sentence regarding a fictional frozen carcass seen close to the summit of the huge African peak: "No one has explained what the leopard was seeking at that altitude."

Olberman was an observant fellow, as can be gathered from his musings in the early 1930s. From high on the peak he gazed down at the depredations of loggers: "The once forest-clad regions, now barren or covered with brush, present a sad picture of desolation, all accomplished in the name of

development. Looking upon it, man might well be defined as an insect allied to the grasshopper, only more voracious." Mac also noted that the peak's snow line had risen dramatically. "Forty-eight years ago, when I first saw Shasta, the line of perpetual snow was where the lodge now stands; since then it has receded two miles up the mountain." He noted that the late season of 1933 was the third in a row in which not a speck of snow could be seen from the lodge.

In late 1934 Olberman, following his twelfth summer as custodian, got cranky for the first time ever in his annual report to the *Sierra Club Bulletin*. "There were 434 visitors [this summer], many of them, I regret to say, more interested in loafing around the Lodge than in climbing the mountain. I take this opportunity to ask those who come to the Lodge, especially those who camp out near by, to refrain from cutting boughs from young trees." Olberman, his health going downhill, was seventy-two, and this was his last summer as custodian. Mac had become a Shasta legend in a mere dozen years.

From its inception, the lodge had been a perfect overnight stop for climbers aspiring to the regular "Avalanche Gulch" route (no glaciers, no real problems, and requiring only endurance and an ability to function at 14,000 feet with little opportunity for acclimatization). Almost immediately speed records became a desirable objective. A later writer was mystified: "Something about Shasta has inspired people to try to climb it quickly, a feat that is easy or hard, depending on the climber and his experience with mountains." Few knew of Muir's 4:10 ascent in 1874, or of Harry Babcock's 3:40 ascent in 1883. And of those who did, no one knew where the starting point of these old-timers was, only that it was "near timberline" and thus presumably close to the 1922 cabin. A new game began: start from the cabin and go for it, with watches and witnesses to verify exact times. The already-famous Sierra mountaineer Norman Clyde was first to the starting line and, on July 3, 1923, the day before the formal dedication of the cabin, this human dynamo got up the 6,282 feet in 3:17. After one day of rest he headed upward once again, shaving 34 minutes off his record, undoubtedly helped by his previous footsteps in the snow. The record was now 2:43—or 2,300 feet per hour.

The chase was on, and a month later a youth named Barney McCoy claimed he had taken the time down to 2:17, or a remarkable 2,750 feet per hour. No reputable witness timed this ascent, and the Sierra Club's Lodge Committee discounted it as "impossible under any conditions at any time of the year on any mountain." McCoy bet a hundred dollars that he could repeat his miracle climb, and he joined six others in a competition in early July 1924. Judges got to the top early, using a different route so no one could use their footsteps. An eighteen-year-old named David Lawyer won the race in 2:24; McCoy was second in 2:37.

A later writer, William Bridge Cooke, wrote: "Who can tell what such a man were to accomplish were he to train carefully, watch his diet, become thoroughly acclimatized, then choose the right route and season?" This was a prescient question, for the record has been steadily whittled downward over the years to 1:39 (a superhuman pace of 3,800 feet per hour). The same individual who made this record-setting climb, Robert Webb, longtime caretaker of the lodge, in 1998 did the ascent, lodge to summit, six times in slightly less than twenty-four hours (elevation gain: 37,560 feet!). He and friends had earlier carried six pairs of skis to the summit, allowing Webb to descend in less than half an hour. His "rest" times back down at the lodge varied, but apparently averaged only fifteen minutes.

Recently, a woman has done the ascent in 2:13; another woman traveled from the town of Mount Shasta to the top in 13:30, an elevation gain of 10,560 feet. At "only" 780 feet per hour, this is a record certain to be broken soon.

While many climbers deplore such speed records, feeling that mountains are too sublime to serve as racetracks, others feel differently. I side with the more casual and soulful approach to our wild places. An hour spent sitting on a shelf on a California Fourteener, having a quiet lunch, gazing out over what looks like untouched land, seems a perfect hour to me. But there's plenty of room for speed climbers. As they flash by, we can either ignore them, gossip about their egos, or envy their strength. They certainly won't take up much of our time!

Not much is known about the history of the various climbing routes on Shasta. On peaks like Rainier and Hood, climbing clubs in nearby large cities kept track of new routes. And, as mentioned, such peaks presented formidable glacial challenges, ones that tended to attract notice and be written up in climbing journals. Shasta, sad to say, has no such track record, for most of its routes are nebulous and nontechnical. And of those that aren't, the technical sections are dismally short—hardly worth writing home about.

The normal route, done by the vast majority of climbers, is called Avalanche Gulch, certainly an appropriate name from January through April. Few climb it then, and the only time to have an "easy" time on the peak is from early May to mid-June, for once the avalanche danger has lessened, hardpacked snow makes the ascent trivial if one's legs cooperate. The descent, too, is sublime: only two or three hours if one has mastered the art of glissading.

By July dreadful sun cups appear, making for nightmarish footing (and glissading on the descent becomes impossible). By mid-August in most years, the snow has largely disappeared and scree slopes dominate. On the other sides of Shasta, September is a fine time for competent climbers to ascend the icy glaciers, but the approaches are long and arduous.

The media, not much interested in routes or windows of opportunity, has focused more on the various dramas on the mountain, namely accidents or potential tragedies. There have been many, but three early ones I remember well, for I read the *Berkeley Gazette* and the *Oakland Tribune* avidly in my youth.

During the Thanksgiving weekend of 1953, Jon Lindbergh made national headlines and was featured a few weeks later in *Life* magazine, mainly because he was the son of Charles Lindbergh, America's iconic aviator. Lindbergh, a Stanford University junior, led a winter club trip to attempt the regular route. At the 10,500-foot level everyone strapped on crampons to climb the long, 35-degree slope leading to the summit ridges. Everyone, that is, except Edgar Werner-Hopf, a graduate student. An experienced skier, he opted to keep his skis on, with skins affixed. This was not a good idea, for eight hundred feet up, in icy conditions, he fell and tumbled downward. The next year's "Accidents in American Mountaineering" reported the result dispassionately: "There was one small rock outcrop in the entire slope which he struck head first."

A more personal story for me involved Gordon "Gus" Benner and his friend Emily Hatfield. (Gus was a classmate of my sister in high school.) In late December 1956, with two others, they climbed the regular route in fine style. But on the descent Hatfield slipped and careened twelve hundred feet down the same slope where Werner-Hopf had been killed. Not badly injured, she nevertheless spent five days in a local hospital.

In January 1966, Les Wilson (the father of this book's photographer) was involved in a stormy epic that dominated local headlines for several days. Wilson was a man we Yosemite climbers had nicknamed "Man Mountain," testimony to his height and magnificent physique. His condition was soon to be tested. Wilson and two friends set out to climb Shasta's north side in less than agreeable conditions, with whiteouts, strong gales, and frigid air. For several days they moved upward from their car at 4,500 feet, eventually reaching a point just below the Shasta-Shastina saddle, at about 12,000 feet. A major storm ensued, and the men dug a huge snow cave. Three days passed with the blizzard outside never relenting. Wilson later wrote that by the end of the third day, "for the first time serious concern for our survival came over us.... We still were in no immediate danger; we were warm and sheltered and strong, although somewhat hungry. A tablespoon of oatmeal a day is not an adequate diet. But the storm was no weaker either; it too seemed fully prepared to go on for weeks. At times it took on the personality of a great gray animal waiting quietly for us to venture out." The storm abated the next morning and the men headed down into civilization far overdue, much to the relief of rescuers and family members. Wilson later said that his wife had "told the press that I had gone off and left the house up on jacks. True, actually."

Winter ascents of the great peak have been popular for decades. Sometimes, of course, a February ascent can be almost as easy as a June climb, except for the bitter temperatures and possibility of avalanches. Often, however, as Wilson and his comrades discovered, the mountain can be vicious. Oliver Kehrlein eloquently described a March adventure in the early 1930s. "We battled a true sub-zero arctic blizzard, when wind of high velocity seemed to pick up the whole landscape and engulf us. We wallowed in a dense swirling mass of frozen pellets driven with tremendous force. They seared our faces and searched out every opening in our clothing. At 11,000 feet we despaired of success and, turning our backs on the wind, made our way down to hot soup and warm bags."

One would not have wished to be at the Shasta Alpine Lodge during the seven days in February 1959 when nearly sixteen feet of snow fell. For more than three decades this stood as a world-record snowfall from a single storm. The avalanches on the upper mountain must have been something to see!

〰〰〰〰〰

At present Shasta has more than a dozen routes, most of them rarely done. The pioneers immediately saw the "easy" way up the peak, and today virtually everyone follows in their footsteps. What to expect on this route? One usually camps near the stone shelter, now owned by the nonprofit Sierra Club Foundation. If ever an "alpine start" is recommended, this is the place, for the snow gets ridiculously soft by noon and it's best to be down by then. Off the climbers go, then, at two o'clock in the chill morning. Snow appears soon if one is climbing in June, and crampons are strapped on if the snow is hardpacked. Shallow gullies and moderate slopes form the first few hours up to 10,400-foot Helen Lake, a level, snow-filled area for much of the year. Then the challenge begins: a 2,400-foot uniform slope, tilted at a reasonable 35 degrees, shoots upward, passing a huge rock island called the Heart on the right. Strong legs help during this grind. Dawn arrives. Finally, at 12,800 feet, one reaches a rounded notch atop the well-named Red Banks, just left of Thumb Rock.

A left turn here, along the ridge, leads eventually to Misery Hill, a huff-and-puff struggle at nearly 14,000 feet. A short, level plateau then mysteriously appears. Across this expanse, the ragged summit rocks are seen up and right. If the wind is howling, lingering on the summit is not an option. But shortly comes the fun, if conditions are right and one is competent with an ice axe and self-arresting techniques. After reaching the Red Banks the glissading begins, and this can be the thrill of a summer. It's entirely feasible to reach the lodge, 4,920 feet below, in a mere hour. Good sliding!

SOURCES AND FURTHER READING

Joaquin Miller's comments come from his book *Unwritten History: Life amongst the Modocs.*

William Brewer's *Up and Down California in 1860–1864: The Journal of William H. Brewer* tells of his explorations across the state as a member of the California Geological Survey. Included is a chapter on his climb of Shasta.

Clarence King's comments come from his classic *Mountaineering in the Sierra Nevada* (misnamed in that Shasta is included).

John Muir's account of freezing and broiling comes from his *Mountains of California.*

A lengthy article by Ansel Hall in the 1926 annual issue of the *Sierra Club Bulletin* (Vol. 12, No. 3) covers much of the early history of Shasta, including the building of the lodge and the early speed records. I found recent speed records from the Internet, a great source for Shasta history and current information.

The comments by "Mac" Olberman are found in the "Reports of Officers and Committees" section of the annual issues of the *Sierra Club Bulletin* from 1923 to 1936.

William Bridge Cooke's comment comes from the 1942 annual issue (Vol. 27, No. 4) of the *Sierra Club Bulletin.*

The winter comments by Oliver Kehrlein can be found in the "Mountaineering Notes" section of the 1933 annual issue (Vol. 18, No. 1) of the *Sierra Club Bulletin.*

Some of the material about accidents comes from the relevant year's "Accidents in American Mountaineering," the annual booklet published by the American Alpine Club; other information comes from contemporary newspaper accounts. Les Wilson's comments come from his unpublished article in my possession.

A valuable guidebook is *The Mt. Shasta Book*, by Andy Selters and Michael Zanger (2006). An excellent map of the region is included with this volume. Other maps are available, including the Mount Shasta 7.5-minute USGS quadrangle and a Forest Service map called *A Guide to the Mt. Shasta Wilderness & Castle Crags Wilderness.*

Another book worth perusing is *Climbing California's Fourteeners: The Route Guide to the Fifteen Highest Peaks* (1998), by Stephen Porcella and Cameron Burns. This describes sixteen routes on the mountain.

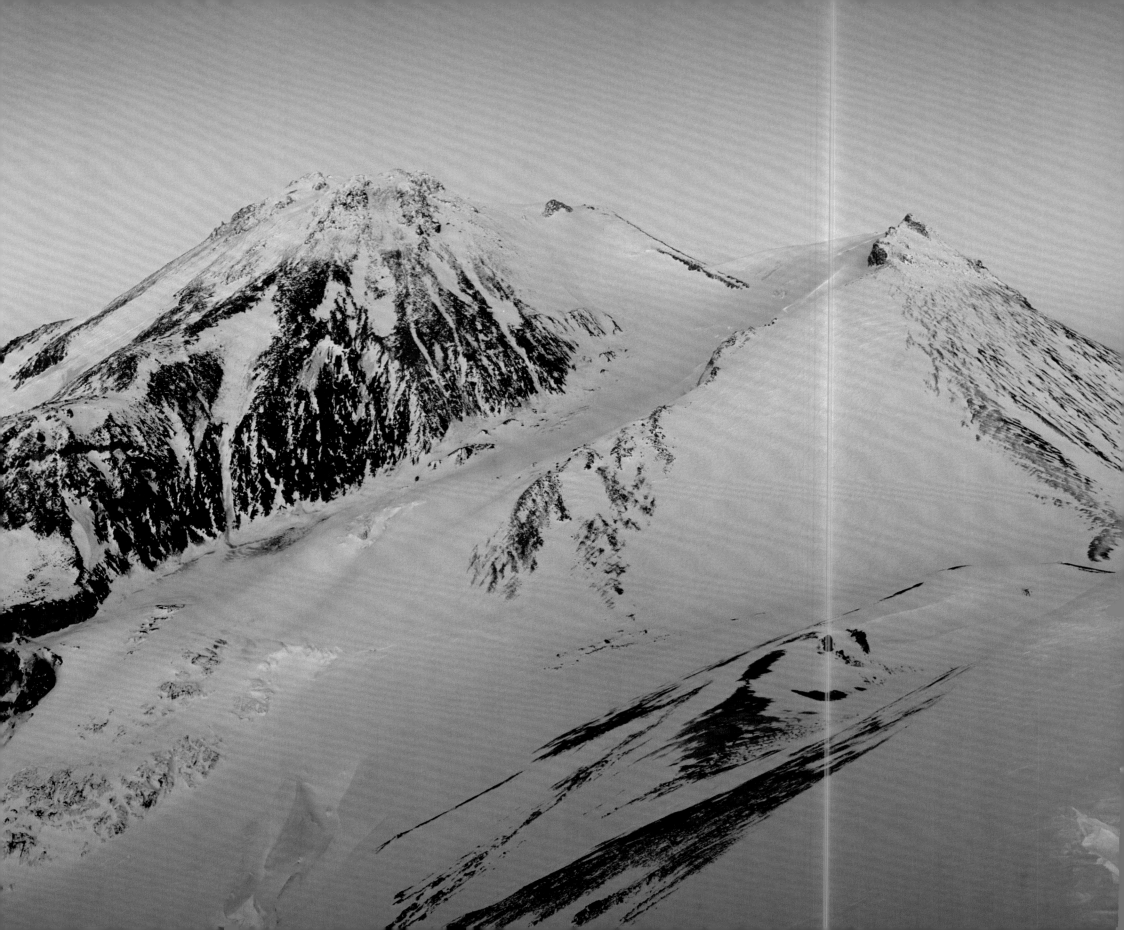

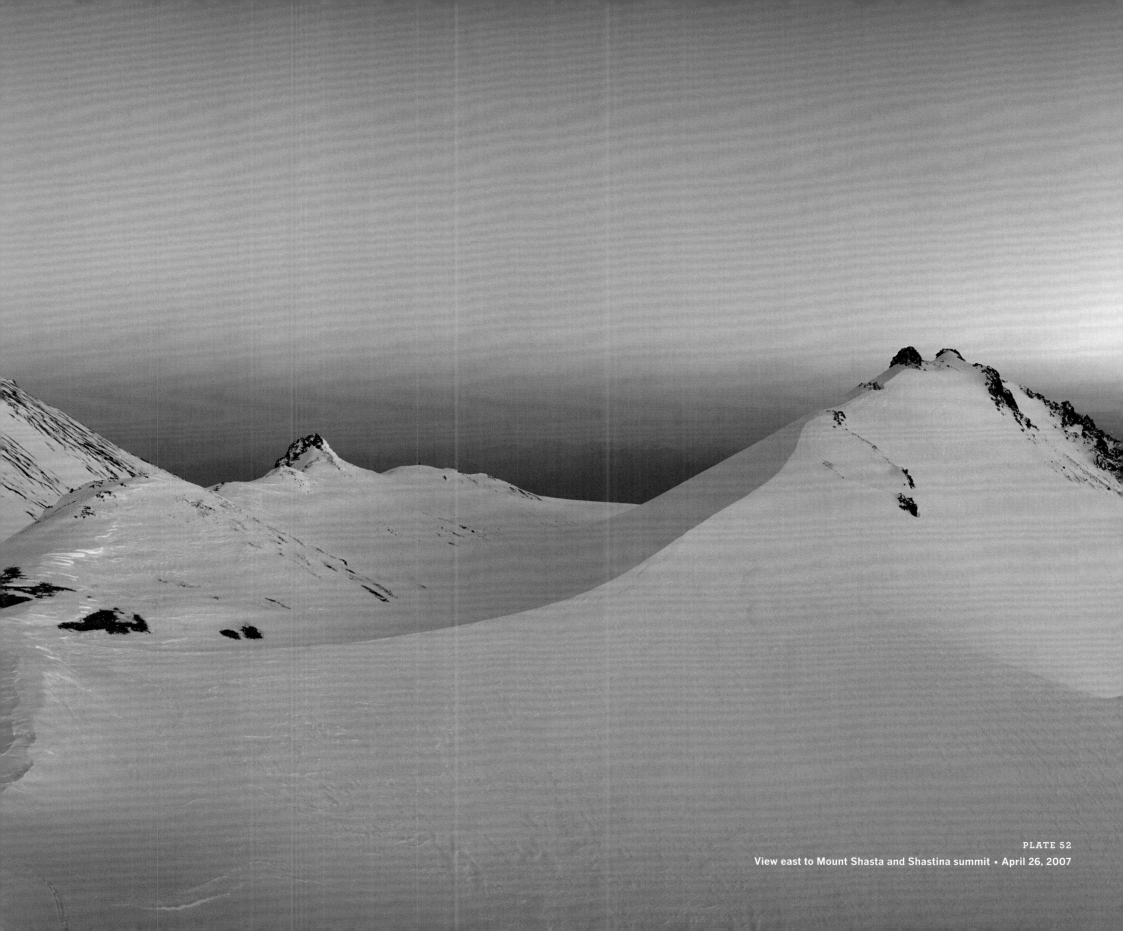

View east to Mount Shasta and Shastina summit • April 26, 2007

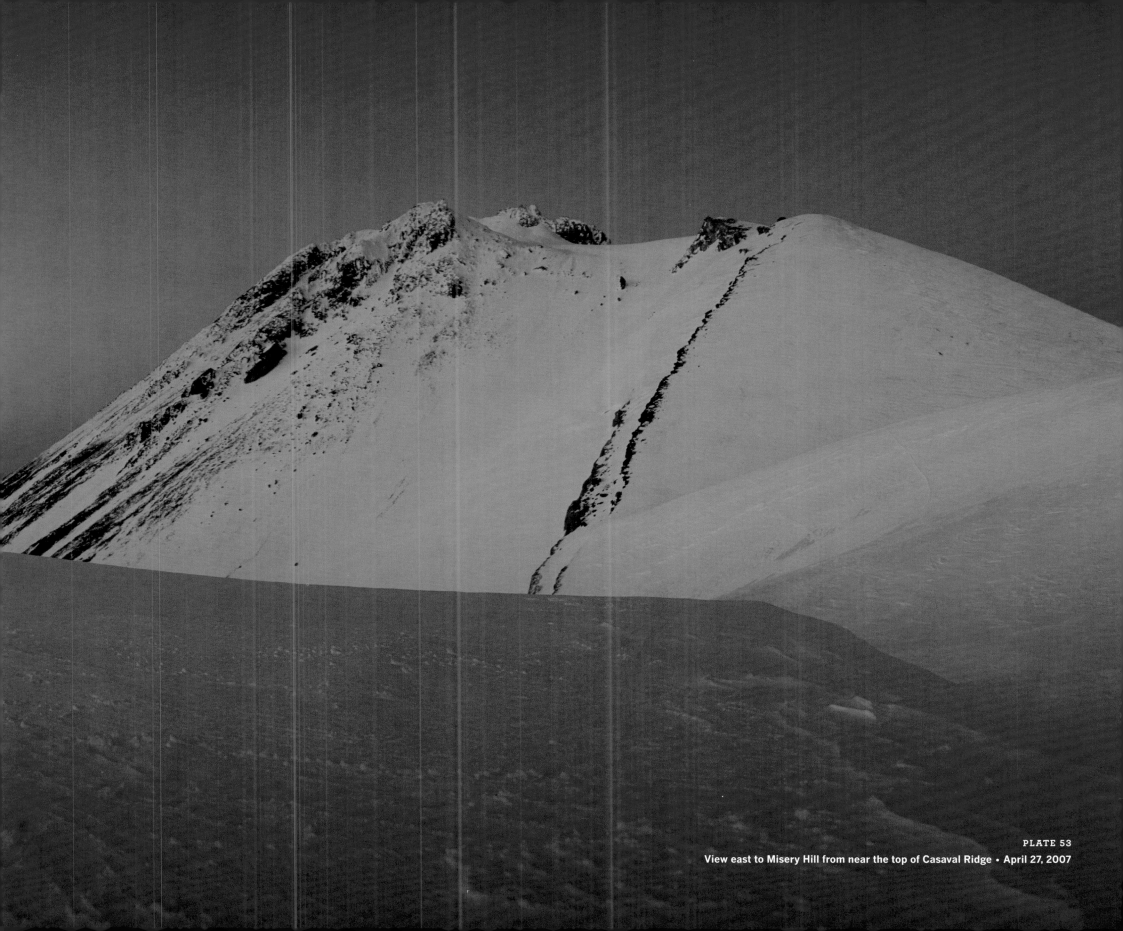

PLATE 53

View east to Misery Hill from near the top of Casaval Ridge • April 27, 2007

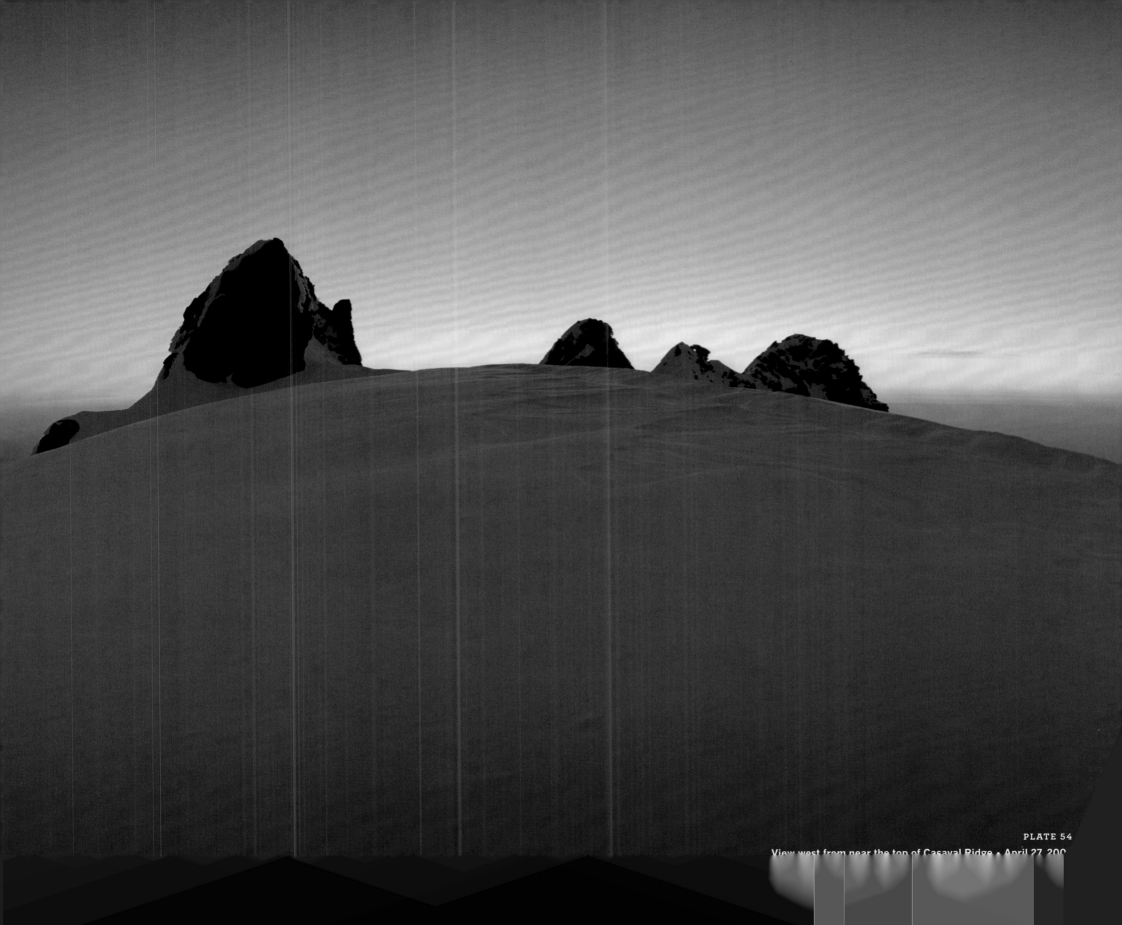

PLATE 54

View west from near the top of Casaval Ridge • April 27, 200

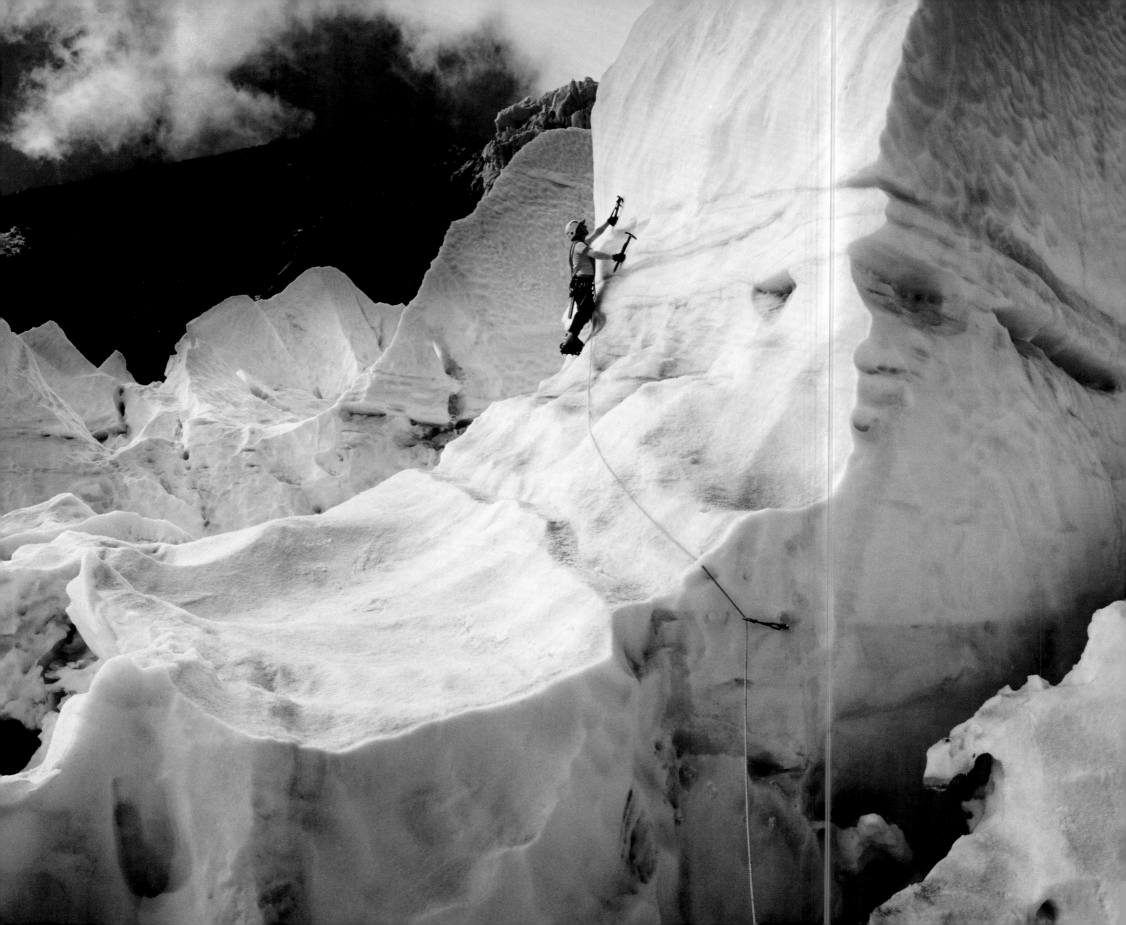

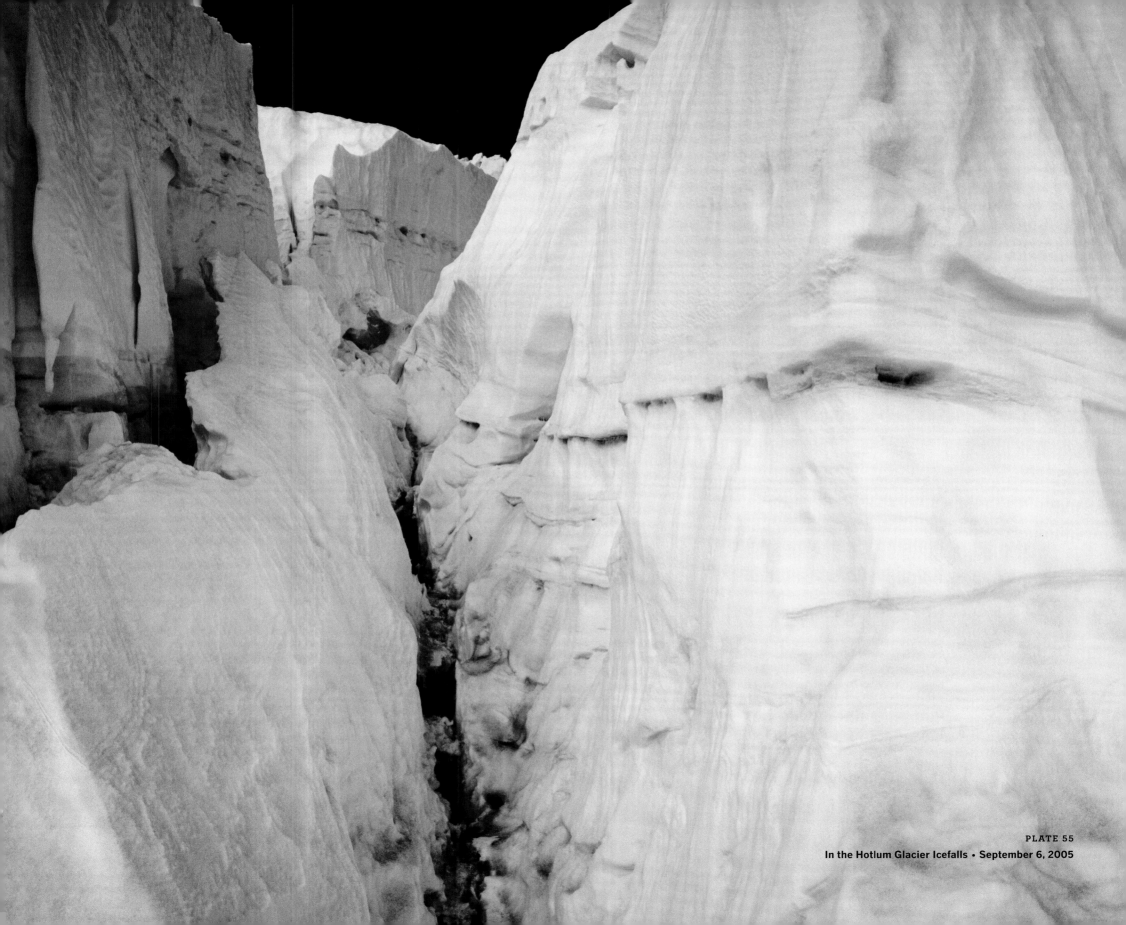

PLATE 55
In the Hotlum Glacier Icefalls • September 6, 2005

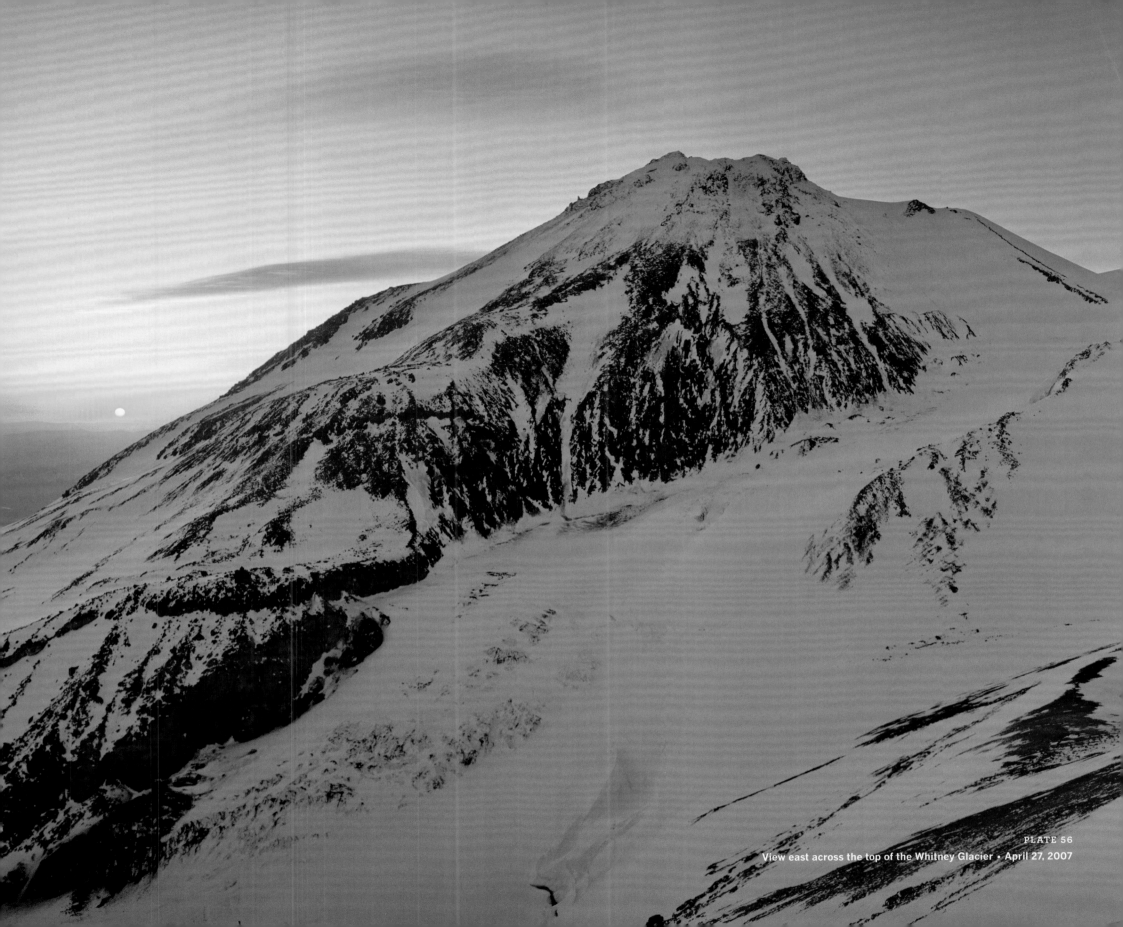

PLATE 56
View east across the top of the Whitney Glacier · April 27, 2007

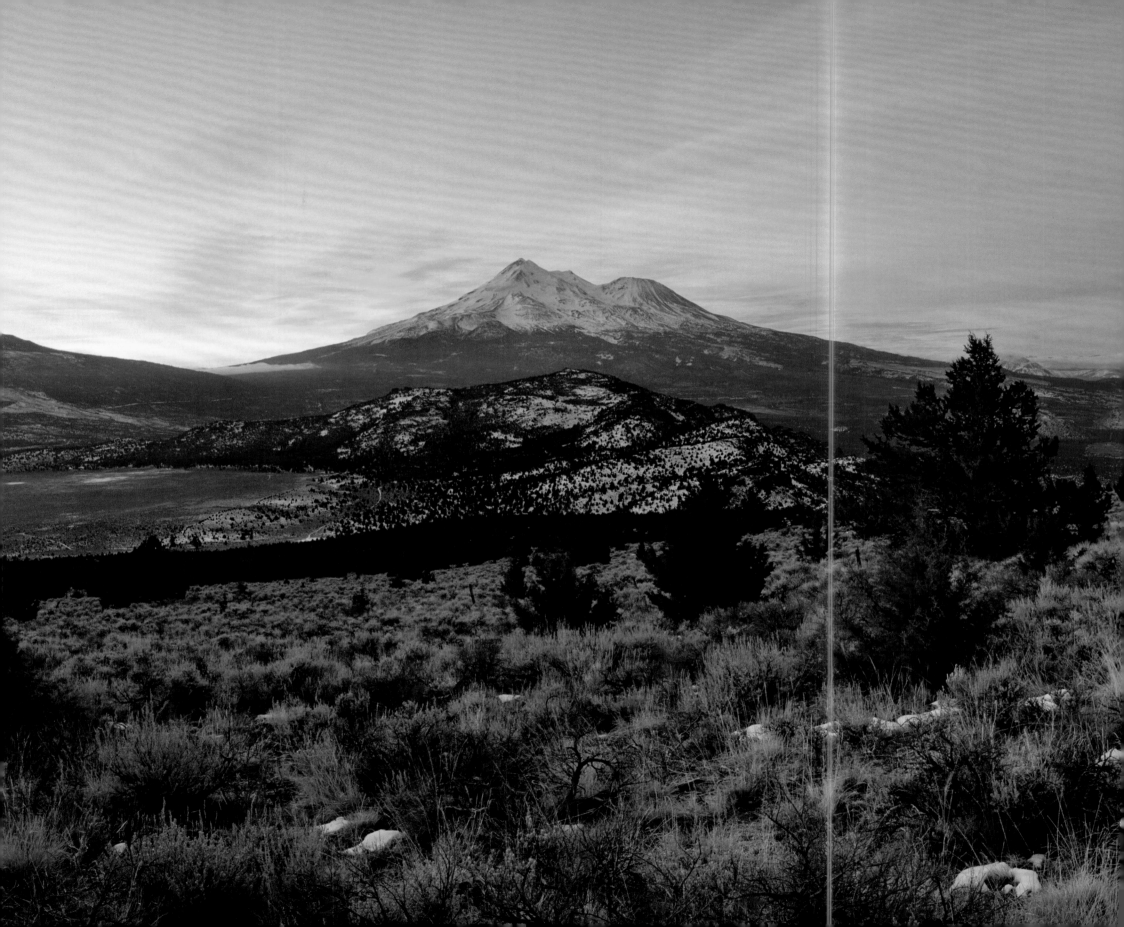

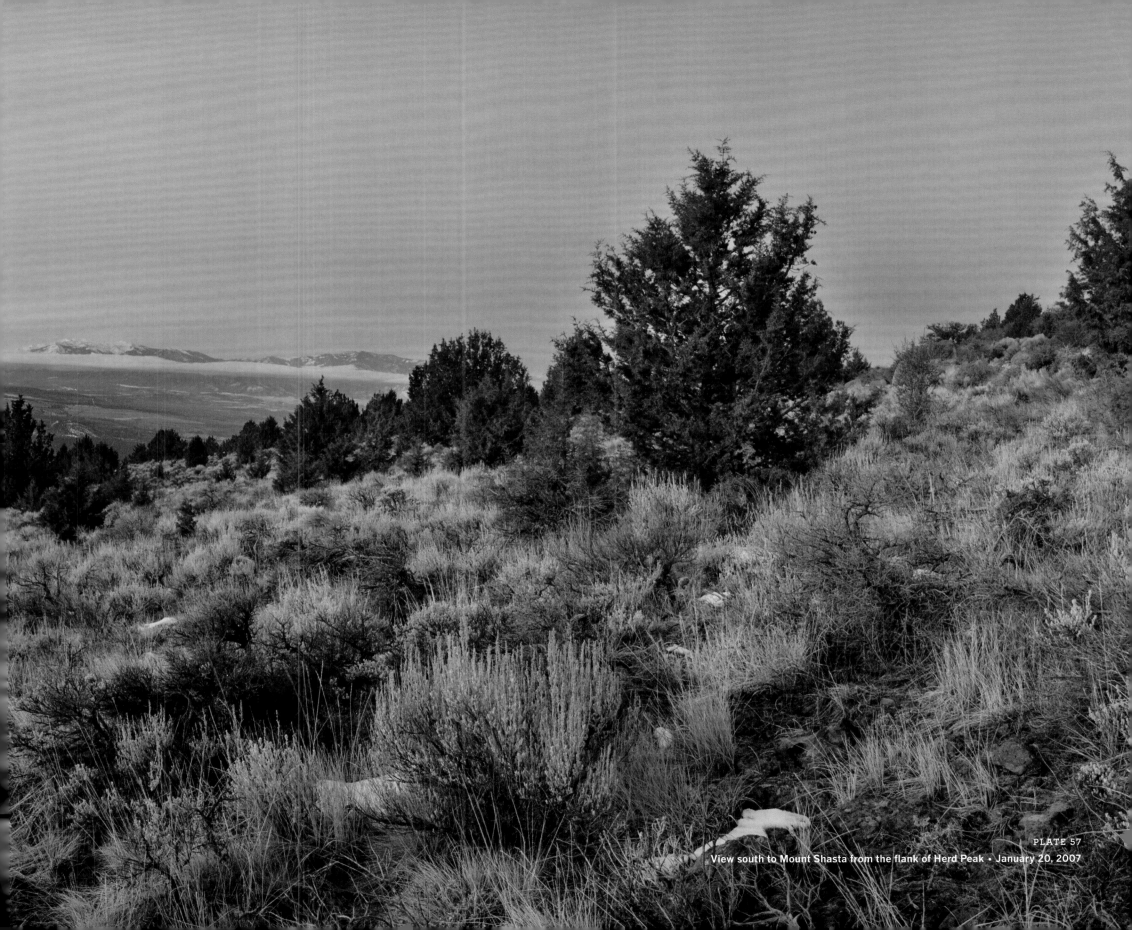

PLATE 57
View south to Mount Shasta from the flank of Herd Peak · January 20, 2007

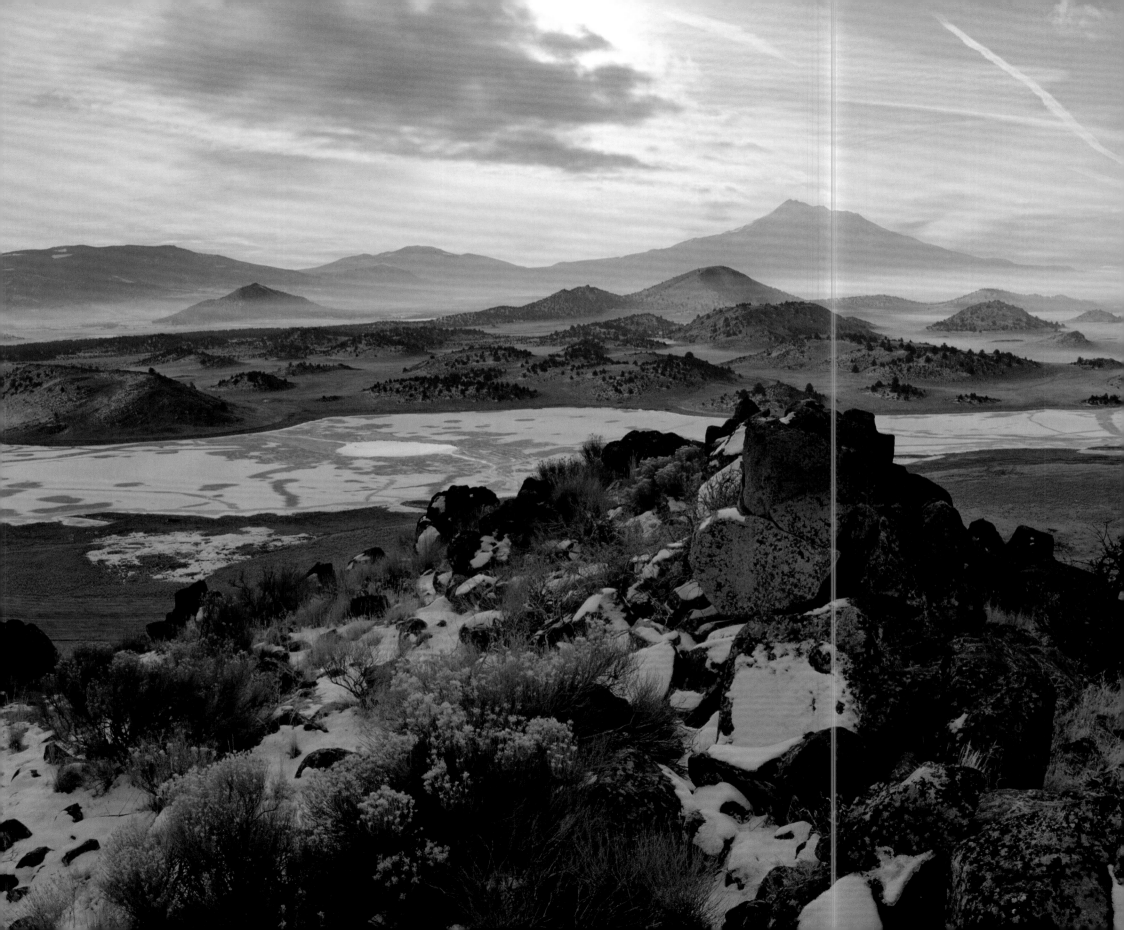

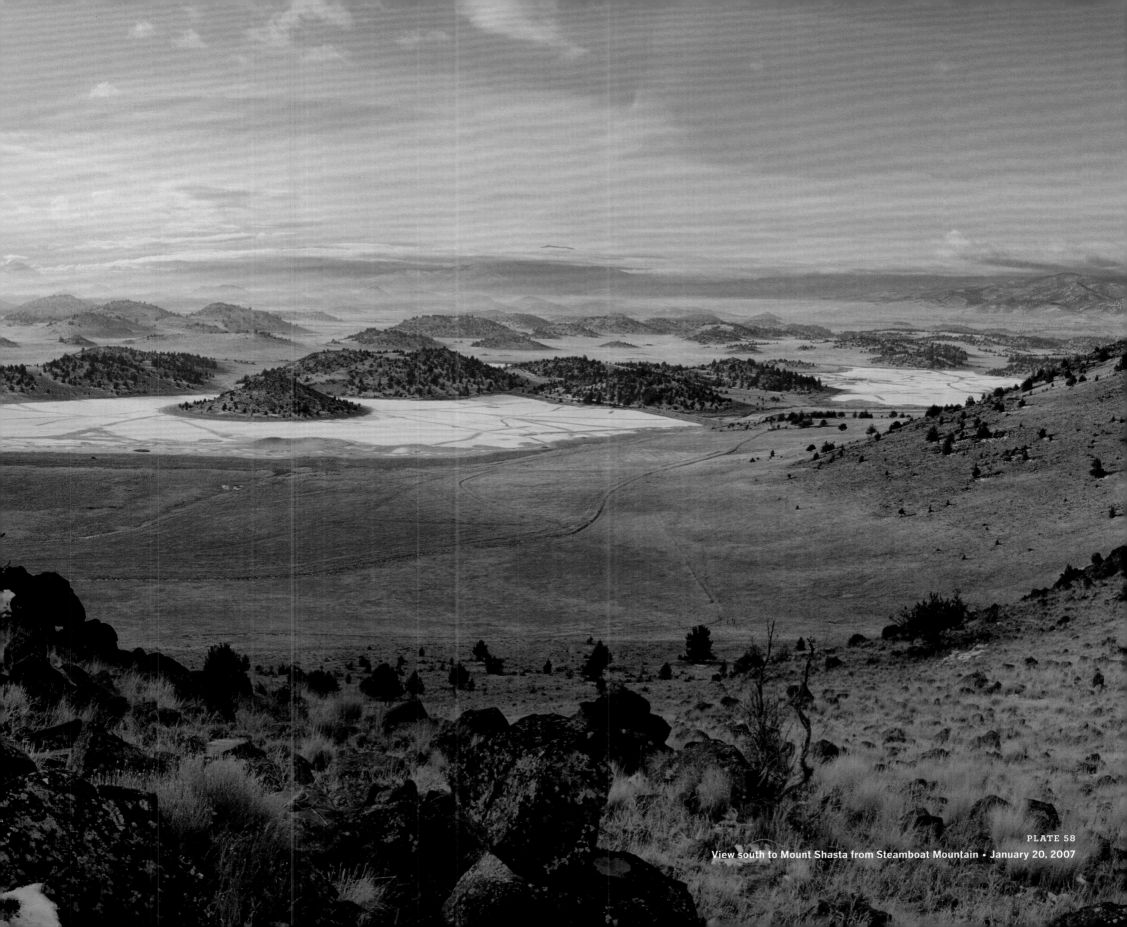

PLATE 58
View south to Mount Shasta from Steamboat Mountain · January 20, 2007

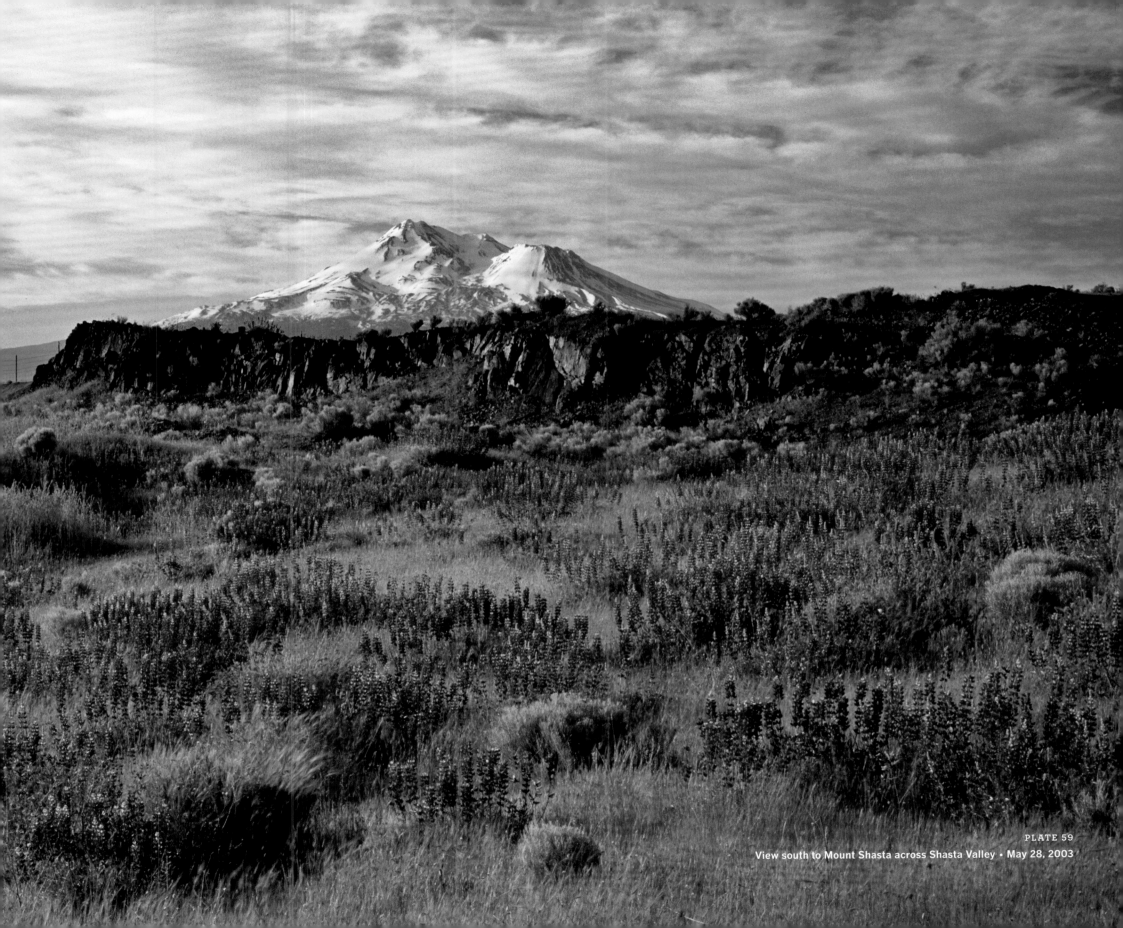

PLATE 59

View south to Mount Shasta across Shasta Valley • May 28, 2003

PHOTOGRAPHER'S NOTE

Shasta was synonymous with discomfort when I was young. My father had a fixation on the mountain. He regularly dragged his family, dog and all, onto Shasta's white flanks. I would stay close to him, often following his ski tracks in a whiteout. My mother and sister, usually much farther back, now claim that they feared for their lives on those trips. Dad's mood always improved as the weather worsened, the mountain's special greeting. His favorite camp was above the Shastina saddle, amidst the rock outcroppings with the Whitney Glacier below, where he said Shasta felt like the "big mountains." In the tent all five of us sipped hot Jell-O from Sierra Club cups. Once, the dog, whimpering in the cold, was allowed in, only to spill the first cup and then, amidst our shouting, the other four in startled succession. Crampons and cold toes brought us to the summit the next morning. These were my earliest memories from one of California's Fourteeners.

Later, starting as a teenager, I climbed regularly with Galen Rowell. A few times each summer, loaded with gear, we drove from the Bay Area to the Eastern Sierra. Galen selected our objectives based on his keen interest in Sierra first ascents. These trips were framed by fast driving and long night marches back to Bishop for a good steak. We always seemed to get to the top, a result of Galen's unique ability to keep looking up. In clouds I might view as an approaching storm, he would see only intervening blue sky. Over the years, we climbed new routes on many peaks, including Mount Sill, North Palisade, Tyndall, and Whitney. Each new route sparked interest in other nearby lines and near-future plans. My last new route with Galen was in 1991, after which I stopped climbing in the High Sierra until 2007, when I found a rope in my pack and a willing partner in my son, Chase, for a new route in the Palisades.

The horizontal plane of 14,000 feet is an arbitrary criterion, and yet it motivated my efforts in the High Sierra, as I realized it had for others. Names like Muir, King, Miller, and LeConte traversed the history of California's high country, and their endeavors were often focused on the 14,000-foot peaks. This book emerged out of the realization that this seemingly arbitrary altitude, these Fourteeners, have had a profound effect on our collective history.

I also conceived of this book as a motivator to get myself back to the Sierra. The project started with a family hike along the John Muir Trail in 2003. The JMT winds some two hundred and twenty miles through the Sierra, at many points immediately adjacent to the Fourteeners. I had skied the trail in February of 1988 with Galen and Rob Mackinlay. The first night on that trip, at 13,480 feet, we pitched our tent on the rocky trail crest of Mount Whitney. Tired and dehydrated, we watched a full moon wheel up out of the Great Basin to the sound of Galen's camera. From Trail Crest, under blue skies, we dropped down the flanks of Mount Whitney, skiing the breakable crust with kick turns, and headed north into Wallace Creek and the headwaters of the Kern. We crossed the remarkable Bighorn Plateau, a tableland studded with whitebark pines, between the Great Western Divide and the Sierra crest. Not a ski track in sight—the winter Sierra was abandoned. Each morning we awoke in darkness to start the stove and begin the lengthy process of melting snow. Coated with the frozen condensation from our breath, the stiff nylon of our tent crackled and protested as we packed. Routines are simple in the winter backcountry. You put layers on, you take layers off, you consult the map. The sun can be unexpectedly warm. Shadows are always cold. By late afternoon, the tent you were happy to leave seems a luxury that will never arrive.

This Fourteeners project would be different. I envisioned long summer days hiking with friends, cool Sierra lakes, wild trout, and meadow campsites with warm granite boulders in the sun. The project began that way on the Muir Trail. However, our twenty-day trip yielded bags of film but no pictures that resonated with the unique vision I pursued. For the next two years I photographed, encouraged by my black-and-white work but still finding my color work lacking.

In September 2006, I convinced my daughter, Kai, to hike up to Russell-Carillon Col, in the Whitney area. We carried very little and lay our sleeping bags in the gravel lee of a large boulder. I woke in the dark to set up my camera on the rock

outcrop above. The sun, rising hundreds of miles away out of the Great Basin, generates a well-known light show on the east face of Whitney. I waited. With the first glow in the sky, I photographed, hoping that one or two images would survive the camera shake in the high winds. I photographed until Whitney was ablaze with the orange light that I had come to capture. Back home, as I looked through this sequence of images, the less dramatic images, taken earlier, in near dark, were the ones that I preferred. They had the quality of soft-box illumination across the entire landscape, with every detail revealed in the predawn light. This was the light I resolved to pursue.

With that decision, my project took a marked turn towards engaging the peaks much more on their terms than I had planned. To photograph near the summit of a peak at the very first or last glow on the horizon, I needed to either hike in the dark or resign myself to sleeping precisely where I planned to photograph. I chose the latter and, quickly, my willing companions for these trips dwindled. The hike up, photograph, sleep in the rocks, wake up in the dark, photograph, hike out scenario was basically unappealing. What had been conceived as a recreational project turned into a forced march to completion.

Spreading the new film on my light table after each trip was the encouragment I needed to continue. The rugged desolation of the highest peaks and their extended planes of granite talus were bathed in the softest light possible. For me, the best images conveyed the ethereal and mystical quality at the very edges of the day. In a landscape largely unchanged since such early adventurers as Muir, Brewer, and King, it is the emotional response to the high country that is timeless for the mountain traveler.

ACKNOWLEDGMENTS

I was fortunate to have good company on many trips to the Fourteeners. Foremost among my partners was Nicholas Maderas, seen on many pages in this book. Other partners were my good friends Tarek Milleron and Kike Arnal. My family members have all waited patiently with me, often in the cold, for the light to change. To Kai, Chase, and my wife, Stacia Cronin, these photographs are dedicated. May these views help draw us all back, again and again, to the Range of Light.

TECHNICAL NOTES

The vast majority of these images were photographed with a medium format Noblex 150 rotating lens camera. This camera, when operational, provides a unique 140 degree angle of view that corresponds closely to the perception of the human eye. Other photographs (shown cropped) were made with a 4x5 Canham field camera and a Mamiya 7 medium-format camera. My film of choice became Kodak T-MAX 100 for black and white, and Portra 160VC (rated at 125 ASA) for color negative film. All negatives were drum-scanned and managed in Photoshop to generate prints and scans for this book.

The Yosemite Association is a 501(c)(3) nonprofit membership organization; since 1923, it has initiated and supported a variety of interpretive, educational, research, scientific, and environmental programs in Yosemite National Park, in cooperation with the National Park Service. Revenue generated by its publishing program, park visitor center bookstores, Yosemite Outdoor Adventures, membership dues, and donations enables it to provide services and direct financial support that promote park stewardship and enrich the visitor experience. To learn more about the association's activities and other publications, or for information about membership, please write to the Yosemite Association, P.O. Box 230, El Portal, CA, 95318, call (209) 379-2646, or visit www.yosemite.org.

Heyday Books, founded in 1974, works to deepen people's understanding and appreciation of the cultural, artistic, historic, and natural resources of California and the American West. It operates under a 501(c)(3) nonprofit educational organization (Heyday Institute) and, in addition to publishing books, sponsors a wide range of programs, outreach, and events. For more information about this or about becoming a Friend of Heyday, please visit our website at www.heydaybooks.com.

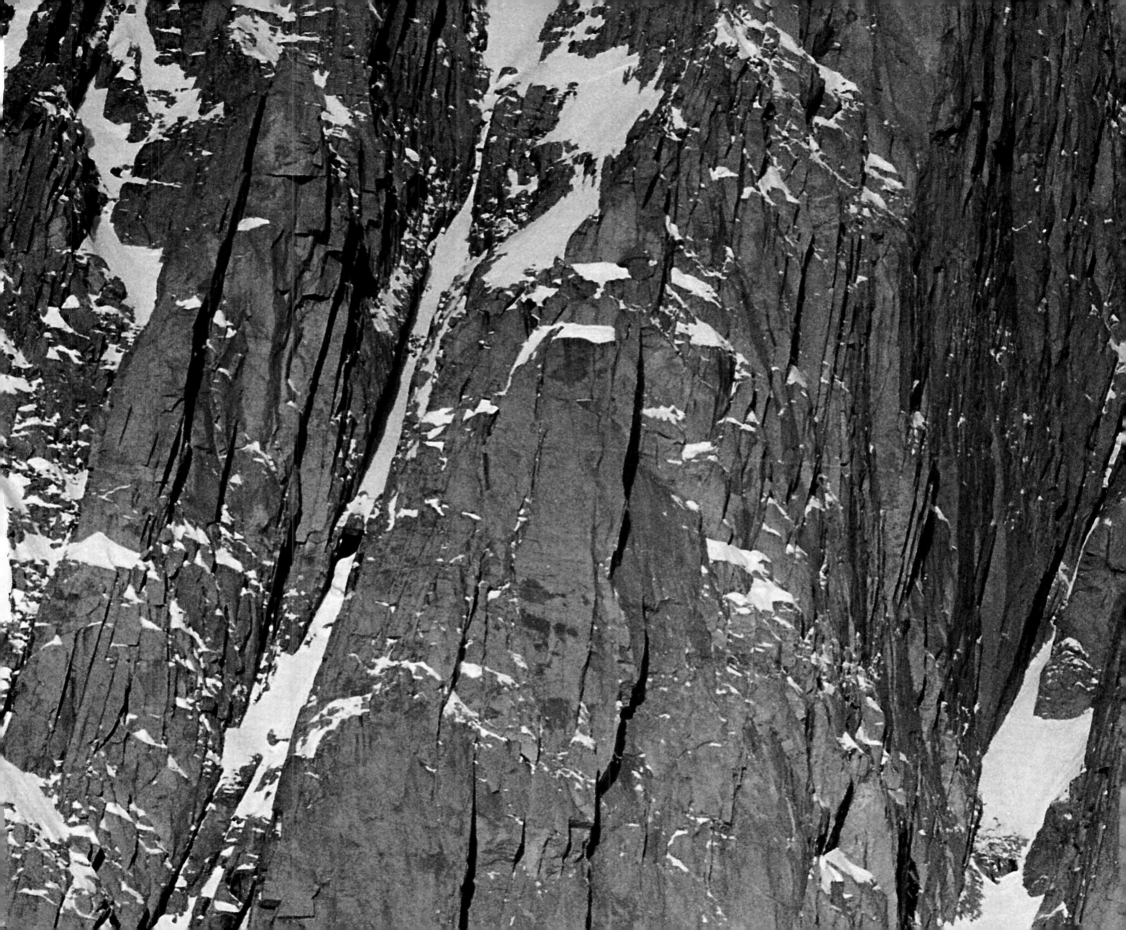

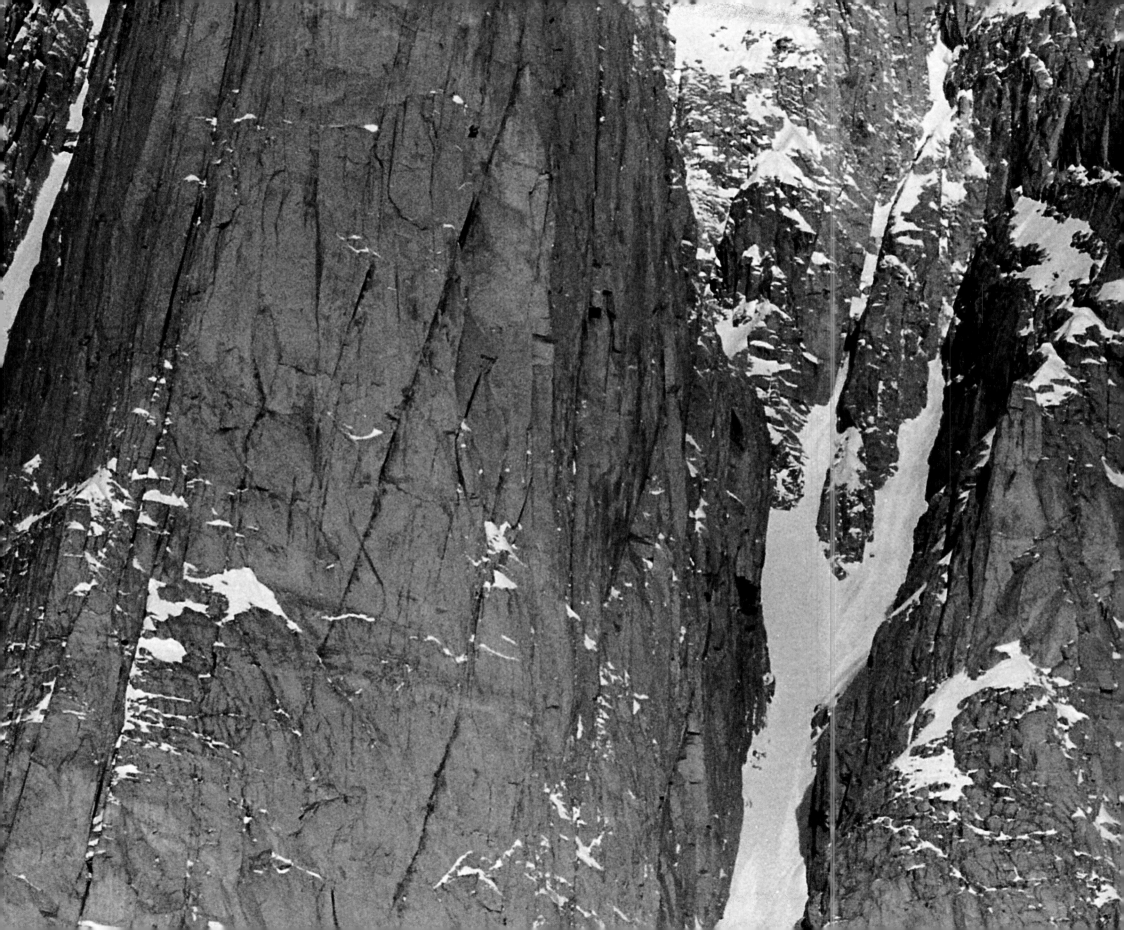